STRONG WOM

NATIVE VISION AND COMMUNITY SURVIVAL

Strong Women Stories

NATIVE VISION AND COMMUNITY SURVIVAL

EDITED BY

Kim Anderson
&
Bonita Lawrence

SUMACH
PRESS

WOMEN'S ISSUES PUBLISHING PROGRAM

SERIES EDITOR BETH MCAULEY

NATIONAL LIBRARY OF CANADA CATALOGUING IN PUBLICATION DATA

Strong women stories: native vision and community survival/
edited by Kim Anderson and Bonita Lawrence.
Includes bibliographical references.
ISBN 1-894549-21-X

1. Native women — Canada — Social conditions. 2. Community
development — Canada. I. Anderson, Kim, 1964 - II. Lawrence, Bonita.

E78.C2S739 2003 305.48'897071 C2003-901921-7

Second printing, 2004

Edited by Beth McAuley
Designed by Elizabeth Martin

Cover detail from *My Indian Me* and *A Woman's Drum* (page 99)
by Lita Fontaine. Both used with permission of Lita Fontaine,
Ernie Mayer and The Winnipeg Art Gallery.

*Sumach Press acknowledges the support of the Canada Council for the
Arts and the Ontario Arts Council for our publishing program. We acknowledge the
Government of Canada through the Book Publishing Industry Development
Program (BPIDP) for our publishing activities.*

ONTARIO ARTS COUNCIL
CONSEIL DES ARTS DE L'ONTARIO

Printed and bound in Canada

Published by
SUMACH PRESS
1415 Bathurst Street #202
Toronto Canada
M5R 3H8

sumachpress@on.aibn.com
www.sumachpress.com

Contents

ACKNOWLEDGEMENTS

We wish to acknowledge all the friends and family who have walked with us as we put this collection together. Among the many, there were Ben Barclay who worked on the editors' photo, and Kathe Gray who proofread the final manuscript. Lita Fontaine, Ernie Mayer and The Winnipeg Art Gallery generously granted us permission to use the artwork that appears on the cover and in the essay that discusses Lita's work. The OFIFC originally funded the research that appears in the articles by Rebecca Martell and Kim Anderson, and they continue to assist us as we launch our "Strong Women Stories." Finally, thanks for the ongoing support from Beth McAuley and Sumach Press, who have given us the means to make our voices heard.

All royalties from the sale of this book will be donated to the Ontario Federation of Indian Friendship Centres Post-Secondary Education Bursary for Native Women.

FOR THE BETTERMENT
OF OUR NATIONS

Bonita Lawrence & Kim Anderson

IN *A Recognition of Being: Reconstructing Native Womanhood,*[1] Kim Anderson explores what we need to know about who we are and where we have come from as Native women. In this anthology, we wanted to pick up from where her book left off — to look at where our communities are now and where we want them to go. What are Native women doing for themselves, their families, their communities and Nations as we recover from the past and work towards a healthier future? *Strong Women Stories: Native Vision and Community Survival* takes a critical look at some core issues and demonstrates how, through hard work and ingenuity, Native women are actively shaping a better world for the future generations. We hope that it inspires all who read it, but particularly our Native relations, whom we expect will recognize the situations presented in many of these stories. We hope that Native women and men, elders and youth will find new ideas for negotiating the challenges they face through the vision and strategies presented here.

The essays in *Strong Women Stories* come from a variety of voices and perspectives. It is no easy task to create an anthology of Native women's stories that spans the experiences of reserve residents and urban women, those with Indian status and those without, those

who identify as mixed-bloods, those who call themselves Metis,[3] and those who identify unequivocally as "Indian," and to do it in a way that shows the organic connections between those experiences. It is clear that the concerns of women who live in First Nations or Metis communities are frequently very different from those who are, for one reason or another, diasporic. And yet, if this anthology demonstrates anything, it is that our experiences represent different sides of the same coin. One way or another, the stories are about the fallout of colonization and the challenge to rebuild.

The collection is structured around the varied experiences of this larger picture. The first section contains profiles of women who have been removed from their original Native communities, while the last section presents the multiple concerns of women about the state of their home communities today. The section in between focuses on the many questions Native women are asking about the issues that they face.

COMING HOME

The first section of *Strong Women Stories* is entitled "Coming Home." In the larger sense, this is something that all of us have had to do, as we re-embrace the traditions that return us to ourselves as Native people. But more directly, it highlights a reality that particularly affects certain groups of Native people. In contemporary times there are increasing numbers of us who, on a daily basis, live with no community or no land base — and in that sense we have no home. Some of us were taken away by the "sixties scoop"[2] and not repatriated, while others cannot regain our Indian status or never had it. In some cases, entire communities have been dispersed, have lost their land base or are denied recognition as Native communities by the federal government, so that it is no longer possible, either economically or practically, for people to live at home. There are also large numbers of women who have been forced from their traditional territories because of abuse or other dysfunction in their home communities. For these different individuals, coming home means reconnecting physically and psychically to their communities of origin, or building alternative communities in the cities where they can feel at home.

The stories in this section reflect these realities. We begin at the Eastern Door, with "Where the Spirit Lives: Women Rebuilding a Non-Status Mi'kmaq Community," an account by Gertie Mai Muise of going back to Newfoundland for a visit. For Gertie Mai, home is a non-status

Mi'kmaq community, one of ten Newfoundland Mi'kmaq communities that the Canadian government refuses to recognize under the *Indian Act*. As she has been forced to live away because of the precarious economic situation at home, the return visits to the community allow for a renewal of her spirit and a time to network with the women and help them deal with the problems they face. The problems are myriad, from the loss of land and a self-sustaining resource base to the violence and dysfunction that is the heritage of colonialism. For Gertie Mai's community, however, survival is rendered all the more precarious by the fact that they are denied recognition as a First Nation, and therefore lack any means to either protect their lands or access services which would help the people.

The struggles of Newfoundland Mi'kmaq people, however, are not unique. From non-status Algonquins in Ontario to Metis communities out West, there are hundreds of Native communities across Canada whose very existence is threatened because of Canada's denial of fiduciary responsibility to them. In the meantime, as Gertie Mai's essay highlights, the women who remain in these communities nurture the traditions and hope for the future, and they continue to welcome their migrant community members whenever they can manage to return.

Our second story speaks to a different history. For Laura Schwager, reconnecting to her Mohawk heritage means retracing the history of her family, who left Akwesasne in the wake of the Canadian government's offer of a land tract. In "The Drum Keeps Beating: Recovering a Mohawk Identity," Laura explores the history of dispossession and dispersal that followed, and in so doing she tells the story of so many Native people who have been disenfranchised or removed from their home territory. As Laura's story makes clear, loss of land is almost inevitably accompanied by loss of cultural knowledge. In this respect, for Laura's family, reconnecting to the traditions as well as with the remaining on-reserve relatives from her ancestral community is a means of repatriating herself and her family, psychically if not physically. Laura shows how it is possible to reconnect, in spite of the fact that under Canadian law her generation can no longer regain Indian status.

It is one thing to attempt to reconnect with one's community of origin. What do you do when your people have been exiled from their homeland — when there is no longer a fixed community which can be seen as "home"? For Metis women living in Eastern Canada, homelessness has long been a way of life. Eastern Metis communities have been

overwhelmed by white settlers for centuries, so that their very existence *as* Metis communities is largely denied within the dominant culture. There are also many Western Metis people living in Eastern Canada because their communities in Western Canada lost their land and were dispersed. In "From the Stories that Women Tell: The Métis Women's Circle," Carole Leclair, Lynn Nicholson and Elize Hartley highlight how a group of Metis women based out of Hamilton have worked to create a community for themselves by forming a Métis women's circle. Their efforts include creating a space for themselves to feel at home in, as well as engaging in popular education projects as a way of helping each woman rewrite herself as Métis back into the history of her community.

Sylvia Maracle's story, "The Eagle Has Landed: Native Women, Leadership and Community Development," provides us with the history of urban Aboriginal community development and the significant role Native women play within those communities. Many Native women have had to leave their home communities because of violence, marital breakdown, loss of property, poverty and gender discrimination. A whole generation of Native women were forcibly disenfranchised by the 1951 *Indian Act* and had to leave. Many of these women responded to their exile from home by creating new communities in the city. As Sylvia documents, the efforts of this generation of women have created a diasporic "home" for the urban Native population. The women living in these urban centres have used their creativity to develop alternative communities where culture and tradition can be maintained and recovered. We have much to learn from their leadership and ingenuity, as documented by Sylvia.

The last homecoming story in this section explores the process of repatriation as experienced by a Native adoptee. Shandra Spears fills a gap in the literature on this subject by offering her perspective about issues that adoptees face from the inside. In "Strong Spirit, Fractured Identity: An Ojibway Adoptee's Journey to Wholeness," she highlights the inherent colonial violence of removing Native children and placing them into white homes, regardless of the loving nature or good intentions of the foster or adoptive parents. Situating the "sixties scoop" as the final step in a process of colonial incursions on her family's identity, she describes the huge psychic rupture that was required for her to reclaim herself as an "Ojibway status Indian" in the eyes of Canada, and as an Anishinaabe kwe in the eyes of her own community. But as Shandra points out, repatriation is seldom the unequivocal "happy ending" we

would hope it would be. For Native adoptees, reclaiming themselves means carving out a whole new road, between the white children they grow up as and the Native adults they become.

Shandra's essay highlights how adoptees are at the forefront of making fundamental demands — that their communities acknowledge them as they are, and that the traditions must be capable of encompassing the complex realities that they have been forced to negotiate. Anticipating the concerns that women write about in the second part of this book, Shandra's essay raises a fundamental question: How does coming home to the traditions work for the people that we are?

ASKING QUESTIONS

The second section of Strong Women Stories, "Asking Questions," moves us to the central question of *What happens when we come home and we don't like what we find?* In terms of coming home to the traditions and culture, there are many things that can make us uncomfortable or that do not seem suitable to the people that we have become. There are also women who have lived in their communities all their lives but find themselves still lacking a comfortable space called home. Our struggles are about finding a place where we have the respect, authority and freedom that are due us as Native women.

Emma LaRocque has written that "as women we must be circumspect in our recall of tradition. We must ask ourselves whether and to what extent tradition is liberating to us as women."[4] In this section, we look at some of the ways in which traditions are interpreted or applied. In many cases, we must wrestle with the patriarchal framework of colonialism and ask what it has done to our traditions, including our social and political systems. For women who have always been connected to their communities, it can be doubly difficult to question a patriarchal or otherwise oppressive status quo. These essays provide examples of not only *what* questions to ask but *how* to ask them. The authors in this section undertake some of these difficult questions — sometimes gently and sometimes passionately, but always courageously and honestly.

Our questioning begins with Rosanna Deerchild's "Tribal Feminism Is a Drum Song." Rosanna writes about the artwork of Lita Fontaine, a Dakota/Ojibwa visual artist based in Winnipeg. In her story, Rosanna shows us how art can be an effective way to ask questions. She focuses

on aspects of Native women's identity as a central part of Lita's art. Lita's creative vision has taken her on a journey, from exploring the effects of the colonial process on her immediate family, to questioning the extent to which its patriarchal beliefs have invaded Native ways of seeing the world. Throughout the story, Rosanna explores the thought-provoking challenges to contemporary notions of "the traditional" that pervade some of Lita's installations. She shows how, for example, Lita has taken on the debate in the Native community about whether women should sit around the big drum. This story demonstrates both the important role of Native female visual artists and the types of questions they may be addressing.

If Lita's art questions the extent to which patriarchal notions have influenced contemporary Dakota and Ojibway traditions, Dawn Martin-Hill, a Haudenosaunee woman, is unequivocal in challenging contemporary notions of "traditionalism" for women overall. In "She No Speaks and Other Colonial Constructs of the 'Traditional Woman,'" Dawn draws parallels with the circumstances faced by Afghani women and describes the kind of "perverted radicalism" in the face of extreme colonial oppression that can transform what we consider "traditional" into severe oppression for women. In the name of tradition, she asserts, Haudenosaunee women are actively silenced and denied agency. The disastrous result for these Native communities is that these women are prevented from exercising the leadership that is needed. Looking back in Haudenosaunee history, she suggests that true traditional practices would restore women their authority to ensure that children and family life was once more at the centre of their communities.

The two previous stories question how well traditions serve women in general, and the next two begin with the question, How well do the traditions serve the women we are today? Bonita Lawrence's story, "Approaching the Fourth Mountain: Native Women and the Ageing Process," focuses on Native women as they age. In dialogue with elders and Native women entering menopause, Bonita explores the meaning of this transition in Native women's lives and the extent to which traditional knowledge and ceremonies about menopause have vanished from our cultural practices today. She also raises the question of what we can do to reintroduce some of these practices as we work towards a healthy future.

The next story, "Arts and Letters Club: Two-Spirited Women Artists and Social Change" by Nancy Cooper, describes the work of a number

of two-spirited Native artists and activists. In her art, Nancy names the manner in which two-spirited people have been "written out" of the traditions of their Nations. The denial of the presence of two-spirited women in pre-contact societies, according to Nancy, is central to how gays and lesbians are excluded within many contemporary Native communities. While Native lesbian artists and writers are working hard to educate their communities, the manner in which they are marginalized in the creative arts and in the publishing industry makes it harder for their communities to have access to their voices.

It is not always easy to find a voice within cultures that have been corrupted by patriarchy, and the way in which our women find voice is the subject of the last two stories in this section. In "The Healing Power of Women's Voices," Zainab Amadahy, an African-Cherokee singer and writer based in Toronto, speaks about the centrality of singing to most traditional Native societies — and the importance of singing for contemporary women. Describing the power of singing to effect change in the lives of Native women, she is saddened by the obstacles that traditional women singers all too frequently face in their attempts to share their songs with their communities. She documents the myriad "teachings" that women constantly encounter that restrict the places, times and types of songs they can sing, and points out how organizations often promote men's powwow singing to the exclusion of women singers. Zainab articulates both the problems that women face as they struggle to find their voices and the resistance they manifest in continuing to sing in the face of these obstacles.

For Native women, finding our voices is also about articulating the circumstances we encounter as we work to bring about social change. The final story in this section, "Aboriginal Women's Action Network" by Fay Blaney, describes the work of this Network in Vancouver. This group challenges the many levels of oppression that Native women face. A crucial aspect of their activities has been to highlight the phenomenal extent of violence in their everyday lives. The group has organized around the murder of Pamela George and the targeting of Native women by serial killers. Another major undertaking has been community-based research that explores the actual experiences of women who regained their Indian status through Bill C-31. In examining the manner in which the resources of these women's communities are controlled by men, AWAN has become crucially aware of the extent to which patriarchal practices have informed not just traditional life but also the

everyday life of many reserve communities. Because of this, a central part of their activities involves popular education around dealing with oppression. AWAN refuses to look away from the extent to which sexism, racism and internalized colonialism all affect Native communities, and works to find ways to overcome these divisions. In so doing, AWAN offers us a blueprint for social change, a way to address some of the problems that plague many of our communities.

REBUILDING OUR COMMUNITIES

Asking questions can help us define the kinds of communities that we *don't* want. As we rebuild our communities, we have to draw on tremendous vision to bring about the kind of communities we *do* want. What kind of home are we going to create? There are many, many issues that we have to deal with in the social, political and economic sectors as we take up this challenge. In this third section, "Rebuilding Our Communities," we deal with just a few, taking up questions of sexual health, disability, violence, land loss, education, internal oppression and gender roles. By looking at these issues, we have demonstrated how women play a critical role in the rebuilding of our families, communities and Nations.

In terms of community and nation-building, a good place to start is with the children. If residential schools and the child welfare system took the children out of our communities, it is time for us to put them back in. If violence, alcohol abuse and poverty have created havoc in their lives, it is time we made their concerns central. We need to examine the health and well-being of our children and consider the significance of that in relation to our future. As a starting place, we present three essays here that deal with the subjects of family planning, fetal alcohol syndrome and schooling.

We begin by looking at the way in which we call our children into the world. How can we recapture the sacredness, the reverence for life and the care that traditionally characterized our childbearing and child-rearing practices? In her story, "Vital Signs: Reading Colonialism in Contemporary Adolescent Family Planning," Kim Anderson looks at family planning from a historical perspective and demonstrates that youth today are suffering from a lack of guidance and support in matters of sexual health and pregnancy. The prevalence of adolescent pregnancy and parenting among Native people and the high-risk

conditions under which our youth become pregnant are alarming indicators that speak to a lack of self-care, self-worth and sense of purpose among our future generations. There are many syndromes to blame, including the denigration of sexuality through residential schools and the sexual abuse that is its legacy, the loss of parenting skills during this period, the alcohol and substance abuse, and the widespread poverty among contemporary Native families. Kim focuses on the impact of losing traditional women's knowledge, linking it to the relative lack of authority we now have in terms of managing the family planning practices of our Nations. She calls upon the adults of the community to take up their responsibilities to the children and youth, and points out how one provincial Aboriginal organization is tackling the needs of youth within their capacity.

The way in which we educate our children and youth will also greatly influence our future. Jean Knockwood's story, "Creating a Community-Based School," documents the experience of the Indianbrook First Nation in Nova Scotia and highlights some of the things we need to consider. The motivation to build our own education systems can come from having to deal with outside concerns, such as racism — but is also part of the internal organic process of decolonization. Jean shows how once we begin to "come home," we are no longer satisfied with the inadequacies of a mainstream education. One wonderful aspect of this story is that it demonstrates how everything falls into place as soon as we do something for the children of the community. If we understand our children as the heart of our Nations, and if we make their needs central, the whole community begins to heal. In addition to providing a better space for the children, the Indianbrook school gave the community a welcoming forum for people to meet and communicate. Volunteerism increased, parents had a sense of ownership and eventually adults took up a part of the space for their own education. The school even had an impact on community economic development. In the midst of this success, however, there were also many challenges. Jean's story demonstrates that change is hard to accept, pointing out some of the problems that surface as we begin to heal and make change.

There are certain things that we cannot change, and so we must look for ways to work with these conditions. With Fetal Alcohol Syndrome/Effects — the leading cause of developmental disability in North America — there is no "cure," and there are many Native

children and youth who are alcohol affected. We need to work on prevention, but we must also give attention to our community members who are struggling with this syndrome. In her story, "Fetal Alcohol Syndrome: The Teachers Among Us," Rebecca Martell shares the knowledge she has acquired in her thirty years of experience working with children and communities who are touched by FAS/E. She reminds us that "multi-generational pain can make individuals, families and whole communities turn to alcohol and drugs for relief," and shows how women in her life have taught her to be non-judgemental in light of this knowledge. As a foster parent to a child with fetal alcohol syndrome/effects, and as an addictions worker who has assisted communities in their response to FAS/E, Rebecca shows how Native women have been both courageous and creative in building a supportive home for our alcohol affected community members. Rebecca's story demonstrates how we can recreate safe spaces for all of our children, and highlights the positive changes that begin to happen when we do this work.

From the children, we move to the women. Violence against women has long been a concern, and family violence involving Native women has been reported at epidemic proportions. In "From Victims to Leaders: Activism against Violence towards Women," Cyndy Baskin tells us the story of how Native women move "from victims to leaders" through distinct, culture-based programming that engages all members of a family living in violence. She frames Native family violence within the "colonial policies and oppression of Euro-Canadian society and governments," and shows how it is important and effective to work with both men and women if change is to occur. Cyndy demonstrates how Native approaches to family violence have come from a holistic philosophy around the necessity for *community* healing, adding that this can present positive alternatives to working out family violence issues through the criminal justice system. She also looks at the big picture, pointing out that we need to change laws that allow women to be victimized and that we must do away with "the ethic of domination." From her work experience, Cyndy has seen the direct impact of culture-based family violence programming. She documents the changes in both offenders and victims, in men, women and children who took part in a program that she worked on for several years in Ontario. Cyndy gives us very concrete examples of how a holistic approach to family violence can be applied in a community-based setting.

Sometimes, whole communities experience violence in extreme and acute forms, and the Chippewas of Kettle & Stony Point in Ontario are one such community. In "The Truth About Us: Living in the Aftermath of the Ipperwash Crisis," Shelly E. Bressette, a lifelong resident of the Kettle & Stony Point First Nation, writes about how the crisis affected her community. Her story is a sobering reminder that Native people face ongoing violence and oppression as they try to protect their land. Within this lies the question, What do the women do when they end up living in such a war zone? Shelly points to the need to find justice and the need to speak the truth — and truth telling is particularly important to Ipperwash, considering all of the silencing around this particular case. The Ipperwash Crisis continues, as the land is still occupied and there are many unanswered questions related to the shooting of Dudley George. Shelly considers the healing role of women, and shows how they can have courage in the face of a community that struggles with this chaos. She writes affirming words, chronicling the many things a woman can do, and finishes by reminding us, "Children and elders come first, always, and without exception ... Talk to them. Listen to them. They will always tell the truth."

We have decided to close the book with an essay written by the only male writer in our group. Many women's ceremonies are supported by a male firekeeper, and so we invited Carl Fernández to be a part of this book that is our ceremony. His story, "Coming Full Circle: A Young Man's Perspective on Building Gender Equity in Aboriginal Communities," draws on his interviews with women, men, youth and elders and focuses on how we can bring back the balance to our communities. He looks at "How It Was" and shows how we lost many of the beautiful ways that engendered healthy relations between men and women. He then examines "How It Is," showing examples of the imbalance and uncertainty we live with as a result of male dominance. He finishes by looking to the future. It is a hopeful ending, with Carl offering some of his observations on how we are moving towards a better world. As he says, we have the capacity as Native peoples to spiral forward — to turn back to our healthy traditions of the past while at the same time progressing forward in order to survive in this new century.

*

As we close this project, we breathe a collective sigh of relief and realize how much work has gone into it. Part of the reason has been the lack of resources; in trying to build a book that would both represent and appeal to the grassroots voices of Aboriginal women, we had to call on incredibly busy, overloaded women to take time out and write these essays. *Strong Women Stories* is entirely a project based on volunteer labour — labour that was done in a context where women are constantly struggling to meet all the demands that are made of them. We live in families and communities that struggle with poor health, family breakdown, alcoholism, suicide, premature death, and so on. These are the realities of our lives, and as we tried to meet deadlines and come together to produce this book, every one of these problems presented themselves. This is the reality of being a Native woman. In terms of "roles and responsibilities," this project demonstrated to us that Native women carry heavy loads but that they have a tremendous spirit of generosity in that they continue to give for the betterment of our Nations. We are so grateful to all the authors who have given their time and taken part. To them, we say:

Welaalin, Nia:wen, Wah-doh, Chi Meegwetch, Hai Hai,
Ee-moot-heh-how.

NOTES

1. Kim Anderson, *A Recognition of Being: Reconstructing Native Womanhood* (2000; reprint, Toronto: Sumach Press, 2001).

2. A period during the 1960s when numerous Aboriginal children were apprehended by child welfare authorities and made wards of the state. For more information, see Ernie Crey and Suzanne Fournier, *Stolen From Our Embrace: The Abduction of First Nations Children and the Restoration of Aboriginal Communities* (Vancouver: Douglas and McIntyre, 1997).

3. For an explanation of the different usages of Métis and Metis, see note 1 in chapter 3.

4. Emma LaRocque, "The Colonization of a Native Woman Scholar," in Christine Miller and Patricia Chuchryk, eds., *Women of the First Nations: Power, Wisdom and Strength* (Winnipeg: University of Manitoba Press, 1997), 14.

PART I

COMING

HOME

CHAPTER ONE

WHERE THE SPIRITS LIVE:

WOMEN REBUILDING A NON-STATUS

MI'KMAQ COMMUNITY

Gertie Mai Muise

You may now feel that we have nothing. You may feel poor, but you are not. Many, many people have sacrificed so that we could survive as a race of people. Do not begrudge your inheritance. We have been given the best our ancestors had to give. It is an honour to be here and a privilege to be so loved.

— ELDER'S MESSAGE, END OF THE OCCUPATION OF
THE REVENUE CANADA OFFICES, TORONTO, 1996

MI'KMAQ WOMEN of western Newfoundland live the ultimate contradiction and duality. We are systematically oppressed but, without question, we are altogether strong. We are dependent on men, the church and welfare like no other group of Aboriginal women in this country, yet we are fiercely independent and cut our own trails. We have next to little political representation, yet no major shifts occur without the will of the women. Violence against us at home remains commonplace and socially accepted, yet there's not a single man who would intentionally tempt a Mi'kmaq woman's scorn. Our collective

trauma has immobilized us in so many ways, yet our actions remain intrinsically tied to who we are. We are truly the forgotten women of Canada, yet each of us have been permanently imprinted by at least one other Mi'kmaq woman in a way we can never forget. For example, I am here and can write this article about my community because Mi'kmaq women prayed for a long time, took dares and made sacrifices for me. I will never forget them.

I love to go home and want you to join me now on a visit. You'll get a glimpse of Mi'kmaq history, of our resistance and the complex activisms that are helping this neglected Aboriginal community recover its authority, here on the rocky shores of western Newfoundland.

Going Home to Newfoundland

To be on your way home to the people on the Island is really exhilarating. Today, I am flying into the hub of the Bay St. George and Port au Port Peninsula. I am struck by the fact that even though this is where my heart is, I have not yet returned to live here. I had never intended to live out my adult years away from my family. After graduating from university, counsellors, professors and non-Native professionals advised me to "get my feet wet" in the workforce on the mainland, then come back and apply for work. It was all set. Easy! I was too young not to realize that this advice only worked for privileged white women.

It would be much later before I would come to know that even at that young age, I had already been socialized not to live among my people. Assimilation was already at work within me. University constantly hammered in western values, such as competition and debate, business marketing techniques, psychology and christian theology, which reduced my own people's knowledge to the status of folklore. These concepts were foreign to my family and me, but as a student I was expected to adopt them as accurate and to accept them as the superior ways of the modern world. To this day I have no resolve for it. I often point out that if I had known how a university education would separate me from my family, I would not have gone, and if my father and family had known what getting an education was and does, they wouldn't have been so insistent on my getting one. The education system's aggressive imposition of foreign values would not have been accepted by my family; it would have been considered an act of violence against the spirit. All my family really wanted was for me to escape poverty and to help the future generations do the same.

After university, I could not find a job. The fact that I was an educated woman, without a man, without a child and without the intention to have either in the near future did not help me, as one employer explained to me! Worse, as a Mi'kmaq woman, I was seen as being limited in what I could do and what I could accomplish. It quickly became obvious to me that any economic opportunities that existed would not be offered to or shared with me because of my gender and race. My passionate love for both didn't help, either. I was always told I was "Indian," a Mi'kmaq and not to be ashamed of the fact. I couldn't understand what I would have to be ashamed about. I had no idea. I did not lose my "status," instead my identity as a Mi'kmaq was stripped and stolen from me and from my community. An identity I have since reclaimed and would die to protect.

RECLAIMING STATUS AND SOVEREIGNTY

There are eleven Mi'kmaq bands on the Island. When Newfoundland joined Confederation in 1949, the Mi'kmaq people in the province, as well as the Innu in Labrador, were refused status under the *Indian Act*. Concerned men from communities across the province began efforts in 1974 to revitalize community and confront Canada. The bands came together under the Federation of Newfoundland Indians (FNI) and, in 1984, won formal recognition of the Conne River Band from the federal government. The FNI sued the government in 1989 for breach of fiduciary duty and for unfair treatment of the ten remaining bands. This case is still before the courts.

Mi'kmaq Elders and the traditional community acknowledge us, but everything works against our recognition as Mi'kmaq people of Newfoundland. One big problem is that outsiders and academics have established their authority over our existence and history. They say things like "The Mi'Kmaq migrated over to Newfoundland and murdered the Beothuk." In fact, everybody is an authority on my Nation. For example, when I declare my Nation and then say where my home is, most people will actually say, "No, there are no Mi'kmaq in Newfoundland."

Assimilation and intermarriage are other problems that we face. The centuries of genocide we experienced on the East Coast, including being hunted for bounty and being deliberately starved out of our homes, has made our people over the generations attempt to blend in with the

dominant culture. Our intermarriage with Acadians — who, in the face of oppression and war with the English, came to our communities for refuge —has resulted in our being ignorantly referred to as "jack-a-tars," "half-breeds" or "part-bloods."

In Newfoundland, the federal government has spent a lot of time and energy encouraging our chiefs to get us to call ourselves "Mi'kmaq Descendants" and to join a mainland band, rather than struggling to acknowledge ourselves as a sovereign people in Newfoundland. This effort is premised on the fact that the Mi'kmaq are disappearing as a race here. Even Canada's Human Rights Commission, in its report *The Mi'Kmaqs of Newfoundland*, recommends that Canada reach an agreement with our bands to live as a people within the Nation of Canada, not exist in a Nation-to-Nation relationship with Canada. The report's recommendation is founded on the misinformed belief that this would be the most realistic arrangement since our communities are intrinsically tied to the larger non-Native community. Thus the report is flawed because it advocates cementing a relationship that was created through genocidal practice as the way to correct the intergenerational impact of genocide.

Even the Federation of Newfoundland Micmacs has shifted from its original mandate. It originally wanted recognition under the *Indian Act* for all our bands, which would allow us to re-establish band control over the management of natural resources and attend to the educational, economic and cultural — mainly language and spiritual — needs of the community. Nowadays, the FNI is no longer asking for formal recognition under the Act. Instead, it is talking about the establishment of a "unique" relationship based on a three-part agreement between the federal government, the provincial government and the Federation. While the Federation claims that this unique relationship will return to the Mi'kmaq people their rights to land, resources and royalties, generally such tri-part agreements reduce Aboriginal authority, ownership of tribal resources and access to public resources and royalties. This agreement would essentially cede our control over our territories without actually formalizing any rights or benefits such an agreement supposedly provides.

As some of the chiefs have explained to me, the Federation is taking this position because it is seen as a necessary step towards improving the living conditions of the Mi'kmaq people, the majority of whom experience abject poverty, poor health and unemployment. The people have

nothing and the leadership is tired of fighting with Canada — but it is a fight we cannot lose or put down. Our burden must be shared with other Aboriginal people so that our collective fight is not lost. I, for one, do not wish to cede the territory of our people.

The compromises that our leadership wants to make with Canada are only part of the problem we face, however. Inside our communities, the need to formalize legal definitions about who we are — whether we come under the *Indian Act* or under a "unique" relationship — creates even bigger problems. In order to prove we are legally Mi'kmaq in the eyes of the Canadian government, we are forced to certify our pedigree to comply with mainstream systems of identification. This process, which has nothing to do with how we traditionally view ourselves, can be very expensive because it often involves hiring genealogists to trace ancestry, which was recorded by outsiders often in times when bounties were still placed on our heads.

In my mind, proving pedigree is the height of the government's oppression and a very sharp tool of its covert genocidal practices. The entire process also creates divisions among us. Divide and conquer colonialist tactics are in full swing in Newfoundland, as elsewhere, and work like evil magic. As individual families within communities struggle to establish their pedigrees, they gradually become grouped into larger family units on the basis of shared ancestors. These family groups sometimes begin to argue with one another as they struggle for control over scarce community resources.

As dispossessed people we have yet to fully understand that we are the only ones who can find ways to improve our lives. Aboriginal people here have a difficult time with mainstream politics. I'm unsure where this lack of understanding and vision comes from. We have only been organized into bands for a little over twenty years — in that time we have learned to organize ourselves and to recognize families as band members, but still we rely on petty colonial politics to govern ourselves — politics that exclude so many and that continue to oppress us. We exclude, isolate and weaken ourselves to conform and please the government at the expense of future generations and at the expense of our very own existence. The basic premise of exclusion of one band or band member by another strikes me as cruel. What do we figure will happen if we acknowledge the entire population of Aboriginal people in this country? The irony is that the Muise family finally decided to research its pedigree, and we found out that we have Beothuk ancestry as well.

How would the anthropologists and historians who insist that the Beothuk are extinct deal with that reality check? How would the Canadian government deal with it?

I think we put too much faith in government and not enough in ourselves. The answer to our survival is larger than government money. Nothing will change the condition of our lives until we educate ourselves, change our attitudes and continue to heal ourselves. We now suffer from what some Elders refer to as "low mindedness" — a condition that happens to oppressed people when we become like the oppressor. The Elders tell us that to begin healing, it is necessary that our spirits, bodies and minds be lifted up from this low place. The non-Native solution — an end to our existence as a sovereign people — will occur within the next while unless we begin to think of ourselves, our future and each other in a much different and much more positive manner.

ARRIVING HOME

On this particular day, I don't care about anything except putting my feet firmly on the land, smelling the fresh ocean air, spending time with my sisters and brothers and meeting the latest additions to the family. The older I get, the more I realize how intrinsically tied I am to this territory. I savour a memory of a favourite bog where bakeapples grow (outsiders call them cloudberries). I recall being knee-deep in its mud and crouched over picking the berries, with the aroma of the bog filling my nostrils. This brings a full smile to my face. I am the bog, the cold black river, the wind-swept stunted trees, the ocean, the ice packs and the crooked pines. I am a Mi'kmaq Epit and there are many like me. Raised to know the land. As I approach, I am filled with gratefulness and an immense relief that I am only hours away.

The plane lands, and I've arrived. The three family members who have come to greet me are happy to see me. I am taken to someone's home to be fed. Welcomes are always accompanied by food in Mi'kmaq homes.

LIVING OFF THE LAND AND FISHING FOR SURVIVAL

The Mi'kmaq population of western Newfoundland depends on the land and water for food procurement. Sustenance and traditional Mi'kmaq living are still basic survival skills for many. We have always fished offshore for the full variety of ocean species within the bays —

eels, herring, cod, capelin and lobster, to name just a few. Brook trout and salmon are favourite traditional foods, as is rabbit, caribou and, over the last one hundred years, moose. In the spring and summer times, numerous varieties of berries, greens, herbs, bark, edible vegetation and hazelnuts are gathered and preserved. For many generations our people have farmed root vegetables in extended family-sized gardens and farmed foxes for manageable fur trading. Everything was shared, as it continues to be done today.

The recent rape and subsequent collapse of the offshore cod fishery and the government's capitalist focus on restoring those stocks have created serious hunger and malnutrition among our people. Cod is once again being fished, but licenses are given first to fish plants, which are privately owned, before being given to local fishers. The last several seasons the government has had to open up a food cod fishery under tremendous pressure from a hungry public demanding food. The salmon fishery is being managed by using the same ineffective technology to count the numbers of fish in the rivers and to determine quotas. Recently, fishers who could afford to pay the cost of four salmon tags discovered that two of those salmon would have to be caught in Labrador to be legal! One Mi'kmaq fisher, who saw spawning salmon with seriously battered heads, stacked up in three layers and trapped in between two fences to be counted, said to me, "It puts you sick." Many salmon die in this way. The systems and the thinking that informs Newfoundland's natural resource management is offensive to Mi'kmaq sensibilities — it offends the vital and sacred relationship between the natural environment and ourselves.

Fishery mismanagement on our traditional territory is widespread and comes at the expense of our natural resources and the health of our people. Local access to the limited food resources is increasingly restricted for international trade, eco-tourism and sport fishers and hunters with absolutely no regard for our human and Native rights. Canada's authority over the water and fisheries should be relinquished and returned to local control.

Newfoundland's government is also going too far. Not long ago, the government discussed putting a tax on the women and children who pick cloudberries to sell to the passersby who buy them to feed their families. That same Christmas when the tax was being discussed, a wine stocked the shelf in mainstream shops, which non-Natives had made from this rare and precious berry. That one got a lot of swears and

chuckles from the Mi'kmaq locals. Nothing ever came of it. The outside attempt to create a chic wine for an upscale market failed. I guess someone figured out that that berry is actually too rare to meet the demand.

*

I do not stay long at my family's house and make my way to the Brook, Mi'kmaq ancestral land where many family members have camps. Later my fifteen-year-old nephew, Darren, visits and brings me some fresh trout, which is my favourite. We pan fry the fish, and I enjoy it as much as a glass of mountain spring water on a hot summer's day. Later, we're joined by three local men who live in the bush. Darren's curious. He's heard that anyone can buy fresh Atlantic salmon in the big city. He asks me how city people can buy fresh Atlantic salmon. I have to explain that it's farmed salmon and that "fresh" in the city means food that is nearly frozen, that hasn't gone rank yet, and that it isn't right out of the water. He can't yet imagine what I mean. None of the men are anxious to explain anything further to the young man on that day.

I am told by the men that it's impossible to conform to the government's laws on fishing, especially the salmon. "If we all followed the law, we'd starve!" The women have little choice but to support the men, who are willing to break the law. Everyone knows the risk; the men could be fined and jailed, community camps could be burned and vehicles confiscated. Still, families have to eat and children, especially, must be fed. The men have a lot to say on the subject.

"There's fish in those rivers. The government just wants it for those damned American sport fishermen and businesses."

"They use the environment stuff when it suits them, as an excuse to shut us out. They don't really care about the environment."

"What the heck do they know about environment and managing fish anyway? Look at their records at the Department of Fisheries and Oceans and the records of the provinces' natural resources departments across the country. We should be managing these brooks. The ocean, too. We're the ones who live here. They can't take care of this place like we can."

"They have these so-called wardens to watch over the water. I'm not sure what those guys know about protecting fish! They know how to pick and choose people who know how to fine us poor Indians though, don't they?"

"Yeah, if it's one of us, up here, you can bet we'll get the book thrown at us! But if it's one of their friends or a big shot, nothing gets done to them."

There is a tremendous prejudice and racism against Aboriginals among the non-Native population, yet "racism" is a new word for the people at home, and they are not comfortable with its usage. But when I ask whether the game wardens are racist, the men are quick to recognize the wardens' racism against other Mi'kmaq but not against themselves. "You know they don't like us. Now those men in Burnt Church, they really get the racism for sure with those federal guys. Someone could get killed there. I believe those federal guys are even allowed to carry guns." (This is shocking to folks because Newfoundland is well known for the fact that its enforcement personnel do not carry guns.) However, Alex, the man who has lived the longest in the bush, says in a loud voice, "We got the pups as compared to those DFO officers in Burnt Church, but you know damm well there's racism here in the worst kind of way. We'll never get rid of them now unless we drive them out!"

The rest of the men have grown uncomfortable and fall quiet. This is not a fully supported position. I say nothing further because I passionately agree with Alex. If we are to be successful in reclaiming our territory we have to reclaim our sovereignty and take responsibility for this land. If this is ever to take place, I know the women will have to be convinced.

<p style="text-align:center">*</p>

I spend the night with my brother and his son on the Brook. It's beautiful here. Manawagee Mountain (a sacred burial ground and the place where the spirits live) sits across from the camp. The cool night air is clean and silent, lit only by Grandmother Moon. I could stay here forever. It is hard to believe we are in the heart of some of the most troubled Native communities in the country. I prefer the Brook as a first stop. It helps me to reconnect with the land, to rest and cleanse myself in preparation to work with the women and children. There are always things to do on visits home, and this one will be no different. I had already spoken with several women by telephone before leaving Toronto. We have a tentative plan to gather tomorrow.

WOMEN HEALING AND REBUILDING COMMUNITY

By morning a relative is at the door. She is sent to pick me up and take me back to town. She's brought food, which she insists on preparing, and special coffee, specifically provided for me. I know both are part of a contract binding me to listen to the requests of the older women relatives. While we eat she verifies that I am in fact carrying a drum on this trip. I am told the women get together more regularly now and they'd like me to teach them more of what I know about the medicines and the drum. "It's good for the women," she tells me. "They have so many problems and we all need so much help." There's a knowing chuckle. However, the story isn't funny, and we know this as well. Several of the women are in abusive relationships, one in particular they're worried about. It's as though her spirit is gone and she needs to be woken up. What is wrong with that man, too? Who can help him? They see now that we all need to be re-awakened.

My relative also tells me of the many concerns the women share. Several of the children are dreaming about loved ones who have passed on into the spirit world. The adults are nervous that the children may want to join them there. Three suicides have happened over the winter months; they do not want any more to happen. The children are affected. Everyone is affected. Several women and men have recently reclaimed memories of child sexual abuse and several men have been recently taken to prison for child sexual assault and molestation. One man abused hundreds of children but nobody thinks time in jail will help anyone. One of the old women was found the other night, she was dying. Nobody knew she was sick and without food. This is something that would not have happened even a generation ago. She's a proud woman who would not ask for help; in the Mi'Kmaq way, she would not have had to. Fortunately, she's recovering well. There's a call out asking community members to visit each of the elderly, just to make sure everything is okay with them and that they have someone who regularly checks in on them. Today, when the medicines and drum are brought out, everyone and everything is considered. At home, everything is important to the people. When there is going to be a prayer offered or ceremony held, everything is considered and remembered.

I'm asked if I know of anything else that could help the women and children. They are open to any suggestions. What kinds of activities are happening in Ontario that deal with these issues? Is there anything new?

Do I realize how much work there is to be done? I smile to myself. Just a few years ago, I often felt like the only person willing to speak up about all the social problems in our communities — so many of them created by the intergenerational impacts of genocide and assimilation. Communities at home are no different than many Aboriginal communities across this continent. We struggle with child sexual abuse, incest, child neglect and sexual assault, violence against women and children, young pregnancy, suicide, hunger, depression, substandard housing, alcoholism, STDs and HIV/AIDS, prescription and street-drug addiction. Not to mention the numerous and ongoing abuses by the church and its schooling systems, the provincial and federal governments and big business.

When we reach town, ten women and as many children have gathered at a female relative's home. Women come and go throughout the day. I notice that two of the eldest women are present. This is the first time I've seen them out. They have reclaimed their authority and rightful place in the community. I learn that this gathering was at their request. They want change to come to our community, and they have a vision of a better future for our children. Something important has shifted and changed since my last visit. I've been waiting for this time since I've been a young teenager. I thank the Creator for this incredible gift and I am filled with a brand new hope for our future. The women's individual burdens as well as our collective concerns are better shared. I feel a sense of belonging now — one that I had long forgotten.

There's lots of laughter. The young ones are anxious to see how to prepare the medicines for burning. They want me to share again what I have learned about feasting, the drum, songs and fasting from the Ojibwe, Cree, Haudenosaune and the Mi'Kmaq living in Ontario. So I show them and we sing the songs. Everyone wants to hear the Mi'Kmaq or Abanaki Honour Song again. It's our favourite. We sing it in our language, which translates to mean: The people gather together, greet one another, respect each other, respect our ancestors and walk in the way the Creator intended us to walk.

I talk at length about my understanding of traditional concepts of self-determination; about attitudes towards children, women, men, Elders and the environment; about traditional forms of governance and techniques for listening, talking, decision-making and justice. Traditions that were shared with me through the teachings of the Elders, traditional teachers and medicine people I have been fortunate enough to meet

and spend time with. Luckily, we are not too far removed from our culture and these concepts are easily understood and accepted. In many ways, what we are doing is "reminding" ourselves about the general ways Aboriginal people think about the world. These are the reasons, I believe, that our societies are so strong and our people have survived.

Detailed discussions arise and clarifications sought about what genocide and assimilation are and the effects these have on a people. It is important that everyone learn the simple fact that the social ills within our communities are not because of who we are but because of what has been done to us, and it is important to know that we have the power to change it. Talking about genocide and assimilation at home is difficult because there is still a cultural shame about drawing attention to oneself or complaining about one's life. Women do agree, however, that they have to become involved in the band councils and in the schooling system to educate our children and balance the leadership. There are now at least two women band chiefs and there has been some improvement in accessing local schools in several towns.

Recent teachings from Mi'Kmaq traditional teachers and Elders from Conne River in Newfoundland, Membertou in Nova Scotia, and Burnt Church in New Brunswick are also shared. Several of the women had these opportunities while attending conferences and visiting with family members on the mainland. One of our young nephews has been to a Sweat Lodge ceremony and prayed there for over an hour for the entire family. The eldest remind us of the power of children's heartfelt prayers, and this makes us happy.

The willingness to learn together has grown incredibly. Every resource possible is gathered and shared. Two or three people now have medicines of their own. Throughout the day, each one of us speaks about the personal discoveries we have made about tradition and culture since we last talked. We create a safe environment and much healing work is done. By evening we are all filled up with new energy, and have new ideas to consider that can bring change to every level of ourselves and our community. The men have rejoined the women and children.

As I leave this precious gathering, a deep fear creeps over me as I consider the great odds against our survival. So I say a prayer and shift my mind to focus on the faces of the women and children. All the fear slips away and is replaced with a knowing that our time will come.

CHAPTER TWO

THE DRUM KEEPS BEATING:

RECOVERING A MOHAWK IDENTITY

Laura Schwager

Many Native cultures teach that we carry the memories of our ances-
tors in our physical being. As such, we are immediately connected to
those who have gone before us.

— KIM ANDERSON,
A RECOGNITION OF BEING

WHEN I BEGAN researching my family tree, I had not planned to take
such a significant part in the process. I had not expected it to get so per-
sonal. But in learning about my family history, I started remembering
things I had long forgotten. I remembered my own past and recognized
much of my present in a new light. In learning about my ancestors, I
saw the other parts of who I am. I saw myself as carrying on a part of
them, and in doing so, honouring both their spirits and my own.

As a person of mixed heritage, however, honouring the spirit has not
been easy. My journey begins with two white women — my mother and
my paternal grandmother — who have supported and encouraged
my exploration of my Native identity since I was very young. My Native
family, on the other hand, have passed on to me messages of shame
and denial throughout my life, and have discouraged my efforts to

appreciate this significant part of who I am. Today, I see only irony in this treatment of my heritage. Five hundred, one hundred, fifty years ago the white community discouraged Nativeness — it continues even today. But inside my home, in a quiet protected space, my mother and my grandmother have encouraged me to embrace my Native self. Why this is, I can only speculate. So many memories have been unleashed through my research. I feel I can now give these experiences reason and validation. I can move beyond the darkness that shaped the Native identities of my father and grandfather. I know we are a part of something larger.

In *A Recognition of Being*, Kim Anderson discusses how "some Aboriginal people have always maintained a strong Aboriginal identity, but many of us have not, and at some point we must begin to reclaim ourselves."[1] In seeking out the lives of my ancestors, I begin my journey of recovering a Mohawk identity. Too often I have struggled to feel worthy of naming myself as Aboriginal, especially in the presence of non-Natives. I have felt the power of white society that has lived inside of me, that has made me question whether I am allowed this "Aboriginal identity" and wonder what this Aboriginal identity means. At other times, I feel and even begin to see my Nativeness permeating through me so powerfully that for a moment I do not feel or look so white. For a moment, I do not belong to the white world and do not hear my own criticism and judgement of myself. Instead, I feel a strength, an inner spirit, that all the women in my life have encouraged me to claim.

My journey is one of recognizing and voicing this spirit. It is my tie to my ancestors. It is my reason for why, living in a non-Native society, embracing Native traditions and values has always felt like coming home. Despite the undermining realities that intermarriage had for my ancestors, as well as my present-day family, I feel the two worlds inevitably blending. My challenge now is to feel at home with the spirit, in the truest, most honest sense, balancing myself in the worlds of which I am a part. I was not raised in an environment of Native heritage; I only know the effects of it. I only know that I cannot ignore the beating force of its strength within me.

*

i can still remember that November day. i was five. it was grey and cool outside. i wore a burgundy polyester winter jacket with a fur-trimmed hood. my mom came home with a gift for me. she placed on my head an Indian headdress and in my hand a toy tomahawk. i pretended that my dog, Sandy, was my horse and together with the windwoman we danced and played in the backyard.

i have light brown hair, grey-blue eyes, and fair skin. i look like my mother. the women in my life were never valued. i never valued her. i did not value me.

i sit very quiet and listen to the trees, the wind, corn. i sing to the water.

i first made myself a drum out of an old coffee can, scraps of leather and cloth. i yearned to play it.

"that is the Native in you" my mother would say. but i would think, she is not Native. my father is, but he doesn't speak of it. he doesn't see what she sees. he doesn't value it. i did and so did my mother.

my mother saw my closeness to the earth, my depth, my feeling self, my spiritual self, the little girl in the Indian headdress, everything that my father didn't see, didn't know about.

"the Native in me" came from my father and his father. their silence blanketed me. being Native didn't seem to belong to them, so it didn't belong to me. they devalued the women who encouraged me to be my Native self, so i devalued them, devalued me. so i am not Native.

i wasn't worth much.

i moved secretly and slowly into myself, hesitant, judgemental, and rigid. i swallowed the main stream that my father paddled through.

the same waters his father abides by.
the waters my great grandmother fell into.

*

Many people speak about the importance of honesty. They say that one must begin with the self and move outward, for if you are unaware of what is on the inside, you are unable to give or know anything outside of yourself. This is how I have gone about my ancestral research. By looking into the past lives of my father, grandfather, great-grandmother, her parents, and so on, I have started on a journey of learning and acceptance.

*

In trying to walk the traditional path there are four lifelong questions we ask ourselves: Who am I? In order to answer that I have to know: Where have I come from? And once I know where I have come from, I have to know: Where am I going? And once I know where I am going, I need to know: What is my responsibility?

— Sylvia maracle, quoted in
Kim Anderson, *A Recognition of Being*

Who am I? I see myself as a branch on a tree whose years tell the stories of my ancestors, my family.

Where have I come from? The Hotinonshon:ni, the People of the Longhouse. The Six Nations of the Iroquois Confederacy, which include the Mohawk, Oneida, Onondaga, Cayuga, Seneca and Tuscarora Nations. The lands of the Confederacy resembled a communal house, like that of the longhouse, and the role of each Nation was likened to

that of a family. The Mohawks guarded the territory to the East and became known as the Keepers of the Eastern Door. Many years ago, the Mohawks or Kanien'kehake — "People of the Flint" — would spend the warm mild months along the St. Lawrence River and the colder weather in Mohawk Valley, in central New York State. They lived in "erect tidy, comfortable and permanent homes using locally available building materials … averaging in size from 80–120 feet, covered with Elm bark and sometimes Hemlock bark"[2] in the area that is now known as Akwesasne.

THE STORY OF AKWESASNE —
"PLACE OF PARTRIDGES"[3]

thousands of years ago, according to history, the Kanien'kehake travelled and hunted along the river, the Kaniatarakeh. they found many numbers of game: moose, beavers, deer, muskrat, birds and fish.

one day, as they were exploring the area, they heard a drumming sound from over the hills. they followed the direction of the sound and as they climbed a hill and cleared away the bush, they spotted a male partridge perched on a thick tree branch beating his wings.

this was the drumming sound. this was the first time they had witnessed the partridge's mating ceremony.

there is a saying, "Akwesasne, where the partridge drums his wings."

*

The community of Akwesasne developed as a result of ongoing warfare, first between the French and the English, then between the British and the Americans, and finally, between Canada and the United States. For Mohawk people who were weary of war, the settlement at Akwesasne was a refuge and a haven. Ongoing colonization, however, brought profound changes to the settlement, and took from the people the power and peace they had always known. Today, the Mohawks of Akwesasne recognize colonialism as an ongoing war — the loss of land, the imposition of Christianity and environmental damage having begun long ago.

Along with colonial wars and the new religion, came disease. "In the spring of 1829 small pox killed a great number of Akwesasne Mohawks,

followed by Asiatic cholera and typhus fever in June of 1832 which killed as many as 134 ... there was an outbreak of cholera and small pox that killed 29 and 30 respectively, in 1849, followed by another typhus epidemic that occurred the following year."[4] My great-great-great-grandfather Peter Sawennowane Bay grew up in this environment. By October 9, 1837, he was married to Mary Teiotote. Together, they survived the outbreak of illness that swept through the reserve.

Peter and Mary Bay were the last of my line of Bays to live on the reserve. An offer made by the Canadian government began the dispersal of the Bay line. The Mohawks of Akwesasne were promised a large area of land around Effingham and Weslemkoon Lakes if twenty-four families would agree to settle there. The project was dropped because only five families wanted to go. But Peter and Mary's son, my great-great-grandfather, Johnny Bay, went to have a look at the area and, having seen the Mazinaw Lake, decided to stay.[5] According to my grandfather, the day Johnny Bay moved to the Mazinaw was the day he sold his rights to the reserve.

<div align="center">*</div>

fran-chise (fran'chiz) n. 1. *A privilege granted to a person or group by a government.* 2. Constitutional or statutory right to vote. 3. Authorization to sell a manufacturer's products. 4. *The limit or territory within which a privilege or immunity is authorized.*

en-franchise (en-fran'chiz') v. 1. To endow with *civil rights.* To free: emancipate. 3. To give franchise to. – en-fran'chise'ment n.

dis-franchise (dis-fran'chiz') v. *To deprive of a legal right,* franchise, or privilege.[6]

<div align="center">*</div>

i have always been very close to my mother's parents. they live in Flinton, Ontario, about 50 kilometres north of Napanee on hwy 41, ten minutes southwest of the Mazinaw.

i spent many weekends and summers in my grandparents' care. i loved Flinton, this tiny village surrounded by towering white pine and cedar, farms and fields.

i swam and fished in the Scootamatta River. i camped on the Mazinaw Lake. i walked the dirt streets in my bare feet. i fell asleep to the sound of the bull frogs down at the falls.

i had no idea that i was growing up in the same area, perhaps hearing the same sounds, touching the same earth, as my other (Native) grandfather, his mother and her father did.

<div align="center">*</div>

Where do I come from? My great-great-grandfather Atewennarikhon, also known as John Baptiste Bay, was born in 1850 on the reserve at Akwesasne. He lived there until he married Anne Tekakwen LaForce. Listening to the promises of the Canadian government, they moved many miles north to the Mazinaw Lake, where they raised a family of twelve children. In the histories of Kaladar and Anglesea Townships, my great-great grandfather is described as the "legendary Johnny Bey."[7] He and his family were among the very few Native people living in the area at that time.

Many tales are told about Johnny Bay by the white historians who researched and published the historical accounts of the area, and by the older local people. My mother's family has told me more details about Johnny Bay's life than all the people of my Native family. My grandpa Davison told me how well respected Johnny Bay was and that he was a good man. Another woman recalling her past remembers how Johnny Bay knew many things about medicines and healing. She says, "Once I burned my leg terribly and it didn't want to heal. Johnny treated it with bear's gall steeped and mixed with some other things, and it began to get better in no time at all."[8] None of this information was passed on by those who carry his name, his blood or his spirit.

The Oxen and the Axe, a settler history, is my most detailed source of knowledge about my great-great-grandfather, and for that I am thankful. At the same time, though, I recognize once again the irony of the situation, and feel a sense of anger, that these are the only sources of information about my ancestors. This book, written in the 1970s by people who wanted to capture and recreate the "good old days" of colonial settlement in the area, is permeated with selective memory, prejudice and stereotyping. I am aware that my great-grandfather found

gold on his property, and yet the only recognition accorded him is in the opening line, "Gold was found on this property in the early 1900's by an Indian named Bey." I am curious also about the next line: "Some surface development took place and, finally in 1909, the Company known as the Ore Chimney Mining Company was formed and operated spasmodically ... under various owners and part owners."⁹ Based on my knowledge of colonization, I am forced to assume that even if white settlers in the area gave the "Indian" credit for his advanced knowledge in minerals and the founding of the mines, they inevitably reaped the benefits as well as the ownership.

Johnny Bay is mostly remembered as a good man by the sources I have come across thus far. One of the birchbark canoes he made was used in the Bay of Quinte Mohawk Landing Ceremonies for many years. Others are on display at Bon Echo Provincial Park and the Perth Museum. But I am left to wonder what life was really like for him, living in a non-Native community, where the Bay children grew up influenced by alcohol and, for the most part, separated from their heritage. Near Bon Echo, the remaining timbers of Johnny Bay's cabin can still be found in the "scrub maples of the old clearing on the land now owned by Harry Levere."¹⁰ For me, the remains speak of many things. They are a reminder of my great-great-grandmother Anne, whose only mention is of her death in 1924 at age seventy-five when the cabin burned to the ground. They also speak of a further loss of land, purpose and pride.

According to my great-aunt Theresa, Johnny Bay came to the Mazinaw Lake under the impression that he could build a homestead on the land offered by the government and pass it down to his children. No one informed the uneducated "Indian" before his acceptance of the franchise that he would ever have to pay taxes on the land. Because of this, when Johnny Bay and his wife died, the land could not be passed on to their children. It was never his, legally. My grandfather says the land was "swindled away" from the Bay children into the hands of a settler named Levere. Papa says that supposedly the Bay children were "quite the drinkers in those days" and that they agreed to sign away the land for maybe a couple of dollars or some booze. According to my great-aunt, however, the Bay children would not have had a choice but to sign the land away, since it wasn't theirs to begin with. The land was put up for sale for unpaid taxes. The signatures of the Indian family who had been granted the land in exchange for their enfranchisement mattered only in

that it gave the (new) ownership, the patina of legality.

My grandfather's anger is directed at the settler who acquired the land — but also at his parents' generation who signed the papers. However, it is up to me to put the events into some sort of context that I can understand. It was the initial unjust and dishonest offer made by the Canadian government that put our inheritance into the possession of another. I don't know what sort of life the Bay family led, or how the local settlers really viewed their only Native family before Johnny Bay became described as legendary by contemporary historians. I am very aware of the contempt in my grandfather's voice towards Levere, and perhaps towards his uncles as well. I am aware of how hard it is for some of my family members to speak of their past. I now know how dark that past was. I know that there are numerous reasons in the face of ongoing colonization and racism, for not passing down the traditions and for not having pride in the culture. There are reasons for my grandfather's anger. My great-great-grandparents, Johnny Bay and his wife, as well as their daughter, my great-grandmother, Matilda, are buried in the Catholic cemetery in Flinton. Wilfred Laurier Lessard[11] writes:

> Up to the time of the coming of the white man to Kaladar and Anglesea Townships, there was an early Indian population, a seg-ment of Mohawks from the Iroquois group in sparse, detached encampments located in the vicinity of natural, cold water springs. The largest encampment was located at the site of what is now Flinton, astride the Skootamatta River, and its burying grounds where the Roman Catholic Church and Presbytery now stand.[12]

Lessard also states that "the arrival of the white man in numbers had a terrific impact on the Indian population, which dissipated and vanished."[13]

I am both angered and in awe upon learning of the presence I know the Mohawks had in the Flinton area at one time. I am angered because their burial grounds have been devalued and demolished. I am in awe because I feel a new closeness to my ancestors. Knowing that the Mohawks walked and lived by the Skootamatta River brings validation to my great love for the Flinton area. I am in awe because my great-grandparents, although buried in a Catholic cemetery, were buried with their people. My great-great-grandparents were the first Mohawks known to have returned to the region after the early Mohawk encampments vanished. I am thankful for how life comes full circle.

*

all that's left is a photograph. it is the first and the last thing i know of my great-grandmother.

when i was very young, before questions were asked, i knew she was the source of my Native heritage. i knew that she must have loved my father, and he her. she often looked after him when he was small. he took his first steps right to her. she gave him his name.

i knew that she was the only part of my Native heritage that my father smiled about.

all i have ever had was a strange sense of hope. perhaps i felt she held the "key" to appreciating our Nativeness.

she had no voice, being only a photo. i could imagine her appreciating who i was, am.

looking at the photo, i have always felt some deeper connection to her, a sense and desire that i wanted to know her better.

*

Matilda Julia (Bay) Schwager was born January 15, 1894. She lived on the Mazinaw near the cabin her father Johnny Bay had built when he first moved to the area from Akwesasne. She was the only one of the Bay children to stay in the area. Her husband, William (Bill) Joseph Schwager (1889–1973), though born in Canada, was the son of recent immigrants from Germany. According to my uncle Paul, he was a silent, stubborn, reserved and very powerful man. Matilda and Bill made a home on the point not far from her parents' home.[14] There my great-grandmother stayed until my grandfather (the second youngest of six) was nine. At that point, no longer wishing to be subjected to the darkness of her marriage and facing an uncertain future in the area, she moved to Belleville with her three youngest children.

My grandfather did not speak of his mother, but when I asked, he said that she spoke Mohawk, but only when she was with her siblings, which was very rare. She never spoke it with her children or in the home. She never passed on any of the traditions. While Matilda and her children lived on the Mazinaw, she made baskets from black ash and sweetgrass and mittens from deerhide to sell in Kingston. But when they moved to Belleville, she left all traces of her culture behind, all but the cleansing aroma of sweetgrass that continuously pervaded her home.

I cannot imagine that it was easy for a Native woman with three children to move out on her own, away from everything she knew, against the norm of married couples and against the ideal of the "proper" woman of the time. All I have been told about my great-grand-mother's life in Belleville is how hard she worked at different jobs in order to provide for her children. She cared for several elderly men, provided food for the "hobos" who followed the train tracks just outside her door, and cleaned houses or did others' laundry.[15] I also know that alcoholism and family struggles were not completely left behind. She never again made claims to her Native identity and her children have never truly known the extent to which she was a part of the culture or where they fit within it. Nevertheless, Matilda is lovingly remembered as always sticking up for Native people. "You couldn't say anything bad about the Indians," my great-aunt told me, "or she would seriously put you in your place." Without Indian status, without a community in which she could speak her language or practise her traditions, despite having been baptized Roman Catholic and having inherited a dark

past that she struggled with throughout her life, I believe the spirit remained strong within my great-grandmother.

*

My grandfather, Gilbert Alois Schwager was born February 28, 1931, to Matilda and Bill Schwager. He lived on the Mazinaw Lake until he was nine, when he moved to Belleville with his mother and siblings. He now lives in Shannonville with my grandmother (Nana) Helen. He is a carpenter, a hunter and a fisherman. My grandfather has had his Indian status since 1991. My grandmother says, "Figured he had a right to it." It is my grandmother, who is non-Native, who has passed down an appreciation for our heritage.

I have never known the depths of my grandfather's experience. I have only known him to be a powerful and inaccessible man. The conditions in which my grandfather was raised negatively influenced his family about our Native culture. And I believe that it is this struggle with the culture that has largely influenced him as a parent and a husband. My grandfather was able to provide me with very little history about his family. The rest I have learned in simply observing him and being in his presence. On one occasion, he did drive me to Akwesasne to speak with his cousin Gloria.

*

October 25, 2001

Sitting in Gloria's kitchen, my grandfather was a heavy and silent presence beside me. Gloria gave us bowls of homemade soup and talked about the happenings of Akwesasne. Every so often I managed to squeeze in a question or two about Papa's mother and the Bays that lived on the reserve. My grandfather said very little, until, totally out of the blue, over the chattering of the women at the table, I heard, "The old traditions should go on." I looked at my grandfather, and my heart felt light.

The next interruption Papa made was to ask Gloria if there was still many alcoholics around. To me, this was an acknowledgement of his own past.

The last bit of information I received from my grandfather, before he had us out of there (just under two hours), was that he might have spoken his mother's language "had he been allowed to, livin' in white country."

The second time I approached my grandfather for support, he devalued my inquiries. I realized that my questions were causing difficult issues and old wounds to resurface. For me, his resistance and silence speaks volumes about the darkness, the shame, the denial and the unresolved issues that are associated with my grandfather's experience of Native identity.

*

Where have I come from? My father, Philip Dennis Schwager, was born January 13, 1953. He is the oldest of eight children born to Gilbert and Helen Schwager. My father grew up in Shannonville. They were a poor family. Train tracks pass through the backyard of his childhood home where my grandparents still live.

My father has said he never knew anything about his Native heritage, growing up. He can remember times when his father's cousin John Bay III would come by the house and tell my grandfather that he should have Indian status, but it wasn't until he was in his twenties that he finally paid attention to the fact that a John Bay existed at one time and that there was Native blood in his family. It didn't really hit home until the time he took his grandmother to visit her brother John Bay II (below) in Smith Falls.

From the ledge of the loft in great uncle Johnny's small log house, my father watched as his grandmother and her brother, both in their eighties, danced and played their fiddles. Somehow between the fiddling, the dancing, the happiness, the things John Bay might have said, the character he was, the way he looked and his name, Dad realized a part of his heritage he had never known before.

If Granny had said anything about her Nativeness, Dad never really paid any attention to it. Nobody did. But Dad recalls the visit to Smith Falls with a smile on his face, and in his heart as well. I think there was something about Granny that my father was, still is, proud of.

When Dad worked for Ontario Hydro in the early 1970s, one of the guys nicknamed him "Cochise." My father says it didn't make much sense to him, that he sort of resented the name. After all, he wasn't a "real" Indian.

*

October 28, 2001

Dad drove me home tonight. He asked me how my day with his father went and was not surprised, was quite sympathetic even, that I had the experience that I had. He told me that Papa is like that, a temperamental man. He told me how it scares him sometimes that he sees himself as his father and he hopes he has done better with his children. For the first time in my life, I told him how I had felt, growing up, about my Native identity. How he had never recognized or encouraged that part of me. How I knew he had never done the same for himself. In a small but significant way, I held him accountable, because he was, is, the source of my Native blood. In saying these words I taught my father something. He recognized that it was probably because his father didn't acknowledge his Nativeness. Together we both saw clearly that we were a part of a larger picture.

I asked my dad if he considered his father to be Native. He said in terms of blood and physical appearance, he is more Native than the rest of us, so yes. After some thought, my dad then spoke of his own grandmother. To him she was Native. She had dark skin, dark hair and dark eyes. She did not speak of her culture, but it could be seen and in many ways, perhaps felt. I did not have the courage to ask my father if he thinks I am Native.

I told my dad about the people my grandmother had introduced to me when we went to Tyendinaga (my grandfather transferred his band membership to Tyendinaga territory when he regained his Indian status). I spoke with the council members and chief of Tyendinaga, who were friends of my grandparents. I told Dad how they were astonished that Nana has never been able to get band membership, how they couldn't believe that neither my father nor myself had status or band membership. The wife of the former chief looked at me and said, "Well, you are Indian. You just don't have status." I told this to my father as it had been told to me. I repeated it. I was confirming something for both of us.

*

The issue of Native identity involves conflicting views of who is legitimately entitled to "Nativeness" between the government, non-Native society and Native people. More deeply, it involves conflict within Native communities, within families and within individuals, particularly those of mixed ancestry. It involves a history of colonial domination and classification. It is also culture, tradition, language and values. It is spiritual. It is blood-quantum. It is a feeling, an inner energy. It is also a piece of paper, a legal affirmation given to a selected few. The absence of it threatens the (formal) status of entire Nations.

My grandfather's Indian status is a result of Bill C-31. His status was reinstated under section 6.2 of the *Indian Act,* after it was lost in our family because of disenfranchisement and my great-grandmother's marriage to a non-Native. It took five or more years, a lot of paper work, a lot of proof, a lot of waiting, and finally one phone call made by a white former Member of Parliament to Indian Affairs, in order for my grandfather and his Native heritage to be recognized as legitimate and legal.[16] My grandfather was the first of his mother's children to reclaim Indian status. Acquiring Indian status has been a defining action on his part, a way of reclaiming and appreciating his heritage at some level. It is unfortunate that, as a section 6.2, in a system where we have to look at one another as numbers and sections, he cannot pass his Indian status on.

I do not have a section in the *Indian Act.* I only fit in as the generation after the cut-off from status. My "Nativeness" is based on lineage,

cultural affiliation, my personal beliefs, values and spiritual relationship to the word "Native." But because I do not have Indian status, legally, I am not Mohawk. But these are not my words. I cannot deny the greater force within me that trusts what I feel in my heart.

In the eyes of anyone opposed to historical and modern-day colonization, "Indian status was and is a fictitious creation, used to manipulate Native people, to destabilize First Nations, and to co-opt their lands and resources." [17] To believe in *Indian Act* definitions of identity prevents many Native people from knowing and owning their culture. They allow their identity to be determined by a piece of paper, and their culture to be controlled by a law vastly removed from any of their traditional values. They allow for their extinction. And yet we are here. The drum keeps beating.

The tree of my family begins with Native roots. It is these roots that support and direct the height and strength of the trunk. It is this base from which the branches reach and grow, sometimes touching, intertwining with other trees. It is with each generation, that the roots become larger, more solid, more defined so as to always hold the tree and support the growth.

Where am I going? I am now set on a path of exploring and connecting to my Native heritage, my Native self. I tell my father how I am singing and drumming with other Native women. I share with him what others are teaching me about the ceremonies and traditional teachings, the politics and our struggles to know that strong force within. I share how wonderful it feels to be accepted, to accept myself. I treat our culture as a good thing.

What is my responsibility? I feel deep within me that to deny my Native identity is to forego my responsibilities. By following my heart, I honour my self, I honour the heart of the Earth, those that came before me and those who are to come. That is the path I now walk on.

*

To tell my truth is one thing. To have told the truth of those close to me is an enormous step. Bigger though, are the steps taken by my grandfather and father who, in reading this, denied nothing, and told me to change nothing. I am so grateful for my father who could now tell me he does remember me in my little headdress, and who never felt that being Native was a part of

him, but this was only what he had learned from his father, who was taught self-hate from his grandfather, who was taught denial from a time period and a race of peoples colonizing and devaluing the state of the land, our people and our culture since Columbus. There is healing in speaking the silence. There is strength in accepting and living and not denying the truth. There is now a family and a community where before silence kept us distant.

wake:ka's iawe:kon. nia:wen

NOTES

1. Kim Anderson, *A Recognition of Being: Reconstructing Native Womanhood* (2000; reprint, Toronto: Sumach Press, 2001), 25.

2. Zoltan E. Szabo, "Who are the Mohawk?" (1997), 1. *The Mohawk Nation of Akwesasne–Mohawk History.* <http://www.peacetree.com >. December 2002.

3. This story, written in my own words, was taken from Szabo, "Who are the Mohawk?"

4. Darren Bonaparte, "The Wampum Chronicles" (1999), 1–7. *The History of Akwesasne: From Pre-Contact to Modern Times.* <http://www.wampumchronicles.com>. December 2002.

5. Gene Brown and Nadine Brummell, eds., *The Oxen and the Axe,* first ed. (The Mazinaw Review Ltd., c. 1970s), 124.

6. *Webster's II New Revised Dictionary* (Toronto: Houghton Mifflin Company, 1984).

7. Brown and Brummell, eds., *The Oxen and the Axe,* 123. *The Oxen and the Axe* uses the spelling "Bey" in accordance with the Bey Mines Ltd. I have not yet found any-one who knows why the spelling of Bay was changed for the purposes of the mine. Most of my family has not even considered why there is a difference, or which of the spellings is correct. The Bays told *The Oxen and the Axe* that the name should be spelled Bay, and so this is how I will spell it too.

8. Ibid., 130.

9. Ibid., 159.

10. Ibid., 123.

11. Wilfred Lessard was one of the earliest white settlers in the area documented and remembered by *The Oxen and the Axe.* He and his descendants were/are prominent, influential members of the Roman Catholic Church and the Flinton community.

12. Brown and Brummell, eds., *The Oxen and the Axe,* 115.

13. Ibid.

14. Ibid., 124.

15. This information is compiled from the interviews I conducted with my paternal grandmother and Matilda's oldest grandson, Larry Gifford. I interviewed other family members as well and draw on these interviews throughout this essay. Those I interviewed include Philip Schwager, interviewed 14 and 28 October and 11 November 2001; Gilbert Schwager, interviewed 7 and 25 October 2001; Helen Schwager, interviewed 7 and 25 October and 11 November 2001; Gloria Marquis, interviewed 25 October 2001; Theresa and Paul Dudgeon, interviewed 20 November 2001; Larry Gifford, interviewed 25 November 2001; and Cora and Earl Davison, interviewed 15 October 2001.

16. The late Douglas Alkenbrack, Sr., former MP, was an acquaintance of my grandfather (for reasons I am unsure of). He also knew of Johnny Bay and had at one time owned a Bay canoe.

17. Dawn Marsden, "Emerging Whole from Native-Canadian Relations: Mixed Ancestry Narratives" (MA thesis, University of British Columbia, 1999), 15.

CHAPTER THREE

FROM THE STORIES
THAT WOMEN TELL:
THE MÉTIS WOMEN'S CIRCLE

Carole Leclair & Lynn Nicholson
with Métis Elder Elize Hartley

We are a circle of Métis women who support, educate and em-
power our women. We acknowledge the Creator and the wholistic
relationship between the Earth and the gifts provided to us.
Through reciprocity and the healing journey, we can help our
people reclaim and celebrate our cultures, histories and identities.
— STATEMENT OF PURPOSE,
MÉTIS WOMEN'S CIRCLE, 1999

LONG BEFORE we lifted pen to paper, these thoughts for our statement
of purpose were in our hearts as Aboriginal women. For weeks, each
word was carefully crafted. The women sat together and laboured
through many questions as to why we had come together. Now, when-
ever we read this statement, we are reminded of the laughter, the
struggles and tears of each of the women who contributed to its making.
Despite or because of our differences, we were able to agree that there is
a need for this urban Métis[1] community.

What sets us apart from any other women's group? We are Aboriginal women who have to create positive meanings around the terms of identity that we have inherited from both our parent groups. Métis oral tradition teaches us that we are never entirely "other," that our social and spiritual identities have always overlapped with those of our tribal relatives, other entities and our European relations in shifting patterns of creative necessity. Metis who remember *bush ways*[2] remain connected with our first teacher, the land. In this way, we enact an Aboriginal ecology which adapts to, rather than assimilates, the larger common culture.

In these pages we gather up fragments that evoke and reflect partial accounts of our ways of living in the world as Métis women. We hold them out to you, these strands in the web of Métis/Metis humanity.

OUR BEGINNINGS

The Métis Women's Circle was founded in 1995 by Métis women as a response to a need expressed by women of *mixed-blood* and Métis heritage in Ontario. From the outset we knew that this was a new kind of organization, one which would require a great deal of flexibility in its members. Armed with a flip chart and our various life experiences, we sat together and brainstormed in Métis Elder Elize Hartley's living room. We asked questions like, What is it that we all have in common? What is it that is missing in our contemporary urban lives? Responses and ideas tumbled onto the flip chart as fast as we could write. We still recall the strong emotions in that room, as these grandmothers imagined a safe and strengthening space for Aboriginal women.

The founding cultural influence in this collective is that of its earliest members, Red River Métis from Manitoba and Cree/Metis from Saskatchewan. These women knew that Métis cultural expressions are similar between Northern Ontario communities and the Western provinces. When they began their grassroots work in Southern Ontario, they quickly discovered that things in the cities are very different. When they spoke at local cultural gatherings, some would say, "Don't talk to me about buffalo, I've never seen one." But they often asked, "How do I begin to find out more about my Aboriginal heritage?"

In inviting these women to sit with us, the Métis Women's Circle began its delicate balancing act. Those who identify as distinctly and historically Métis may not sit comfortably with those "other Metis" and

mixed-blood women who choose to rediscover their various Aboriginal roots. But in our Circle there are western Metis/Métis and those who claim a *mixed-blood* heritage, usually European and Iroquoian or Algonkian, Mi'kmaq or Cree roots, as well as Anishinaabe. After many years of persistence on the part of our leaders Circle women, some First Nations and western Métis organizations are willing to work with us, although at the outset they are usually confused about exactly who we are.

We are frequently asked the confrontational question, "*If* you're Métis, what are you doing here in Ontario?" The questioners' opinions of history and geopolitics assure them that the Métis belong in Western Canada only. They impose this reality on us, challenging our histories and our right to be here in this place. If we in this Circle had a choice to call ourselves something other than Métis, what would it be? The word Metis can be charged with damaging misconceptions and stereo-types, especially for women. Our members respectfully discuss this issue, searching for appropriate language and new ways in which to describe their circumstances. We promote inclusiveness while struggling with predetermined concepts of authenticity.

DOCUMENTATION AND STORYTELLING

Documents, whether written by government or church authorities, cre-ated by artists or photographers, or orally transmitted through elders and family members, give meaning to the facts of peoples' experiences. They provide structures that help us make sense of what we see and experience. For many Aboriginal people, information is crucial in retrieving and telling stories about who we were and are, what our future holds and what we are entitled to, both individually and as a people.

Part of the healing work that needs to be done in Metis communi-ties is to refute the notion that we are alive only in history books or ancient records. We are still here, still living on our land, albeit in very different circumstances than our ancestors. Although our faces and bod-ies may have changed over centuries of close encounters with settler peoples, some elements of the spirit of a people remain, mysteriously stronger in some than in others. However, when we go searching for his-torical documents, the information we uncover may offer little certainty about issues of race and belonging. Government policy, denial and suppression of information about Aboriginal heritage have operated

thoroughly at public levels (schools, churches, government institutions) and with mixed result at family levels to eradicate or bury the facts of our heritage.

At these same levels today, Metis are recovering many fragments of family history. Currently, the easing of restrictions on what can be retrieved under the *Freedom of Information Act,* the systematic compiling of data on computerized systems and a more positive acceptance of Aboriginal heritage has made research on the federal government's policies towards Aboriginal people less tedious and more rewarding than in the past. But pieces of paper, written documents, proof of existence and entitlement are difficult to find for *mixed-blood* people prior to 1800 in Canada. Settlements of the western Métis are the most thoroughly documented, largely for the purposes of determining land entitlement.[3] Archives reveal that there were many instances where affidavits sworn by *half-breed* individuals were disallowed by the very same bureaucrats deciding who was entitled to claim land.

In Ontario, the Robinson Treaty was the only land treaty to mention Metis communities, and it was left to the tribal nations to decide whether they would be included in treaty negotiations or not. Some records exist identifying *mixed-blood* individuals, but generally the policy of the government of the day was to identify people as either *Indian* or white. While there remain many small communities of *mixed-blood* peoples in various regions throughout Canada, documentation that includes racial information is scattered and inconsistent.

In the past, orphanages were used to solve the problem of where to put unwanted Metis and *mixed-blood* children. The intergenerational effects of an institutionalized childhood in residential schools are being researched and publicized by First Nations communities. Metis people still wait for this part of their story to be told. Records are lost, sealed or forgotten about by individuals who refuse to be defined by generalities of race and cultural inferiority.

We work to recover documents written on stone, on paper, on bodies and preserved in family stories. Group affiliation with other Aboriginal organizations often demands paper documentation and proof of ancestry. Some of our members have thick binders full of papers attesting to their Aboriginal heritage that is hundreds of years old. Others have scant evidence. Colonization requires that documentation takes precedence over the authority of our mothers' words or their pained silences surrounding the specific details of their Aboriginal

heritage. Some of the women fear being told that they don't belong. Other women have chosen to identify with mainstream Canadian culture, and yet they are drawn to our gatherings and conferences. Circle member Angela Whitwell shares her personal reflections on documentation:

> I started on my own Aboriginal journey when my aunt Ruby asked me why I hadn't learned my Mohawk language. That painful question moved me to try and get my status card, figuring that would be the best way to "become Aboriginal." When I was turned down by the government, I felt lost. Many of my relatives could get this number but I couldn't.[4]

Angela found her way to the Métis Women's Circle, and after several years of many brave initiatives, she is regaining her natural confidence. Through genealogical research she discovered that her father's people may have been members of a Northern Ontario Métis community. She is learning to understand her complex inheritance as strength. She says, "Within the Circle I am encouraged to learn my own histories, languages and traditions. The women encourage me to be who I already am."

Of course there is confusion over the definition of who is/isn't Metis. We recognize this confusion as an element of historically genocidal colonial practices. For purposes of membership in the Métis Women's Circle, we confront the issues of inclusion and exclusion by adopting the three conditions generally agreed upon in the findings of the 1995 *Report of the Royal Commission on Aboriginal Peoples.* These conditions are mixed Aboriginal ancestry, self-declaration as Metis and community acceptance. A woman may join the Circle on the basis of self-declaration as Metis or *mixed-blood* and community acceptance. Formal documentation is also desirable and each member is encouraged by our genealogists to retrieve this information. Those without documentation of Aboriginal heritage are unable to hold executive offices.

In the end, labels are less important than why we come together as a group of women. *Mixed-heritage* women have "breathed in" ways of knowing from both cultures. Spending many intimate hours with Aboriginal grandmothers and other kin strengthen what might otherwise be an indistinct sense of Aboriginal identity. We also acknowledge and respect the fact that we carry non-Aboriginal heritage. We do not attempt to hide what is written on our bodies. This is living out who we are.

SOURCES OF OUR AUTHORITY

These Women Are Speaking for Themselves
for Maddy Harper and Mary Pitawanikwat

The clarity through struggle,
the exacting plan
To speak the truth and to expect the same
Didn't weaken.

We were taught from the fountains of your wonder and pain
What it was we needed to know about our roles as Nishnabe kwe.
I wondered then how you could have continually bared your souls
Now I know
There is no other way.

— NANCY COOPER[5]

Sitting at the centre of our Circle is our Elder and *ogimakwe*, Elize Hartley. Her contribution to the Circle includes sharing her cultural knowledge and her political acumen and experience. When asked about Métis women's sources of authority, Elize refers to her childhood in the tiny village of Vassar in Manitoba,[6] and to the values and life ways of her family. She says:

> In those days, it was all teamwork. The women knew exactly what they had to do in order to get the results they needed and the men knew that too. So, if the women needed a long table to feed loggers or wedding guests, the men knew that they had to go and get that wood and they picked a certain tree that would be the length that the women wanted. It was teamwork and there was no cajoling or nagging. It was strictly business. The women did their job, the men did theirs and the end product was what the community made together. My father worked very hard, ganging for the Canadian National Railway, and like many of the Métis men of his generation, he was not a good farmer. He worked in the vegetable garden after a long day's labour, but he took his instructions from mother.
>
> A vital source of mother's authority came from knowing her surroundings, from knowing the land, how it worked and who lived on it. She knew how to grow food, and how to make warm, heavy

blankets out of scraps.[7] She could always find the spots where the cranberries and blueberries grew plentifully, and she raised ten children with very little money. She knew to set her hens by Grandmother Moon. She also knew the habits of bears and rabbits, hungry skunks and chicken-thieving bobcats, as well as the secrets of the wild plants growing in the bush. Much of what she knew she learned through observation. Mother had a perfect mind for how things work in the natural world. Say, for instance, a skunk came around, looking for chicken eggs. She'd say, "Well, we're going to dig a hole right here, fix that skunk for good." She'd put something skunks like to eat in the hole and watch. When the skunk was in the hole, and in the right position, very quick, she'd cover the skunk with earth. Never once did one of those trapped skunks spray her. Although we were poor, mother was so resourceful.[8]

To write or speak about Metis in Canada is a daunting task. Metis writers Maria Campbell and Emma LaRocque insist that Metis need to tell their own stories and build on their own strengths if they are to reach places of real choice. This requires us to find and tell Metis stories as evidence of the ways we relate to the world around us. Métis documentary filmmaker Christine Welsh reminds us, "And because they [Europeans] wrote it, the history that has been passed down to their descendants — the history that has been taught to generations of Métis children, including me — is their story, from their point of view."[9]

Our stories and our differences are deeply embedded in the stories of those who wrote our histories. Some of our attempts to expand and displace these histories have failed because we place too much reliance on what has been written about Métis. Does this failure mean we ought to adopt a "what's the use" attitude? In her films, *Women in the Shadows* and *Keepers of the Fire,* Welsh invites us to change our historical point of view, to think outside the now-familiar assumptions with her questions, What of our Indian foremothers? What about their struggle and their courage? What might they have understood to be an improvement of the *Indian* way of life? Elize Hartley often recommends *Women in the Shadows* to women who are searching for their Aboriginal roots. She also shared her personal journey of understanding herself as a Métis woman with us:

I've spent most of my life living in translation, moving back and forth between the larger common culture and métissage, never totally assimilated into the mainstream. Looking at my dark skin,

many times people have asked me, "Why don't you just say you're Native?" While it's true that Brokenhead Reserve[10] is part of our past, our folks lived on the outskirts there, never really accepted, so how was I to say "I'm Native?"

Among my many duties today, I sit as a Grandmother for the Native Women of Ontario. My years of experience have given me the authority and the confidence to declare myself to be a Native woman. I was born to work. I never do things half-way. While I was earning a living and looking after my old age, I was busy doing that, but my awareness of being Métis never left me.

Elize's story shows us how our ancestors always walk with us on this journey:

When I retired I began to research my family history. I was sitting in the library in St. Boniface one day, searching through genealogies, writing down names, when all of a sudden I heard a voice saying, "Granddaughter, what took you so long to come and find us?" The librarian came with another stack of books, but I told him, "That's enough for today, I'm starting to hear voices!" He smiled and reassured me that I wasn't the only one, that he knew of many who had heard them. It kind of startles you, you know, because you're not really prepared to hear the dead speak. But they do, most certainly. My ancestors, those old-time people, want to be recognized, acknowledged, brought forward. They are still part of us, and they speak with an urgency about the things we need to know as Aboriginal people. And so I began my task, piling up evidence of long-forgotten losses and values. As I look back, I see that we Métis did pretty well with five of the gifts of the Seven Grandfathers; honesty, courage, truth, humility, bravery and respect. We did not do as well with love and wisdom. We were a defeated and overrun people. Our hearts were frozen in our bodies.[11]

As Métis women, our path to self-realization can be hindered by people within our own communities. There are some who do not want to offer us the recognition and place we need. Others are living out the patriarchal legacy of our colonial past. Elize relates her experiences with political struggles:

After those old grandparents chastised me there in the library, I knew I'd have to work in the Métis milieu. My first step was to go to the

Manitoba Métis Federation and apply for membership. I showed them who I was and they gave me a card.

I soon discovered that a card is only the beginning if one wants to get involved in activism. Before long I was in deep trouble with the Métis political men. Some took one look at me and said, "We don't need her in our circle, she asks too many questions." Their reactions to me involved significant issues of power-sharing with women, something our men have learned that they no longer have to do. It's true I am outspoken, unlike so many of the soft-spoken women I know who prefer to work quietly behind the scenes. Are these quiet women reproducing old colonial patterns?

I nod in agreement with Metis Elder Maria Campbell when she writes, "I don't decide anything in my life. The grandmothers — these bossy old ladies — always push me around, direct me and tell me what I have to do." She says, "When they say 'the muses,' I call it Grandmothers coming."[12] "Grandmothers coming" told me that no matter how hard we women work, the legacy of patriarchy remains strong in our non-governmental organizations. Muddled politics and in-fighting are common. In the west, Métis are fighting about what colour of sash to wear. I've got one of each, so I guess I can wear either one and I'm okay! But politics can be as crooked as Coyote's hind leg. Many women get hurt and leave the political arena.

All the struggles I've been through only make me more determined. I say, "You just wait and see what the women will do." It has taken longer than I hoped, because many of our women are still not coming out of that kitchen. They are afraid because there is very little protection for us except our faith in "Grandmothers coming."[13]

Our Circle works hard to recreate our individual and collective Métis women's authorities. Elize helps us by reminding us of our responsibility to collect and preserve our stories in order to pass them down to the next generation. There are too few culture-carriers in Ontario today, and she is anxious for us to capture the knowledge we need to know before it is diminished any further. We have therefore fostered our own "Grandmothers coming" through several research projects, including one about a fictional/historical Métis midwife.

THE 1810 MÉTIS MIDWIFE'S MEDICINE PLANTING AT WESTFIELD HERITAGE VILLAGE

Few Canadians realize that the threads of Metis history are intertwined across the country and most intensively around the perimeter of the Great Lakes. Waterways served as the arteries for Metis survival. Metis women's voices, however, are not part of the historical texts. To break the silence surrounding our grandmothers' lives and to challenge long-standing misconceptions about them, we decided to construct the persona of a Métis woman who is strong in her culture and quite able to survive and nurture others around her. We named this project, which is funded by the Ontario Trillium Foundation, the Métis Midwife's Medicine Planting.

The project reconstructs Métis women's histories specific to the southern Great Lakes region. It historicizes Métis women's experiences and livelihoods, strengthens cultural representation and teaches our children through examples that are based on the life of a traditional Métis midwife. It allows us to search for the answers to our question, What does "Métis" mean in Southern Ontario?

Our project is supported by the Westfield Heritage Village, owned by the Hamilton Region Conservation Authority and situated in the remote countryside northwest of Hamilton. We believe that this unique approach of blending the physical work of tending a garden with the intellectual work in researching plant medicines and birthing culture will make significant contributions to women's self-development and to the health and well-being of Métis women and their families generally.

Piece by piece, the Circle women are recovering fragments of knowledge about the life of a traditional Métis woman from documented research. Through oral histories and interviews, we are trying to understand the collected knowledge of Métis values and Aboriginal worldviews. We wonder how, in 1810, a Métis midwife would have lived here where we live today. It is a tediously slow search, but one that strengthens our Women's Circle's struggle to discover answers. We see how our newfound knowledge transcends time and through a distinct cultural memory empowers Métis women today. We are working hard to discover and retrieve information that is buried deep in women's minds, to collect their stories and "knowings" — all of which contribute to community-building.

Westfield Village offers several advantages for studying a Métis

woman's history. The natural setting of the Village encourages us to study the indigenous flora and fauna and to understand how the midwife would have used these in her work. The Village has provided three authentic buildings that shape our midwife's daily routines. She carries out her practice of midwifery from the first building — the midwife's cabin, also known as the Maracle house. This historic building was built in the mid-1800s and moved here from the Six Nations Territory near Brantford. When Elize first saw the tiny log cabin she said that it reminded her very much of those in her home village of Vassar.

Situated close to the midwife's cabin is an original Anglican church — one of the oldest in Ontario that has been desanctioned. The church confronts us with many questions about the far-reaching impact of Christianity on Metis culture. The wooden cross throws shadows across the medicine garden and is a constant reminder of the effects of patriarchal hierarchy. How does the midwife understand the blending of Christian and traditional rituals? We seek out Elders who will share their stories with us so that we might find these answers.

The third building is a trading post, a natural point from which to describe the role the Metis played in mapping out a new nation. The fur trader is probably the most common role that the public readily associates with Metis culture. The trading post is filled with the symbols of that life — the Hudson Bay blankets, animal traps and pelts. Our midwife prepares common medicines for trade. Her fur trader husband will take these on his journeys to the Ojibwe in the north and the Cherokee in the south and return with goods for the trading post. The midwife counsels her children about the danger and destruction to Native life found in the barrels of whiskey lined up along the wall of the building.

In our research, we are learning about different kinds of "Métisness." We consider how migration and marriage patterns, relocations, adoptions and wars shaped us. Interpreting history through the perspective of Métis women provides alternative accounts and better understandings of our traditions. Members of the Circle present their interpretations based on this research and are guided by their ancestral histories; they take care to interpret their findings within those cultural parameters. For example, if the researcher has Ojibwe ancestry, she will depict the midwife character within that heritage. In one interpretation, the midwife becomes Veronique Beausoleil, a woman of French and Ojibwe ancestry. In another, the midwife is Priscilla Lyons, a woman who lives within her Mohawk and English ancestry.

The midwife develops into a real woman living in her tradition as each of the Circle women adds details from her own area of study — for example, plant medicines, traditional clothing and beading patterns, and child-rearing practices. As a tribute to our Métis midwife character, one of the Circle women is learning an Ojibwe lullaby in the Odawa language, which she will share with the Circle and which will become part of the midwife's medicine bundle.

Lynn Nicholson, a member of the Women's Circle, is passionate about ethnobotany. She talks about how drawing on her grandmother's history shapes her contribution:

> I want to bring the midwife's character to life through the stories passed down to me about my grandmother; that's what she would have been called, simply grandmother. My grandmother was a strong, independent woman. She was an herbalist and attended to serious illnesses in the family. She knew the medicines. She was able to nurture the sick back to health and prolong lives.[14]

Lynn is studying the plant medicines that are indigenous to the area. She finds it encouraging to know that they are the same ones her grandmother and great-grandmother used in their healing. She has also become painfully aware that some of the plants are as threatened as Métis culture itself.

We have hosted workshops with traditional herbalists who instruct us how to identify and use the medicines. This is a different way of learning when compared with how the midwife would have learned at her grandmother's side. We realize that we must adapt and that we do not have the privilege to learn in the same way as our grandmothers. It is also essential to develop the spiritual aspects of working with the plant medicines — learning the planting songs and prayers for planting, for example. Lynn continues to look for the Elders who can teach her how to conduct herself in a respectful manner as she comes to understand the ways of the plant beings.

The Métis midwife project is invigorating and exciting, but not without its challenges. But these challenges add to our understanding of the realities experienced by our midwife. In addition to the lack of information, one of the biggest hurdles in depicting the midwife is stereotyping. We can only imagine the degree of racism and oppression she had to endure. Today, we must negotiate her voice within a historic village that is steeped in colonialistic governance and counter the

skepticism of the public, Westfield's volunteers and the Village administration who doubt the Métis presence in Ontario. They ask us, "Aren't Métis only found in the West? What is a Métis woman doing here? Isn't she an *Indian?*" By putting ourselves into the midwife's character, we are able to understand her thinking and the steps she had to take to survive, to protect her family and to carry on her beliefs.

The project has raised many questions. What was the midwife's relationship to non-Native female settlers? to the village doctor? Was there co-operation, misunderstanding or avoidance in those relationships? As development encroached, how did she negotiate the disappearance of her natural medicines? Did settlement threaten her livelihood or did she welcome it for the new economic opportunities it promised?

*

Our authority comes from our ancestors and from doing the things we do as women. Our work brings the Circle together in hopeful anticipation each time a tiny scrap of history is uncovered. Relying on these old teachings guides us as we develop our identity "as a living process in today's society." [15] Our strength comes from all of what we are. Elize cautions us not to "romanticize" community. She tells us that in old Métis communities, teasing, joking and criticizing very often stung people into conformity. These human behaviours occur in our Circle, too.

Conformity, deciding by consensus what "the right way" is for us, what constitutes proof of Aboriginal ancestry and learning and putting into practice the teachings of our various traditions in contemporary urban environments are issues that we take up in our Circle community. Process is our strategy, patience and compassion for ourselves and one another, our tactics. We find common ground in discovering that a certain patterned floor mat, made of reeds and woven by women, indicates that you are entering a Métis household. We know the feeling of community in learning an old song and realizing that it is the same one the midwife sang to her babies hundreds of years ago.

Our meetings are usually held at Elize's home and they are great fun. The doorbell rings and one of us rushes to answer, eager to greet another arrival. The front hallway gets crowded with laughing women, hugging one another among the coats, shoes, purses and potluck containers. Sharing a meal together is always first on the agenda. Some meetings are dedicated to organizational business, others are arranged to

have an Elder or a culture-bearer share a teaching with us, and all meetings quietly begin with a sage smudge. Often the meetings end with our strong voices rocking the room in a song given to us by other Aboriginal women. The singers range in age from nine-year-old Veronique, proudly sounding her grandmother's drum, to eighty-six-year-old Muriel, who still hops a bus to be with the women. True to our understanding of reality, the Circle has become a space where we can learn to recognize the meanings of *bimaadziwin, orenda* or *kischay Manitoo* in our lives.

NOTES

1. In an attempt at clarity, when Métis is written in French, we refer to those who are descendants of French-Métis, or those who "still hold tightly to their French-Métis culture and their mutual lineage today." This spelling is also used where organizations or authors use it. The contemporary term Metis, without French spelling, is used to refer to those Metis people and communities who are other than French ancestry — those who understand themselves to be Cree/Metis, Salish/Metis, Dene/Metis, Scottish or English/Metis, Labrador/Metis, and so on. The Southern Metis are organizing in the United States, and although their histories differ from Canadian experience, many have chosen to call themselves Metis. We respect their choice. We recognize that the decision to use the term Metis inclusively is controversial. Political claims are vociferously defended on all sides as to who has the right to adopt or refuse it. We use the term Aboriginal to refer to First Nations, Inuit and Metis Peoples in Canada. It is always capitalized unless authors write it otherwise.

 People who express combinations of Aboriginal and non-Aboriginal identities who do not identify themselves as Metis are referred to as *mixed-blood* peoples. The terms are italicized to signal their contested status and to point to problems of pseudo-biology inherent in such widely used terms. The identifier *Indian* is italicized to signal the problem of generalized categories of identity, an aspect which Metis organizations continue to grapple with. The terms *bush* and *bush ways* are italicized to allude to the many layers of meaning which go beyond landscape and geography, and move towards expressing a Metis culturescape which includes our relationship to all the inhabitants of our much loved *bush.*

2. See note 1.

3. See D. N. Sprague and R. P. Frye, *The Genealogy of the First Metis Nation* (Winnipeg: Pemmican Publications, 1993).

4. Communication from Circle member Angela Whitwell, February 8, 2002.

5. Nancy Cooper, "These Women Are Speaking for Themselves," in Beth Brant, ed., *Sweetgrass Grows All Around Her* (Toronto: Native Women in the Arts, 1995), 66.

6. Vassar has been declared a "Historic Métis Village" by the Government of Manitoba.

7. For a detailed description of Metis women's daily lives, see Diane Payment's essay, "La Vie en Rose? Metis Women at Batoche, 1879–1920," in Christine Miller and Patricia Chuchryk, eds., *Women of the First Nations: Power, Wisdom, and Strength* (Winnipeg: University of Manitoba Press, 1997), 19–37.

8. Elize Hartley, personal communication with the authors, January 26, 2002.

9. Christine Welsh, "Women in the Shadows: Reclaiming a Metis Heritage," in Ajay Heble and Donna Penee, eds., *New Contexts of Canadian Criticism* (Peterborough: Broadview Press, 1997), 61.

10. A Saulteaux Reserve in Manitoba.

11. Elize Hartley, interview, January 29, 2002.

12. Maria Campbell, "Maria Campbell," in Hartmut Lutz, ed., *Contemporary Challenges: Conversations with Canadian Native Authors* (Saskatoon: Fifth House Publishers, 1991), 49.

13. Hartley, interview.

14. Lynn Nicholson, personal communication, January 18, 2002.

15. Duke Redbird, *We Are Metis: A Metis View of the Development of a Native Canadian People* (Toronto: Firefly Publications, 1981), 2.

CHAPTER FOUR

THE EAGLE HAS LANDED:
NATIVE WOMEN, LEADERSHIP AND
COMMUNITY DEVELOPMENT

Sylvia Maracle

WHEN I WAS A STUDENT in the early 1970s, a special teacher came to the Native Canadian Centre of Toronto. I will never forget what he said. Hopi Elder Thomas Banyaca shared a prophecy with us that day that I have since seen come alive. He came to tell us about the future of the Indigenous peoples of the Americas. In one powerful statement he made, he said that when the eagle landed on the moon, the people would recover. Elder Banyaca's statement came directly from the Hopi prophecies. We were all astonished — the Apollo program had just landed its lunar module the *Eagle* on the moon in 1969. The statement, "the Eagle has landed," thus foreshadowed major change in our communities.

In my lifetime, we have moved from people with crippling problems to communities that are slowly healing and reshaping our future. I have witnessed tremendous community development over the last thirty-five years, and much of it has been led by women. In this essay, I want to

explore some of the ways in which urban Aboriginal women have developed the institutions that have helped to bring our people together to heal.

BIRTH OF THE ABORIGINAL HEALING MOVEMENT

Thirty-five years ago, Aboriginal communities were struggling with rampant addictions, low education levels, poor housing, few employment opportunities and numerous family stresses. We had people whose lives had been profoundly scarred by the violence of residential school, training schools, adoption and other child and family service interventions; people who were apologetic for who they were. We had internalized the many forms of violence we experienced with colonization and had learned to express it laterally, against one another. Internalized colonization also meant we were not able to appreciate the value of our cultures or to see their application as vibrant and vital forms of community development. As communities, we lacked cohesiveness. We needed a vision.

Since that time, I have seen Native people make remarkable changes as they began the powerful movement towards cultural revitalization. Native people have taken up the consuming desire to ask the questions Who am I? Where have I come from? Where am I going? What are my responsibilities? I believe that Aboriginal women were the first ones to wake up to this process, and the first to take up their responsibilities.

I recall attending a conference entitled "Rève-Toi!" (Wake up!) that was hosted by the Quebec Native Women's Association in the early 1970s. I remember watching women wake up to the call and begin to see what it was they wanted. Whether their vision was a friendship centre, a Native women's centre, a shelter or a dance troupe, they were willing to work for it. In doing so, they encouraged the painters and craftspeople, the dreamers and the teachers and the clans to recover their vision and culture. This took place in urban and rural settings, but many Native women had moved into urban centres by the 1970s.

It's important to consider why so many Aboriginal women found themselves in urban settings. First Nations women may have come because they weren't part of families that were popular. A number of Aboriginal women were victimized by the violence in their communities and were therefore forced to leave. Some had to leave when they married out and found themselves disenfranchised of their Indian status and

band membership. Others left because they were not able to live with the very aggressive application of band policies that marginalized them as women in their communities, for example, in housing. There were also women who came to urban centres so their children could be educated. Many Metis and other non-status Aboriginal women came from communities that were never provided with a land base and were dispersed into the cities. For all of these reasons and more, Aboriginal women were forced to leave their communities, but they took their identities with them, as women, as clans, as Nations. And so, even though so many had no choice but to become urban, and some endured terrible experiences in the process, the creativity of these women turned hardship into opportunity. They knew that their families needed places to belong in urban settings as Native people, and so they created the very organizations that could help address their survival.

The beginnings of most of these organizations were very humble. No sooner were Native women established in urban settings than they would offer their homes for hospitality and even shelter for newcomers. From there, small gathering places were set up informally in somebody's garage or in a church basement. These places, funded by bake sales and the proceeds from selling beadwork or raffling quilts, and surviving on the volunteer work of community women, gradually grew into the first Friendship Centres. Sometimes Native women did it alone, and sometimes these centres were created through networks with other non-profit community groups or government agencies.

Their services started with tea and talk, and ultimately grew into sophisticated counselling and referral agencies. They gradually grew into the role of community development centres, attracting other Native women who were able to envision, and ultimately create, community-based agencies to look at specific needs in the areas of housing, employment and addictions treatment, to name a few. Many women provided important economic support to themselves and their families as they began to earn salaries in Aboriginal community organizations. These emerging organizations were symbols of pride in our communities. Out of nothing but a dream, an idea, hard work and the creativity of community women, they became our social safety nets, cultural education centres and agents of change.

There is no evidence that the women who were involved in creating the early Friendship Centres ever thought that they would become social planning bodies, or social justice centres or house discussions about

self-determination and self-governance. The women did not set out specifically to do these things, yet all of the actions we undertake today are the results of that early organizing and volunteering. Furthermore, women usually developed these community groups and organizations to support the well-being of the community before they undertook to develop community resources for themselves. It was not until the mid-1970s that organizations specifically for the support of women were developed.

WOMEN'S CREATIVITY AND LEADERSHIP

In our communities, there are people who have titles and there are people who are leaders. These are not necessarily the same people. Our leaders are not necessarily the ones who have taken on a title. Natural leaders are the ones who seem to get things done. They have a healthy vision, possess knowledge, are passionately committed and have a personal leadership style that promotes action. Early on in our development, it was these natural leaders who worked to change our communities, and these leaders were, in overwhelming numbers, women.

While all this community development was happening, I saw the men rushing to keep up. They were our leaders in the formal sense, but they were running to catch up to their people. Many were not necessarily as healthy as their people yet. We know that a large percentage of our people have been affected by addictions, residential school trauma, criminal justice contact, violence and racism. All of these contributed to our generally unhealthy communities. Many who had been appointed our leaders at the time came from these roots as well, and many tried to lay claim to the work that the women had done.

Why was it primarily men who were occupying formal positions of leadership? When the treaty parties came to us, the Europeans didn't bring their women. In turn, they didn't want to deal with the women who were the leaders of our families, clans, communities and Nations. Colonial government policies and laws, including the *Indian Act*, reinforced political practices that excluded women. This interference ensured that only men carried titles like chief, band councillor and band administrator until very recently. In following these *Indian Act* practices over the past century, we have internalized the belief that those who carry these titles are the natural leaders of our communities. Many of us know that this is not always true, but public policy and negotiations

with government continue to support this system of leadership, and often to the exclusion of women. For these reasons, it has been women who have led the challenge to change discriminatory practices and to look at more responsible leadership processes. I've seen governments prop up systems that governments have always propped up and watched women respond. That kind of advocacy had to occur at the community level where women could build organizations with mandates to challenge the way things were and to create change.

Some of our current notions of leadership were formed during the time that women were totally excluded from politics. Our development as peoples has been characterized by this tension between formal male leadership and informal female leadership, and there have been too few opportunities to recognize and celebrate what our women have done or to explore the distinct qualities of our women's leadership.

How do women approach leadership? Our traditions tell us that we are not the same as men, nor should we try to use the same approaches they use. I learned this lesson from my grandmother on a visit home from university in 1973. My grandmother had never been to school and was curious to know what I was learning. She had some seventy grandchildren and another thirty-two great-grandchildren, and at that point I was the only one who had gone to university. As she was one of the most magnificent people I knew, I wanted to prove that I was worthy of her question. I responded by saying that I was learning about women's liberation. It was the hey day of second-wave feminism and feminism was a hot topic, but my grandmother had no idea what I was talking about. When she asked me to explain what I meant by women's liberation, I replied that women wanted to be equal with their men. It was about equality, I thought. But when my grandfather translated these notions into Mohawk, my grandmother started laughing. She said something in Mohawk, and when I asked my grandfather to translate, he told me that her exact words were "Why would women want to lower themselves to be equal to men?"

I had intended to impress my grandmother with all my worldly knowledge, yet she humbled me with a few words, reminding me of how powerful we are as women and of the great responsibilities we carry for our people. To my grandmother, women were lowered to Mother Earth first, with the responsibility to create and nurture, and she believed it was our responsibility to complete creation. It is inevitable, therefore, that our recovery as peoples would be led by the women. This interac-

tion with my grandmother helped me to understand the role of women in community development.

Real community development involves working hard, for long hours, without real compensation. Our women worked in community development because they were waking up to their responsibilities, and they had the vision. They did the work for the children, their family and the generations to come. They did it because they saw people living in ways that were not acceptable. They did it because many of the cultural teachings encouraged them to do it. Early community development allowed women to express who they were. They may have been driven out of their home community, but they were able to create a sense of community elsewhere, and especially in urban areas, which provided an anonymity and safety that allowed our women to freely express their creativity and vision.

In addition to vision, the early community development also created relationships, working partnerships and opportunities for sharing. I think that in real community development, there is a tendency to share the dream as opposed to the power. This is perhaps one of the fundamental differences between women's and men's approaches to community development. I have come to believe that it is not the power that is the ultimate end, it is the dream, and that this is the way that Aboriginal women have worked. For example, once these women got these organizations going, they did a remarkable thing as leaders: they let someone else take over. I think that this is a tremendous approach. To hand over one's vision to the next leader, natural or titled, is a very empowering thing. That is not to say that organizations that were the reflection of their leader did not suffer in some way when the founder left. But the fact that most of these founders had the vision to let other women take over attests to the unique leadership styles of Aboriginal women.

As a result of women's participation, I have seen an urban leadership that has become increasingly accountable. It's really hard to not tell your sister, daughter, aunt, mother or best friend what you are up to. I think it's a lot easier than being elected to formal leadership, where perhaps 30 percent of the community votes by ballot and puts you in power. Whether it was a conscious, long-range thought or a realization of a prophecy, I saw changes in leadership take place and people become more credible. I saw women engaging in more inclusive community-development processes.

Women are now 52 percent of the Aboriginal population, yet we are not 52 percent of the elected leadership of formal Aboriginal political organizations. When I look at urban organizations, I see a better representation of women than what I see among the chiefs, band councillors and leadership in the political organizations. Urban areas have long received more women who have been forced to migrate, and so they have participated in greater numbers in the labour force and in decision-making positions in our urban organizations.

Women's creativity continues to challenge and periodically threaten the processes in some of our organizations today. In the 1970s, Native women referred to the various First Nations organizations as male dominated. Metis and other non-Status women have also encountered male domination in their organizations. We now see the establishment of women's secretariats and councils within First Nations and Metis politics as a response to the desire for women's involvement. But whether these will become real expressions of community development and empowerment remains to be seen.

MOVING ON TO THE FUTURE

In the future, I think we are going to see more women creating partnerships and opportunities for sharing. It will be good to see all those women with all their energies pooled together. And although our initial urban leaders are ageing, many of those women who created the Friendship Centres and the network of other urban Aboriginal organizations are still around. They have provided the leadership today with the seeds to continue community development, and they continue to watch what we do to nurture those seeds and help them grow.

As more Aboriginal women become formal leaders, will we lose sight of those behaviours that encouraged our resiliency, brightness and creativity? Will we become part and parcel of the process that will limit young women's thinking? There wasn't an old guard when we came along, so there was no one to tell us what could or could not be done. At the present moment, I try very hard as part of my responsibility to encourage the next generation.

I worry that, as women leaders, we may have been negligent as mentors. When we were starting out, we benefited from the presence of those natural leaders who took the time to involve us and engage us, while building all of the organizations that they built. Now that we are

involved in maintaining, improving, strengthening and expanding these groups, we have found ourselves too busy to mentor. We have to make time to talk with young people, especially young women, and to help them reflect on and analyze the issues that shape our leadership role. The other side of mentoring, however, is that those who want to be mentored have to be patient, ask questions, believe and commit their time and energies.

I think that many young women are again champing at the bit in terms of community development and leadership. Our women continue to be the cutting edge of our development and the voice that challenges our inequity. One way we see them doing this is in challenging some of our cultural practices. For example, there are increasing numbers of young women taking up singing and drumming, even though they are often met with resistance. These are seen historically as activities for our young men, but young women are challenging that cultural norm. The more they are told that it is not appropriate, the more they embrace it.

I think in the future, we will see young women leading our development into a number of new areas. They may already be leading the way in terms of health care, seniors' programming, culture-based education and holistic programming, as well as in entertainment and information technology. And of course it is our younger people, both women and men, who are already showing natural leadership in the arts, literature, and music and dance, through dreaming and creating new visions of being Aboriginal in the twenty-first century.

To foster community development, we need to actively engage our young men in undoing some of the gender stereotypes that they have learned. It is not acceptable in a healing community to encourage young men to drum and learn the teachings and have young women stand back. It is not acceptable in a healing community to organize athletic activities for boys and young men and have the young women stand around and watch. These conditions and experiences will bring forth the next generation of natural leaders, who will challenge the traditions they are given. Our job as adults will be to create safe spaces for both genders to develop; places where they can have conversations about each other in order to understand what they're feeling and thinking.

We continue to be affected and to feel the repercussion of formal political developments. It was, in large part, Indian Affairs policy and legislation that encouraged women to organize as Native women in the

1970s. For a period, there were some common areas of concern for all Aboriginal women. However, as our leadership evolved, so did the issues that they had to confront. While all of us face racism, poverty and loss of land, government legislation controls our realities in such different ways that many of us have questioned whether or not First Nations, Metis and Inuit women share enough similar circumstances that can be dealt with through common approaches. This has led to the same kind of fractionalization within the Aboriginal women's community that we see in the Aboriginal political organizations. We find ourselves having to organize separately according to how Canada has classified us, as First Nations, Metis or Inuit. And yet while we may have to organize in ways that differ from one another, ultimately we continue to face many common experiences as Aboriginal women.

I wonder how much the development of women's committees within the First Nations, Metis and Inuit political organizations will further fractionalize us. It is certainly envisioned as a strength in redirecting and redesigning the organizations as they were developed in the late 1960s and early 1970s. And yet it will take strong leaders to sit and talk about how they feel and to look to a future beyond their grandchildren's grandchildren in a time when all of our organizations are threatened by competition for federal government resources.

Urban women face specific circumstances. First Nations like to say that they represent the interests of their urban members, but they never talk to us or consult with us. The *Corbiere* decision[1] says that we have the right to be involved in the selection of leadership in our home First Nations. In reality, we are tolerated there, but not welcome. Furthermore, chiefs have claimed that they represent their people regardless of residency and without having to consult them. The *Corbiere* decision said yes to more representation and it also said that it was the right of the individual member of a First Nation to access services and professions where and how that individual chose to do so. To invoke our token involvement in the politics of our home communities, or to have our affairs governed exclusively from our home communities, may limit the creativity and the nurturing that has brought us this far. As urban women, we have to consider the impact of this representation on our development.

FULL CIRCLE

As the numbers of Aboriginal people on the healing path increase, there will be questions and challenges about what to do after the healing is completed. We are not used to living life to its fullest, but rather to healing and helping others. We will need to learn how to balance the numerous aspects of life that we juggle: academic and lived experience, traditional culture and new forms of cultural expression, professional and personal life, and nurturing others versus nurturing ourselves.

As I understand it, leaders were traditionally understood to be servants of the people. The next generation will have to integrate this cultural practice into daily organizational behaviour. At the same time, there will be a need for more political savvy. This will mean that leaders will have to be more aware of politics that are both internal and external in order to facilitate community growth and development.

The process of colonization reinforces the divisions that undermine the power of the circle and cause women to distance themselves from one another. This has especially been done through the imposition of the labels First Nations, Metis and Inuit. Our early natural leaders used their collective power and efforts to create community-controlled organizations. Since then, divisiveness has been heightened and has become more pronounced. Increasingly the fight for the future has become the fight for money. We focus on majority and minority power and use the processes learned from the colonizers, not those roles and responsibilities we have learned to carry in our healing journey. These were not the values and practices of those women who created our early community organizations.

Our leaders will need to sit again with the eagle and all of our other teachers to reflect on what is important in our future, define what role they will play, identify shared dreams and then determine how this will be reflected in our organizations and communities. If we recognize and accept this visioning task, we will be much stronger in the next phase of community development.

There is no doubt that Aboriginal women are leading the way in recovering our health as peoples, implementing the prophecies, recreating communities and birthing new dreams. We are now living these responsibilities as formal and natural leaders. And when those original women who are still watching us ask, "What are these women doing with what we started?" we will have to acknowledge that there is still

much to be done. There are entirely new challenges still to be met and many young voices still to be developed. With 50 percent of our population under the age of twenty-four and 40 percent under the age of sixteen, there is a huge population of young women coming forward.

I have no doubt that our power will continue. We will answer those original women by recognizing that we borrow from our children. We must commit ourselves to realizing those yet unmet prophecies and to being responsible leaders regardless of the structure of our organizations. We must promise that we will continue to dream. We must show those original women that the eagle has landed and that we have picked up our eagle feathers.

NOTES

1. The Assembly of First Nations has produced a document on the *Corbiere* decision which reads: "In *Corbiere*, the Supreme Court of Canada ruled that denying the vote to members because they live off reserve is a form of discrimination. *Corbiere* determined that voting rights could not be discriminatory. By creating this new category of discrimination, many questions were raised about other rights for non-resident members." See "The Corbiere Decision: What It Means for First Nations." *Assembly of First Nations.* <www.afn.ca>.

STRONG SPIRIT, FRACTURED IDENTITY:

AN OJIBWAY ADOPTEE'S JOURNEY

TO WHOLENESS

Shandra Spears

TRANSRACIAL ADOPTION of Native children is more complex than anyone who has not lived through the experience can imagine. I have lived through it. Apart from the obvious disconnection from Native community and birth relatives, transracially adopted First Nations children face specific challenges, which we continue to face throughout the course of our adult lives. Mainstream society, when it acknowledges this issue at all, suggests that our trauma is a result of the abuse that we have experienced and that this abuse was inflicted by a few aberrant individuals. As with residential school survivors, this discourse can be stretched to say that many Native children did not experience violence first-hand and, therefore, have not experienced trauma.

By evaluating us as individual cases and by focusing primarily on our physical experience, the dominant society disconnects us from the larger aspects of politics and history. However, the removal of entire

generations of Native children from our communities and families is a genocidal blow to our Nations, and we feel that violence in our bones. The myth of Native people as "conquered" implies that we were defeated in battle, but cultural warfare attacks the hearts and minds of vulnerable children. The myth of adopted Native children as "abandoned by troubled birth parents" denies the bonds of love between Native children and their families and communities and constructs white parents as heroic rescuers.

As human beings, white parents can of course love a Native child. White skin does not convey a lesser ability to love, sacrifice and struggle as parents. White skin does not cause child abuse or racism. Adoption is one of the most beautiful manifestations of the human capacity to love and nurture. My parents love me, and they have remained a constant, active presence in my life. Love is a powerful force that can transcend differences of race and culture. But transracial adoptions do not solve racial problems when one group in society maintains a position of political, economic, military and cultural dominance over other groups. Within the framework of institutionalized racism and colonization, members of the dominant group are able to misuse their powers, which they have done in so many ways and for so many years, that it becomes normal for them. In this position, how can a single, isolated Native child help but feel her or his peril, no matter how much she or he is loved?

In the context of colonization, the adoption of Native children by white families is an attempt to assimilate us into Canadian society. If Native children grow up as Canadians, we will presumably cease to be part of an "Indian problem." White adoptive parents are co-opted into this assimilation process by their urgent need to parent.

It is convenient to imagine that a parent's love can erase history and political conflict — but children grow up and conflict remains. Children are not "bridges between two worlds." Children cannot be programmed to become anyone but who they are. The attempt to mould Native children into an alien identity, out of laziness or self-interest, endangers our lives. Those of us who survive the experience often emerge angry at our loss and fiercely committed to our Native identity once we rediscover it. The only way to have earned our loyalty in any permanent way would have been to meet our real cultural, spiritual, emotional and physical needs with fairness and honesty. The possibility of finding accurate information about Native culture, which could lead parents to find culture-based support for Native children, is beyond the reach of the

average Canadian, because this information is suppressed within dominant communication systems. In some totalitarian regimes, people disappear because death squads take them away. In Canada, young Native people disappear into the dominant society through love, lies and ideology.

CHALLENGING THE MYTHOLOGY OF ADOPTION

My life story can be read from a couple of different ideological positions. One ideology states that colonization is a myth, that it no longer exists, that it wasn't bad for Indigenous people, and that it has had no lasting impact on our lives. This ideological position goes on to suggest that the Native way of life is unrealistic, backward and has little value, and that any child would be grateful for the chance to be raised by loving, white, middle-class parents and have access to good health care, education and employment opportunities. Life on the reserve leads to life in prison or on the streets, so adoptive parents can give Native children a chance at a better life. If I understand my life according to this mythology, it was blessed and prosperous. This is one truth.

Another truth, from another ideological position, is that I was robbed of a political, historical, spiritual, linguistic and cultural base which could have given me a great sense of self-esteem and strength. This position also acknowledges that a large proportion of Native people who ended up homeless, incarcerated, addicted or psychologically scarred were products of this "better life." Native people who remained connected to community and culture didn't come over to our house for dinner. I never heard my language spoken, and I was never given accurate information about my culture. I grew up within an ideology that said I did not exist, because Native people did not exist, except as mascots or objects of desire.[1] Through this process of symbolic annihilation,[2] I ceased to exist as a Native person within my own mind.

I was already part white and lived surrounded by white colleagues and relatives. How much further could I step away from "Nativeness" — by marrying a white person and investing in a white, middle-class, Canadian way of life? Wouldn't that be simpler and less painful? How could my children return from that even greater distance? Love truly can conquer all. If I followed this process, it would use my own love relationships to turn me into a "death sentence" for my own descendants, at least in terms of being "practising" Ojibways. In my life, and in the

history of my family, residential schooling and transracial adoption took me so far away from my language and culture that only a violent upheaval was able to bring me back. This is my story.

The Story of My Survival

I was born in 1968 and was surrendered at birth for adoption. I lived in Toronto with two foster families before being adopted at five months of age. My older sister was very excited to have a new baby sister in the house. I had big brown eyes and auburn hair, and I'd already had the first of six surgeries to correct my club feet. My baby picture shows me sitting in my car seat on the sidewalk of my foster family's home with tiny casts on my legs on the day I was brought home from Toronto.

My first memory is of laughing. I was at the Hospital for Sick Children. I was eighteen months old, and I was about to have my ankle broken and reset with a pin. The surgeon was explaining that holes would have to be cut into the little boots attached to the brace I wore at night. I remember sitting on the counter in the blue light of the X-ray display, looking from the doctor to my parents, thinking that this was the funniest thing I'd ever heard. "Holes in my ankles; holes in my boots!" I thought it was hilarious.

Our family was playful, outdoorsy and emotionally intense. We participated in a music society, the church and Girl Guides. My sister and I took dance lessons and sang in the church choir. We had a little Pomeranian dog named Rusty. We camped almost every weekend, every summer, for most of my childhood. I loved it. When I was four years old, I learned that I was adopted. After many discussions, I came to understand that my other parents had been unable to take care of me, and that my Mom and Dad[3] were very happy that I was their little girl. I was adopted, and I had problems with my feet. My Dad's father had died. My Mom had health problems. My sister had allergies. Everyone in our family had her or his challenges.

My adoption story was that I was one-eighth Indian and that my grandfather had been an Indian chief. That made me an Indian princess. I had brown hair and brown eyes, and tanned well in the summertime. That was the extent of my Native identity.

Our home was also violent, and I became the family scapegoat. I experienced violence, shaming and screaming. There were no cigarette burns and no rapes, and it didn't happen all the time. It was a pattern of domestic violence that had affected our extended family for several gen-

erations, so it did not begin as an attack on me as a Native child. But it was real. It happened — and it happened more to me than to my white sister. Conversations were dangerous and all members of the family were sensitized to signs of a fight. I couldn't negotiate my way through dangerous discussions very well, and I was a very sensitive child. Some Native adoptees say that they refused to cry when they were battered. I cried every time. I was always terrified of those experiences.

I spent a significant portion of my childhood refusing to talk, because talking was a trap that led to screaming and punishment. I used comforting techniques, including dissociation, to quiet myself. If I was alone, I was able to feel some relief. I created spaces within my own imagination where I could dream. I floated up out of my distress, telling myself happy stories. Sometimes, my bedroom would seem to shift, as if I was seeing it from my bed and from above at the same time. I was very young when I got the idea that I could go to a place that was full of music and love and beauty. I knew some of the people who hovered in the hallway outside my bedroom. They were not clearly visual like "ghosts." Instead, they appeared as beautiful, singing columns of light. I had known them before I was born and I wanted to go back to them. I knew this meant that I had to die, and in a vague way I wished that would happen.

The violence and fear didn't mean that I never had any fun. On the contrary, our family had family games, jokes and traditions that were playful and imaginative. We could turn the smallest events into celebrations. We were voracious readers, and my earliest spiritual teachings came from the alternative worlds of fantasy and science-fiction novels. I loved my family and home. I didn't like feeling trapped and afraid.

I developed my sense of identity by internalizing everything around me. Having no Native women in my life, I had no way of knowing that I was a beautiful Native girl. I didn't even know that I was Native. There was no Native "mirror" that reflected my beauty; only a white mirror that reflected my difference. I compared myself to the girls around me, with their small waists and cute noses. I didn't look like them, but I had no reason to believe I was supposed to look any other way. Therefore, I "knew" that I was a white girl — an ugly white girl. I was a typical "ugly duckling." Having no one to tell me that I was worth protecting, I "knew" that I was worthless and bad.

At twelve years old, I started high school and discovered acting. I needed acceptance and affection, and I looked for those things outside

the home, finding a place for myself with the artsy alternative crowd. I started to come out of my shell. By the end of high school, my days and nights were filled with arts activities, volunteering, part-time jobs and going to night clubs. I came out of my shell at home as well. I stopped being silent and became openly hostile. The violence was escalating, and one parent was afraid of seriously injuring me. My parents called the Children's Aid Society to see if I could be placed in foster care. They were told that I would probably not find a foster home and could end up homeless. I stayed. I screamed and fought. I was sometimes kicked out, and sometimes I kicked myself out. I started keeping a running count-down on my bedroom door: "135 days until I can leave this house."

The violence stopped when I became physically large enough to fight back. No one in my family has hit me since my seventeenth birth-day. Emotionally, however, I remained a scapegoat, and I acted out my role as a troublemaker. I smoked, drove when I was drunk and engaged in other risky, self-destructive behaviours. I longed for affection from the young men who were most cruel to me and rejected those who treated me with respect.

Though home and family were tough for me, I never wanted to leave for foster care or life on the street. This was *my* home. They were my family. I had always believed that I was a real daughter to my parents. I didn't see my family as something temporary or myself as a statistic. I had a life. I would have been horrified to be sent away. So I stayed until I graduated from high school and left for Toronto. I entered the Visual Arts BFA program at York University in 1987, at the age of eighteen.

At York, my self-destructive behaviours caught up with me, and I got hurt. I survived months of illness and suicidal depression by leaning on alcohol and my friends. I managed to salvage my credits, but I had been kicked out of my program. At that point, I could have chosen to appeal the academic decision and return to school, but I made a differ-ent choice. I believe my spiritual helpers were pushing me to get serious about survival and recovery. I decided to register with the Children's Aid Society, to meet my birth mother. Given the amount of pain I was feel-ing, and with my life at risk, it seemed to me that I might as well find her before I ended up dead. I expected a two-year wait, at least, but I wanted to get the process started. The entire process took only four months, and we met that October.

From White to Native in Four "Easy" Years

The reunion with my birth mother was a positive experience, and we were very close for two years. She told me about my birth father, and that he was Ojibway. In that moment, I went from being "one-eighth Indian" to being Ojibway: the half-white daughter of an Ojibway man. This information had been falsified in my CAS file, where my birth father was listed as "one-quarter Indian." For the first time, I had a name for my Nation and names for my birth parents. I had the name of the reserve that he was from. These identifiers were very powerful for me. I also had images of people who looked like me. Almost overnight, like the ugly duckling, I decided I was quite good-looking! I started mentioning my Ojibway identity to random Native people; once, to a customer at K-Mart, and then to a student. This was a probing, hesitant process. I was checking to see whether they would laugh at me, because it was still obvious to me that I was the same white Shandra I had always been. But they encouraged me to continue searching for my Native relatives and even to apply for my Indian Status.

I felt like I had permission to continue. However, Ojibway identity was completely new to me. As a "one-eighth Indian," I lived in Canada as a white person and occasionally brought up the fact that I was "part-Indian." This meant that one of my ancestors had been Native but that I was not. If asked, I would say that I was proud to be part-Native, but it was a pride in something I had no direct experience with, like my artistic ability, or my post-punk music, or my family role as a rebel, it made me different, and I had learned to take pride in my uniqueness. I began to understand that I was an Ojibway person, but it still felt very unreal. I had no idea what to do with any of it. I wasn't really conscious of race, because I half-consciously believed that "race" referred only to "non-white" people. I started noticing the races of my friends and began talking to them about identity and culture.

My birth mother took me to events where I could meet other Native people and ask questions, and she took me to the first Toronto rally in support of the activists in Kahnesetake who had been attacked by provincial police. Before our relationship went sour, she gave me a lot of help in taking those first steps. By the end of the summer of 1990, I had had a crash course in activism. At first, I felt most comfortable with non-Native supporters. But then, I began to understand that Native activists would be maimed and killed while non-Native activists often faced less

lethal consequences. That was a crucial moment, and it changed my sense of identity permanently.

Some Native women and men challenged my ethnicity in aggressive or insulting ways. I became very defensive about my fair skin, but didn't have enough confidence to really stand up for myself. Inside, part of me still felt like my Nativeness was a hoax, and I was seeing how far I could push it, but another part recognized that I had a right to pursue it and resented the discrimination I faced.

My life was full of "firsts." I worked in a Native organization for the first time and went to my first powwow. I lived with my first Native boyfriend. I was homeless and accessed a Native women's shelter for the first time. I learned to do beadwork and went to cultural events. I made friends with Native people who were homeless or middle class; who were ex-cons, activists, healers, artists, executive directors or entrepreneurs. My friends from high school and university were graduating, marrying and moving on with their careers, while I was synthesizing a whole new sense of identity at every level of my body, mind and spirit. I was angry about the loss of Native culture I had experienced as a child, and I was mourning the "white" direction that I was rejecting as an adult. This choice connected me to my new community and identity, and separated me from everything I had ever known.

Finally, in late 1991, I was ready to attempt contact with my birth father's side of the family. I was pretty angry by this time, with my birth mother for our failed relationship and with my birth father who, I believed, had rejected me. Long-suppressed feelings of abandonment began to emerge, and they were intense. Again, in a moment of intense pain and anger, I decided I either had to find him or go forward in my life without him. There were a couple of snags in this process, but by the summer of 1992, I met my uncle in Toronto, and visited my other family members in the Lake of the Woods area.

It had been four years since I met my birth mother, and I had immersed myself in the Toronto Native community without the legitimizing presence of an extended Native family. I was biracial, fair-skinned, non-status, urban and culturally confused, and I had been raised by a white family, yet I had managed to make the identity shift. My reunion with my father's side of the family was my first trip to the reserve, and the family arranged for me to be instated as a band member. I was finally a Status Indian with a Native family. I even looked "more Native" when I returned, so that friends asked if I had dyed my

hair. But my birth father, who had been homeless, was deceased. He had died in 1987, eighteen months before I began my search, and he had been left to die with no treatment in a hospital hallway. For the next six years, I wandered through the stages of a very confusing grief. Like so many other elements of my story, it felt unreal. How could I be grieving for someone I didn't know? Did I have a right to grieve? Eventually, it was through ceremony that I found some peace.

DRESSING UP LIKE AN INDIAN

Ceremonies were very helpful to me, and I learned from excellent healers and traditional teachers. I learned to take on some responsibilities at our lodge. I learned my name and my clan and began to drum and sing. I explored the role of helper. I was learning to be respectful, and it felt good. My hair was very long and I kept it braided. I tried wearing skirts, as I had been taught to do. I even managed to find a way back to my teaching/leadership role, by teaching voice technique to Native women drummers. But I still felt I was out of my element.

The wild, expressive rebel that I had always been was being pushed aside for a long-haired, skirt-wearing woman working in social services between acting jobs. I wanted to be the irreverent, sarcastic, dynamic artist I had always been. I wore the uniform of a strong, traditional woman, but I still went home at night and felt crazy and self-destructive. I was invited to sing, but I couldn't speak the way I wanted to speak. I carried a journal around for those times when I wanted to say something that white or Native people in my life didn't accept or understand. I tried to be wild, expressive, proper, respectable and rebellious all at once, but it was next to impossible. People could only accept a portion of me at a time. Lots of white friends dropped me completely, unable to cope with the changes I was going through.

I eventually split myself into different Shandras for each of these situations. One went home for weekends with the family, while another went to the lodge and sang, and yet another was an actor and martial artist. Switching from one reality to another gave me headaches, and triggered intense feelings of rage. I usually turned these rages on myself. There were times when I could barely recognize people I worked with every day, or forgot elements of traditional protocol because I was switched into "white" mode. Few people went from acting class, to martial arts class, to a traditional ceremony, to an all-night party, and

then back to a nine-to-five office job all in one day. But I had done this all my life. I was a cultural chameleon, just as I had been growing up. I was feeling better and I had some of the answers I needed, but I was still pretending.

It can be very humiliating to be a Native adoptee within our community. Community members act as though our return to our community will solve all our problems. They think we should leave our childhood histories in the past and focus on behaving more like "real" Native people. After being constructed all our lives as "the problem," we return to our communities to face more of the same treatment. As recently as last year, a Native friend told me that she thinks I am brighter than most adoptees and that's why I can understand our culture. That bigotry suggests that adoption equals stupidity. It seems unthinkable, but it exists.

Adoptees are called "lost birds." I don't feel like a lost bird! I am a strong, surviving Anishinaabe kwe who found my way back, alone, through a series of challenges, without any concrete or ideological support for my determination. That doesn't make me "lost." I understand the concept, though. What I call the "Adoptee Syndrome," a collection of shutdown and self-destructive behaviours, is very much like that of a bird who has fallen from the nest or a person who is so seriously ill that she or he can no longer eat.

Healing the Fractures with Anger and Authenticity

How do I experience the Syndrome? It begins when situations restimulate my post-traumatic grief and rage. At this point, I either get what I need to relax the trigger or I stay triggered. For a while, I may continue to function, but I begin to lose some of my healthy habits. I eat proper meals and show up for work or appointments, but I stop using the prayers, meditation or medicines that can help me. I dissociate, then shut down and go numb or feel overwhelmed by rage or panic. I reach out for help, but if the help isn't exactly what I need, I don't ask again. I beat up on myself. I start missing deadlines or I drop relationships. Sometimes, I get so "stuck" that I do nothing while my work, or my rent, is not taken care of. Thoughts of self-injury or suicide repeatedly enter my mind. I have to stay away from knives, subway ledges and high balconies, because I feel the temptation to jump, or to cut.

Sometimes, I self-injure just enough to break out of the spin, although as a general rule I try not to. I become obsessed with negative, harmful people or situations. I become critical of others and of myself. Sometimes, I can't focus, or I run out of the room crying. Sometimes, my feelings boil over into physical gestures; I throw things. One such "release" cost me an expensive camera last year, because that was what was in my hand at the moment. This kind of trigger can last anywhere from a day to a year. I am using the present tense, because this is an ongoing obstacle. The fact that I can describe it, or even cope with it, does not mean that it goes away.

I've come to accept that I am vulnerable to certain situations, and that the buttons waiting to be pushed are like fault lines within my personality. I can crumble and fall apart, even though I am very strong. I have techniques that I can use to cope with these triggers, and I'm getting better at putting myself back together. I have a hard-won sense of my own identity, in all its variety and contradictions.

The thing is that, even though I was an "instant Indian," I had knowledge and spiritual gifts the whole time, even as a child. "Real (Catholic/reserve) Indians" like to mock "urban Indians" who take up traditional spirituality. I was a prime target. I could even see their point! All they could see were assimilated Native people coming back, full of earnest longing and gobbling up teachings. But that "wannabe" image didn't matter to me. The more I learned, the more I discovered that I had had dreams and spiritual guidance helping me throughout my life. I discovered that my birth family had been spiritual and political leaders for generations before the boarding school/adoption disruption. I am not a pre-Colombian Ojibway woman. But neither are the "real Indians." We are all struggling through different aspects of the same genocidal program.

Contextualizing my experiences and understanding the history can help. If I can see that I am part of an entire generation that was "scooped," then I can see that I am not one isolated, worthless, troublesome person. I can see that "scoop" as part of a larger program of cultural genocide, recognized as such by the United Nations. I can make connections between my experience and the experience of my grandparents and father in residential school, and see that I am part of a family that has been systemically stripped of language, culture and family connection. I can understand that the process of colonization has been repeated throughout the world, with culturally specific

modifications for different colonized groups. This allows me to argue with the dominant ideology in my own mind. I can fight back by making good choices for future generations. Finally, I can see my parents (all four of them) as human beings who have weaknesses and make mistakes, and know that they gave me all they had. That is a function of both maturity and healing, and it takes me out of the position of the abandoned, wounded child. I believe that my experience has made me a very effective problem-solver, and as such, I have been as systematic in healing my wounds as the colonizer has been in wounding me.

One technique I use is reframing. For example, I was on to my fourth set of parents by the time I was six months old, as well as having invasive orthopedic surgery. Early childhood development researchers talk of those months as important in terms of bonding. In that case, my ability to bond would have been terribly disrupted, and to some extent that is true. In reframing that experience, however, I can see that although the people and places in my life seemed to change quite abruptly, someone always showed up to take care of me. That is also true. I have never had an adult love relationship that has lasted even a year, and I am thirty-four years old. That indicates some problems with bonding. But it is also true that in times of chaos and distress, I know help will arrive, and that hope gives me a great strength. It has allowed me to completely overturn my life in order to follow the urging of my spirit to come home, because somehow I know that help will be there for me.

I use other techniques as well to integrate myself and to stay focused on life-affirming choices. I stay away from self-help books which position me as a victim and focus on ones that support positive goal-setting. I avoid outside definitions of who I am, setting a careful, detached distance around both compliments and criticisms. I evaluate situations in terms of my own authenticity, avoiding those which rely on superficial elements like dress and behaviour. I ask myself, "Can I be accepted in this situation if I have purple hair? Can I be sarcastic and overly dramatic, the way I like to be? Can I wear this skirt when I choose to? If this situation does not allow me to be whole and authentic, I might have to step away from it." I understand that my decision to keep living is conditional, and that the condition is that each day is mine to live as I see fit. If I choose to live today, then I own this day. It is a gift from the Creator, but it is also a choice made by me.

Sometimes I grab hold of my intense anger and vent sarcastically about it until I can't help but laugh, or engage in revenge fantasies that are so silly they make me smile. I deliberately overeat or smoke too many cigarettes if that's what it takes for me to feel grounded. I reach out to the people who know how to tease me just right, or people with whom I can grumble, cry or scream. Sometimes, when I've run out of other techniques, I carry a stone around and rub it to remind myself of life and the Earth. On those days, that stone is all that stands between me and my thoughts of dying. I also try not to be alarmed by the Syndrome shutdowns.

When I shut down, I can get into big trouble and put important things on the back burner, but I am also processing overwhelming amounts of information at spiritual, physical, mental and emotional levels. I could not have made these great shifts in ideology, spirituality, personality and culture without creating some spaces in my life to fuse and integrate the new elements into a central self. That's why I shut down three times while writing this article: I had to get past the skeptical, dominant ideology in my own mind and find my way to a place where I could speak this other truth.

The Strong Spirit Knows What Is True

Back in 1991, at the abused women's shelter, a housemate gave me a strong teaching. She said that if I want to find my direction in life, I should go inside and find myself as a little kid and ask myself what I want to be. A few months later in ceremony, I had a chance to do just that. The ceremony brought us into connection with parts of ourselves. I was reunited with myself at four years old. I was dancing and laughing inside one of those columns of light that I had seen as a young girl. I asked my four-year-old self, "Aren't you in pain? Don't your legs hurt? Aren't you afraid?" Four-year-old-me replied, "No, silly. I'm dancing!" A couple of years later, when I was named, Elder Waabishkamigizikwe named me "Laughter Woman." My first memory is of laughing. It is who I am.

Another grandmother taught me that people can try to hurt us, but they cannot change who we are. Or, as my Mother says, "Shandra, shit doesn't stick to you." I have an inner strength that bounces back from trouble, and I celebrate that. That ability to heal also exists within our families and communities and will lead us to solutions.

We can hold state and civic institutions responsible for their genocidal practices but that will not ultimately solve our distress. We are responsible for our own healing, and we are strong enough to achieve it. Native-child welfare organizations and open adoptions are creating better options for our children, and Native people are tackling problems in a variety of ways. Fortunately, we are not all one type of "Indian." Each of us has a different history, bringing different strengths to this cultural and political battlefield. In the polite Canadian culture war that seeks to break apart our strong families, we have an opportunity to discover our greatest strengths. The colonizer can try to hurt us, but can only succeed if we change who we are.

NOTES

1. Roland Barthes, *Mythologies* (Paris: Seuil, 1970).

2. Gaye Tuchman, "Introduction: The Symbolic Annihilation of Women by the Mass Media," in Gaye Tuchman, Arlene Kaplan Daniels and James Benét, eds., *Hearth and Home: Images of Women in the Mass Media* (New York: Oxford University Press, 1978).

3. The post-reunion life of an adoptee can be complicated for many reasons, including having two sets of parents. To clarify — my parents, who raised me, are called "Mom and Dad," while my birth parents are called "my birth parents," or are referred to by their first names. "Mom" and "Dad" have been capitalized throughout the essay to emphasize this distinction. I have been calling my parents Mom and Dad since I learned how to talk, and I have done so throughout this essay instead of using more clinical terms like "my adoptive parents." I prefer to express the normalcy and chaos of my adoption and post-reunion experience by using authentic language.

PART II

ASKING

QUESTIONS

TRIBAL FEMINISM IS A DRUM SONG

Rosanna Deerchild

IT IS SAID THAT *long ago there was no drum among our peoples. Then the spirits gave a vision to a woman. She was gifted with the drum and told it was the heartbeat of Mother Earth. She returned to her people with the first drum. They were overjoyed with such a beautiful gift. As part of the vision the spirits told her that, although she would bring the drum to the people, it was the men who would carry the drumstick. It was the men who would play the heartbeat for the people. Because in that way they would remain connected to Mother Earth and so understand their relationship to women.*

*

It's a dimly lit room. Not enough light to see its corners but enough to see the large drum in its centre. The drum commands the space with its humbleness. It's what is commonly called a powwow drum. Its wide round body rests on a tall, slender wooden stand. On its east, south, west and north sides, willow staves reach up and bend over and outward. The staves are decorated with ribbons and feathers. One might think there isn't anything unusual about this drum. It looks to be a typical large drum. One you might see and hear at any powwow.

But there is a sound that comes from its centre. It's not drumming. Or singing. It is the sound of a single heartbeat. The beat slightly moves the deerhide skin to its rhythm. Maybe this is not so extraordinary. It is after all just a recording coming from a speaker inside the drum's body. Perhaps it's meant to represent and convey the importance of the drum to Aboriginal peoples, to say this is the heartbeat of Mother Earth and, in turn, the heartbeat of our Nations.

What about the pictures, then? The large canvases that surround this drum with its own heartbeat. Those black and white pictures that seem to be the drum's true body. The pictures are of women. Not so unusual. Perhaps just another way of saying this is our mother. Well maybe, except the four pictures are not the faces of women but the breasts of women.

*

This is the art of Lita Fontaine. She is Dakota/Ojibwa, an artist and lately a tribal feminist. You may wonder what a tribal feminist is and what makes her any different than a mainstream feminist. It would be too simple to say a tribal feminist is a feminist with Indigenous heritage. It would be too complex to do a comparative inventory, dissecting the ideologies, methodologies and theories, complete with footnotes and bibliographies of both perspectives.

Instead, I'll explain through storytelling,[1] as is the custom among Aboriginal peoples. Actually, the story isn't really a story. It's more of a drum. Or, rather, a drumbeat. Not with a drumstick, but with a woman's heartbeat. It is a heartbeat that lies beneath her breast. The sound is really a question that has been asked for millennia: Who am I?

This is the question that Fontaine explores and celebrates through her art. She has been a professional artist for over ten years, although she has been making stories through art since she was fifteen years old. Her art began with interpreting Ojibwa mythology. She was particularly interested in what the spirit people of those legends and stories might look like. She went on to finish her masters in fine arts at the University of Regina in Saskatchewan.

Over the course of her artistic journey, Fontaine's art has changed from outward observation of mythology to interpreting her own story. Her art has moved inward, becoming increasingly personal. Through it, she has explored her urban upbringing, her womanhood and her culture,

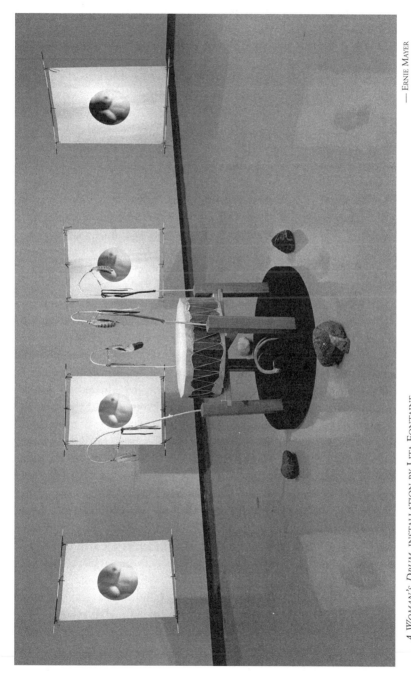

— Ernie Mayer

A Woman's Drum Installation by Lita Fontaine

even her mother's residential school experiences. Using many disciplines, including mixed media, collage and black and white photography, she continually explores, defines and redefines who she is. Her goal is to re-evaluate, reframe and ultimately reclaim her Aboriginal identity and womanhood from colonialism, racism and sexism.

But not just from the dominant white culture. Fontaine says she has begun to discover that these "isms" also exist in Aboriginal societies and traditions. She has begun to confront what she sees as the patriarchy that has seeped into these long-held beliefs, ceremonies and gender roles. For her this is tribal feminism, a new and whispered dialogue. It is a philosophy that Fontaine adopted from Paula Gunn Allen's book *The Sacred Hoop: Recovering the Feminine in American Indian Tradition.*[2] Fontaine describes the ideology as approaching feminism through a culture lens. But she looks within her own culture, ceremonies and traditions from a feminist perspective: "Tribal first because first and foremost my Aboriginality is important, but feminist because I've adopted some of their ideals. I can relate and understand."

In this way Fontaine seeks the truth in her identity inside and outside the race line. This new way of feminist thinking and evaluating soon manifested itself into her art. More specifically, the drum.

In contemporary times, the teaching of how the First Nations received the drum has been translated into a rule — women cannot sit in the first row behind the big drum, nor are they allowed to play the drum. Instead, they sit or stand in the second row behind the men and sing. Many who practise the traditional ways will say it is because "that's the way it's always been done." But it has left some Aboriginal women with a bad taste in their mouths and they have asked the question, Tradition or sexism?

Fontaine was one of those who struggled with this teaching. When she went to powwows, she was uncomfortable and confused about how women were not allowed to play the heartbeat of our Mother Earth and of our peoples: "I was like, why can't women sit at the drum? I would love to see that but because of certain traditions and attitudes we couldn't."

Fontaine struggled to understand this tradition that seemed so far removed from what she knew to be a matriarchal belief system. Most Aboriginal cultures have been matriarchal. Although the female was not recognized as being the head of the family, state and church, she was most certainly the root of the family. Therefore, it was the woman who

was the true leader of the nation. The basis for that comes from the certainty that the Earth is our original mother. All life comes from the Earth. She feeds us, clothes us and shelters us and, in turn, we give her the highest respect. She is where we are born and where our bodies return when we die. This Mother Earth principle has survived, and there remains a deep respect and connection to the Earth. Many philosophies, values and ceremonies continue to revolve around this principle. An example of this is the Sweat Lodge ceremony. The round lodge symbolizes the Earth's womb and by returning there we are in a sense reborn. Even in the more social activity of the powwow, Mother Earth is present when we dance to her heartbeat. From this basis grows the knowledge that women, like Mother Earth, give us life and feed, clothe and shelter us. Women, too, must be highly respected.

Aboriginal societies "walked in balance" with the Earth, with the spirit and with one another. Although the woman was seen to be the strength, she was by no means at the top of the hierarchical structure. In fact, there was a natural equality between the sexes. Each had their ceremonies, roles and purpose in the community and within the order of life. Neither one was less or more important than the other.

In stark contrast, European social structure was based on the Christian belief in a male God and his male son. There was no female equal to them. Even the Virgin Mary was not given equal status despite the fact she was the mother. She was relegated to the vessel of Christ. The belief was that this male duo gave "man" the title of master over all things — the Earth, the animals and, above all, his mate, "woman." It was a hierarchy that spread throughout the entire social structure. The male was recognized as the head of the family, the head of the state, the head of the Church and the head of the military.

Beginning with the arrival of Christopher Columbus in 1492, during his search for gold and land for Spain, European contact changed the way we had always lived. When the Europeans met our peoples they assumed that the men were in charge. Over the course of the 510 years since then, recognition of the matriarchy, in terms of how women are viewed and treated, has been reduced to an obligatory nod.

Tribal feminism argues that matriarchy gave way to patriarchy within our business, community and governing structures, and women lost their status and their leadership roles. Although it is slowly changing today, leadership roles for women in band politics and national organizations like the Assembly of First Nations are scarce. In fact, in its early

days, the AFN was called the National Indian Brotherhood, completely excluding women.

Under this learned patriarchy, gender rules also shifted ceremonial protocol. Aside from the well-known example of no women at the big drum, women today are required to wear skirts in many traditional ceremonies. It is important to acknowledge that the practice of women wearing skirts originated from the teaching that the skirt represents the Hoop of Life and connects a woman to Mother Earth. Like the Earth, a woman has the creative power to give life. When a woman wears a skirt, that circle surrounds her, connects her to Mother and channels Earth energy from Mother into her core. When a woman wears a skirt, it acts as her boundary and protects her from all she wants to keep out. While wearing of skirts was not optional, this bond with Mother Earth was its primary reason.

However, over time and as a result of colonization, many have forgotten that this sacred bond existed between Mother Earth and women. Like any teaching, it served to remind us not to bind. Yet this teaching has become a gender rule where if a woman does not wear a skirt she may be asked to leave the ceremony. Fontaine says this fundamental shift from matriarchy to patriarchy was not an accident:

> The way to get to a nation is through the women and I think what they [the Europeans] did was put down the woman's image. They made her into the princess or the squaw. They knew the woman was the power in the Aboriginal nation. I think they campaigned in throwing negative stereotypes at us and they brought us down.

It is not something she thinks was there prior to contact nor was it a way of thinking that was easily or quickly adopted. Fontaine says this subtle sexism has been threaded into our cultural fabric as a result of hundreds of years of extermination attempts, oppression and assimilation policies and practices. Over the course of 500 years, our ancestors were told not to speak their language or to show their Aboriginality, but to adopt the European ways. This was termed as civilizing the Indian, or assimilation.

It is these subtle changes in attitude that Fontaine wanted to confront. She could not resolve the feeling that something was wrong or find an answer to her question in the powwow circle. So rather than accept it, she decided to re-examine it within the framework of her art. Her art has always been a place through which she explores questions about her personal history. Now it would be a place to question her cultural practices:

They are being rigid and not letting those women be at the drum because "tradition" says so. To me that is a very subtle patriarchy. I don't think they see it, but it's there. I feel it and my challenge was to challenge that.

And challenge she did. A large drum, a heart beating from its centre, surrounded by pictures of women's breasts. No doubt it was controversial. No doubt it provoked, embarrassed and even offended many in the Aboriginal community. That was something Fontaine was prepared for. When she made *A Woman's Drum* and put it out for public dialogue and debate, she was aware there might be misinterpretation and even backlash. She expected much of it would come from the older generation and those who were staunch traditionalists.

The drum is one of the most sacred objects among many of our Nations. There are strict rules and protocol associated with the drum and for those who carry and play it. It is to be kept "clean" at all times. That includes not associating it with sexual references, like images of women's breasts.

Breasts have been turned into a sexual object by mainstream society. To bare your breasts is not considered chaste or modest. Therefore, putting a drum together with such images is far more serious than just asking questions about gender roles and equality within cultural lifestyles. It is not something that would be welcomed in a community that does not even discuss sex or anything related to it.

Some say this adversity to sex, sexuality or even sensuality is yet another result of colonization, this time from the church. Missionaries brought to our peoples the idea that anything sexual or sensual was wrong, with the exception of sex within marriage in order to reproduce. The ideal woman as a virtuous and modest virgin as opposed to an easy whore was heavily preached and ingrained within our cultures.

In addition to that, entire generations were taken to residential schools, where for many sex became not only forbidden but dirty. Since the late 1980s, there have been thousands from the residential school generation who have reported sexual abuse at the hands of the same people who preached purity. They became secrets our people were forced to keep. For many, sex came to equal shame. It is no wonder, then, that our ceremonies, indeed many of our cultural philosophies, have been separated from sex and sexuality.

Aside from the sexual/sensual connotation that might be seen in the work, Fontaine's art, perhaps for the first time, became a direct challenge

to a long-held tradition. Just suggesting that a long-held tradition might be wrong is controversial. For many "traditionalists," our ceremonies, gender roles and philosophies have remained unchanged over time. This was the accepted way of doing things. To suggest that colonialism, racism and sexism exist in our societies, much less our sacred spiritual practices, is almost taboo. Some say to just question is disrespectful and invites bad fortune into your life because it displeases the spirits. It is certainly frowned upon in many ceremonial circles. Those that do question tradition are seen as outsiders to our cultures, or they are seen as people who are misguided about what the teachings mean.

Fontaine says her art is not about connecting sexual imagery and sacred objects. In fact, it has nothing to do with sex. Nor is it meant to flaunt ancient lifestyles and traditions. *A Woman's Drum* is a manifestation of her own questions. It is her struggle to fit "that's the ways it's always been done" into a contemporary structure where women supposedly can do anything men can do.

Her challenge was and is about recognizing and pointing out the subtle contradictions within those ancient traditions, since and because of contact. She felt that *A Woman's Drum* would serve as a reminder of where we come from and how far we've come from that. It would serve to remind the Aboriginal male, indeed the entire circle, that women deserve the same respect as the drum and belonged beside it with the men, not behind the men. That was the intent of the original teaching. Fontaine has found that her drum has been a barometer of that recognition. She says upon hearing about it, women come to see it, walk around it, listen to the sound of the heartbeat, look at the breasts surrounding it, and tell her they feel as though they found their place. It confirmed what Fontaine already knew — that challenging gender roles, rules, ceremonies and even our spiritual beliefs is not off limits. Nor, she argues, is it something that is new:

> You look at Norvel Morrisseau. He broke cultural taboo. He took sacred images from Ojibwa culture and put it on canvas ... He challenged his traditions and I admire that. I think I have every right as everyone else does to challenge that ... I'm not trying to change culture, I'm just trying to put it into a contemporary context.

Fontaine is not the only Aboriginal woman to confront, challenge and change the men-only rule in ceremonies. In the early 1990s, this "tradition" of not allowing women at the drum began to be confronted.

Many asked if women gave men the drum, why couldn't they take it back? Some insisted the men were not taking care of the drum and its teachings properly. Then that rule was broken. Women picked up the drumstick and started their own drum groups. Today, women's drum groups are appearing in both the United States and Canada.

It is a change that is slowly being accepted by the powwow circle, but only, if at all, on the competition powwow circuit. For the most part, women are still not allowed to play the big drum in traditional powwows.

For Fontaine, tribal feminism does not mean defiance or rejection of values, philosophies and ceremonies that have been practised for thousands of years prior and after European contact. It is not a matter of trying or even wanting to change these Aboriginal traditions. For her, it is the same reason that more and more women are picking up the drum. It is about bringing back the balance and restoring the matriarchy: "Women are reclaiming, taking back their rightful place within our Aboriginal societies. I think it is about time to bring back that balance."

Her art is a reflection of Lita Fontaine's own journey to define and redefine who she is. This taking back of a rightful place mirrors Fontaine's own goal to re-evaluate, reframe and reclaim her Aboriginal identity, her womanhood and her story. Which, like the drum and its heartbeat, is the story of all our peoples.

NOTES

1. All quotes are drawn from my interview with Lita Fontaine, Winnipeg, November 25, 2001.

2. Boston: Beacon Press, 1986.

CHAPTER SEVEN

SHE NO SPEAKS

AND OTHER COLONIAL CONSTRUCTS

OF "THE TRADITIONAL WOMAN"

Dawn Martin-Hill

SINCE SEPTEMBER 11, 2001, people's thoughts have been affected in a variety of ways. Perceptions about Islam, the Taliban's fundamentalist regime and the nature of terrorism are shaped by the deaths that took place in New York City and Washington, DC, and by the violence of the state's response to the attacks. As a Mohawk woman residing at Six Nations, Ontario, the focus on fundamentalism and the severity of the state's response strike a chord with me because of what we struggle with in my community — traditionalism and the role of women, and the repression we have experienced at the hands of the state. As I remember the events of September 11, I am transported back in time to Oka and to other past struggles in which we fought to defend our rights articulated by the Peacemaker in our constitution. The commonalities between colonialism in Afghanistan and in Mohawk communities are strikingly similar and thought-provoking. From the margins of colonialism emerges an anger, even a hatred, for the people who oppress, exploit and commit crimes of genocide and who remain steeped in denial, or worse, benevolence.[1]

The global reality of colonialism leaves Indigenous communities shattered, fragmented and traumatized, and creates space for the growth of a desperate and perverted radicalism. Afghanistan is but one of the many places on earth where "traditionalism" has been transformed into severe oppression with the active assistance of the West. Women and children all too often become the target of these colonialist-induced regimes. In the name of resisting colonial domination, ideologies develop in which a complex multi-layered "colonial" version of traditionalism justifies the subordination of Indigenous women. The perversion of traditional beliefs strips women of their historical roles and authority, transforming their status from leaders into servants.[2] In pre-contact culture, we were regarded as Sacred Women and shared in the spiritual, economic and political authority of our societies. But under colonialism, as I discuss below, we were devalued and lost our authority and voice.

Today, Afghani women continue to survive unspeakably harsh conditions, not as Muslim women, but as women living out the consequences of Western policies of exploitation and reactionary radicalism. As a Haudenosaunne woman from the Mohawk Nation, I know something of the West's impact on Indigenous culture and tradition. Let me illustrate with an example that goes right to the heart of the matter.

In a Haudenosaunee community, a woman's daughter was raped at a party. There were witnesses, and her mother sought justice for her daughter, only to be approached by the local Peacekeepers[3] and told not to go to the police. The Peacekeepers told her that they would "handle it" and that if she went to the police, she would be a traitor to her Nation. When she inquired how they planned to deal with it, they told her that their solution was to put the perpetrator in a Sweat Lodge, "to teach him how to respect women." When she protested that this was not punishment for his crime, they told her, "It's not our way to punish, we must teach him."[4]

The mother decided to investigate our traditions that deal with sexual assault according to the Great Law, and she sought out a Clan mother who would have some authority on the matter. The Clan mother explained to her that traditionally a violator of women would have suffered severe consequences for his crime. This punishment would have been carried out by the women of the community. Afterwards, the mother shared with me and others her feeling of being terrorized, intimidated and scorned by the Peacekeepers. She was experiencing first-hand how "tradition" is used to subordinate women and to silence women.

She concluded that the Peacekeepers had perverted tradition to suit their own needs and to protect their own interests at the expense of a young woman who had been severely violated. The fragmentation of our cultures, beliefs and values as a result of colonialism has made our notions of tradition vulnerable to horizontal oppression — that is, those oppressed people who need to assume a sense of power and control do so by thwarting traditional beliefs.

The emergence of an Indigenous "traditional" woman who is silent and obedient to male authority contributes to the image of a voiceless woman whom I call She No Speaks. The stereotype of She No Speaks is a construction born from the tapestry of our colonial landscape. Her image emerged from our darkest era, similar to the infamous "end of the trail" warrior — defeated, hunched over, head down and with no future.

Who is She No Speaks? She is the woman who never questions male authority. She never reveals her experiences of being abused by the man who is up there on that stage, telling the world about the sacredness of women and the land. While New Age women — the middle-class white women who seek out Indigenous spirituality — flock to soak up the traditional man's teachings, She No Speaks serves him coffee. She is the woman who knows about sexual abuse, since it has happened to her from her earliest memories. She is quiet, she prays, she obeys, she raises the children, she stays home, she never questions or challenges domination — she is subservient.

The most powerful disseminator of this ideology of the subservient Aboriginal woman has been and continues to be the media, especially Hollywood movies. The Hollywood Indian served to justify a history that contradicted democratic values and ideas. The stereotype developed and perpetuated by the "western" genre has had enormous implications for Aboriginal women. Demeaning representations of Aboriginal women are found in all of these movies and many of them are still shown on television.[5] I question how much of that imagery Indigenous men and woman have internalized. I recently attended the Healing the Spirit World Wide Conference held in Albuquerque, New Mexico. One of the keynote speakers was Cecilia Firethunder, a Lakota women's activist, who stated that Indian women in the U.S. are the most violently raped of any ethnic group. We cannot dismiss stereotypes as harmless prejudice, and I wonder just how connected violence against Aboriginal women is to the stereotypes generated by Hollywood and the media.

Perhaps the Taliban's version of a traditional woman is extreme, but

the ideas they embrace about women have all the ingredients of the North American version of the She No Speaks traditional woman. Have we reinvented fragments of a "traditional woman" from dehumanized Eurocentric images of Indigenous women as subservient sexual objects: silent, loyal and mindless? How can we better understand the West's influence on our own Indigenous consciousness? How can we ensure that what we claim to be traditional is a tool for liberation and not a tool of oppression?

I do not claim to speak for Indigenous women, Mohawk women or for women of any other Nation. I speak from my experiences and ancestry, and from what I have observed as I travelled through many Indigenous communities over the past decade. I must emphasize that I have seen many positive roles for women in these communities, yet I have seen the existence of She No Speaks as well — not in servitude to the Creator but in servitude to dysfunctional men. These roles are a reality in our communities, even when they are not necessarily the norm.

Christianity is another European tradition that has influenced our communities and shaped the way that women have been treated. Through my travels in the Prairies, some of the ceremonies I attended started with the Pipe and the Lord's Prayer, which was accepted by the majority of the people present. The adoption of Christian practices while maintaining tradition is, in fact, common within Indigenous communities in the Americas. My goal is not to present a scholarly work proving the extent to which Christianity has influenced traditionalism. My goal is to raise awareness in Indigenous communities that we must be cognizant and mindful that our adoption of European values has influenced and shaped gender roles in many ways. Some of the results of Christianity have led to the exclusion of women from ceremonies and to exalting female servitude as "traditional." Although the cultural revitalization movement is critical to our cultural survival and to teaching our young people traditional ways, we must ensure that we are teaching and passing on traditions that are *true to us*.

DECLINING AUTHORITY
AND THE EMERGENCE OF SHE NO SPEAKS

Traditionally, in my Nation, Haudenosaunee women did not "stay home alone with children." They worked in the fields harvesting and preparing foods and clothing. Children were raised by the mother's clan

(her extended matrilineal family), usually by the elder women. The mother's brothers were also responsible for rearing the children, and her husband was expected to maintain his role and responsibilities with his mother's clan and in rearing his sister's children. This left little room for spousal or child abuse, since young families were never left in isolation. Raising children was a collective responsibility of the clan; it was not and is not our tradition to raise children in isolation. That is the Western tradition and it is based on the nuclear family, which isolates the mother from her extended family and leaves her and her children vulnerable to her husband's authority.

The legacy of missionizing, residential schools and assimilation policies have also altered the role of Haudenosaunee women, although many Haudenosaunee women will deny that their authority has been subordinated to men. The transformation of matrilineal culture into a patriarchal culture was a gradual process, which began with European contact. Ward Churchill describes the efforts of colonial agencies to indoctrinate the Western values of patriarchy, individualism and racial superiority. Residential schools and missions were the agency used to intellectually, emotionally, spiritually and psychologically entrench Western values into our children. These children who have been hurt and shaped by colonial values are today's Elders, advising us in spiritual matters and holding great authority in our communities. Churchill has commented that this type of transformation is one of the ways in which people become self-colonizing — we no longer need the priest or Indian Agent since we have learned to do the oppressing for them.[6]

Women's authority was also diminished by the undermining of the Clan mothers' status. European resistance to the authority of the Clan mothers began with Benjamin Franklin's disgust for the Iroquois men's "petticoat" government whose meddling women demanded neutrality in the War of Independence between Britain and the United States. As a result, the Americans could not rely on the Iroquois to be their firm allies.[7] Within our own communities, the loss of our Clan mothers' authority is said to have begun with the Code of Handsome Lake. This Code was introduced in the late 1700s by Handsome Lake, a Seneca prophet, and was a series of revelations that transformed Iroquoian social conduct.[8] It is important to remember that this was an era marked by the severe erosion of our land base, economic wealth, social structures of matrilineal extended families and, most significantly, our spirituality, which is the foundation of our power and our knowledge. All of these

early attempts to erode our society by the Western settlers supported patriarchy and male dominance. The traditional respect for women, which was structurally supported through the Great Law and which had established mechanisms of democracy and matrilinealism, was severely undermined. The extended family, which the Clan mother would council and guide, became fragmented through the processes of genocide and ethnocide.[9]

The Code of Handsome Lake articulated the modern role for Haudenosaunee women, a role which had already been forced upon our communities through the multiple processes involved in exerting colonial control, and it was being called our "traditional" role. Internalization of patriarchal notions of the silent subordinate woman gave rise to the She No Speaks "traditional" woman, which has been embraced by our twenty-first-century communities.

The counterpart to She No Speaks that is also being embraced by Indigenous communities is the stereotype of the "Villainous Woman." The Villainous Woman is touted as a master manipulator with a golden tongue who has malicious intent against all Native people. This stereotype was advocated by missionaries, Indian Agents and those colonial agencies that felt threatened by the leadership that Indigenous women demonstrated. Nowadays, the woman who attempts to exercise leadership in public and private capacities is often characterized as meddling and immoral. A contemporary example of how this stereotype is deployed can be found in the treatment of Roberta Jamieson, the Six Nations' first-ever female chief. Since the beginning of her tenure as chief, there have been several petitions to impeach her and one local newspaper ran cartoon depictions of her. Ms. Jamieson has been vilified by the Aboriginal and non-Aboriginal press as possessing all the characteristics of the Villainous Woman. This reaction to the modern role of a traditional woman tells us that she is not to speak, lead or have vision.

The project of decolonization today is to reclaim what has become lost in our recent history: the values, beliefs and practices of Sacred Woman. This is, in fact, quietly happening in our communities, despite the resistance of some "traditionalists" — that is, those who prefer that women maintain the role of She No Speaks. There are phenomenal Haudenosaunee women that have dedicated themselves to improving the quality of life in their communities. From building women's shelters to birthing centres, they have practised leadership and vision by talking about the issues and acting on them. Many Six Nations women have

relied on the principles of matrilineal cultures to guide their wisdom, strength and vision. I have nothing more than absolute respect for the amazing work done by Indigenous women at home and around Turtle Island.

RE-INSCRIBING SHE NO SPEAKS: SPIRITUAL PRACTICES AND THE HEALING MOVEMENT

Grassroots and government-sponsored healing movements have emerged in response to our need to heal from the intergenerational trauma that our families, communities and nations have endured over the past centuries. We are healing, but it is a path fraught with the debris of colonial domination. Indigenous institutions are facing challenging issues surrounding tradition and healing. The current "demand" for traditional knowledge is forcing Indigenous service-based institutions to provide Elders and healers.

There are many common questions we struggle with. For example, who is an authentic healer? Who is a true Indigenous spiritual leader or Elder? Elders have asked themselves whether pipes and ceremonies belong in health services and educational institutions; they have questioned whether governments' involvement in these processes damages the autonomy of spiritual leaders. Does the payment of an honorarium to a spiritual leader by a government agency prove to be a source of ownership and domination?[10] The pressure on Indigenous organizations to produce traditional cultural knowledge is creating modern challenges in Indian Country, and we must be mindful of the gender issues that it raises.

Cultural gatherings have reached peak levels as a result of the government offering funding to the healing movement through its Healing and Wellness Strategy or the Healing Foundation in Canada. This has given rise to traditional practices being offered at urban and rural healing centres. Along with the positive side of urban Aboriginal peoples being able to access culture and tradition through Friendship Centres, universities and health centres, there have been some negative results.

Power struggles are inevitable — money, power and prestige are the cornerstones of the Western wage-economy and these values have infiltrated our traditional ways of healing. The "traditional" Elders have good reason to worry about the erosion of our ceremonies and supporting structures. Too often, capitalist structures corrupt the spiritual principles of tradition, leaving them vulnerable to corruption. "Conservative" healers, Elders or spiritualists often refrain from participating in the

Healing and Wellness conferences as well as within institutions that sponsor them. Their position is nested in the view that Western institutions are not sincere in their claims of support; rather, they want to control and own tradition. The emergence of these younger, more conservative Elders, healers and spiritualists may have been a direct response to the demand for traditional health providers. So these are the two cornerstones of our present-day healing movement: the conservatives or traditionalists who want to retain more autonomy from Western patriarchal attitudes and values, and the new younger traditionalists who embrace Western patriarchy.

This demand for "tradition" may have caused the revictimization of Aboriginal women by less experienced traditional teachers, spiritual leaders and healers. In the framework of these government strategies, less trained and experienced men, both young and old, hold the same authority as a doctor or priest. As we know, through countless media reports, power has been abused by Western male authorities, doctors and priests many times. Tradition is now vulnerable since it is "outside community control."

In pre-contact times, traditions may not have been perfect. They were undoubtedly changed and fragmented through the era of relocation, assimilation, missionization and dispossession. But until quite recently, there were built-in mechanisms to ensure that traditional forms of power had checks and balances. Today, few checks and balances are in place since both the ceremonies and the spiritual leaders and Elders are removed from their supportive and informed cultural grouping. Often, the host community is not informed about the cultural tradition or protocol of the traditional guest, and for this reason the host community is vulnerable in ways that the guest's home community would not be. The mobility of traditional leaders created by the current framework of healing initiatives leaves out what our ancestors always knew needed to be kept in check: the balance of power. And for some, the seduction of power may prove too great to resist.

Although thousands of Indigenous peoples were and still are profoundly moved by and healed through the healing movement, sensitive issues of abuse have surfaced. Abuses have ranged from sexual and physical to emotional and spiritual; their scope has ranged from public humiliations by traditional teachers to sexual harassment. I have experienced this myself. At one event I organized in 1995, a respected "Elder, spiritual leader and teacher" informed me that he would be staying at

my house for the duration of the conference. When I told him that I didn't have any room he replied, "Well, I was planning on sleeping with you." Always dumbfounded when presented with such lechery, I fell all over my words and offered to pay for his hotel room. At the conference, as rebuttal to my rejecting his advances, he publicly took a few shots at my abilities to work with Elders and at my organizing skills. Even in the healing movement, saying NO has its social consequences for women and their families.

Another situation that emerged from this gathering involved an invited medicine man. He showed up as a substitute for another speaker, and a young student of mine became this man's helper. She was having a difficult time in her life and this guest soon picked up on her vulnerable state. Soon I learned that he had played with her mind in order to position himself as her saviour. His actions had meant a lot to her spiritually and I floundered in trying to caution her while not taking meaningful spiritual experiences away from her. In the end, he crossed the line, and she was forced to throw away the gifts and teachings he had given her over the course of the four-day conference because of this.

How do we deal with this? We now prepare our students by reviewing the ethical and moral conduct of traditional peoples and by keeping an open dialogue about gender roles, the logic of same-sex helpers and our own vulnerability. We must talk about it. I am sure that priests who abuse their authority and silence their victims fall into the same psychological relationship that many traditional women experience with their respected spiritual guides. The heart of this issue is the spiritual devastation a woman experiences when a trusted and respected spiritual leader abuses his position to sexually exploit her.

It is obvious throughout the healing movement that a number of individuals subscribe to the She No Speaks notion of the traditional woman. This results in the demeaning treatment of women at a time when they are attempting to rebuild their identities as Native women. I have travelled to Sundances, Unity Rides and Unity Runs and other grassroots gatherings and it is impossible not to notice the frequent scolding of women by a few male Elders, pipe carriers and teachers for any one of a number of supposed violations of "tradition" — for not wearing dresses, for being on their moon time or for not knowing their language. I have witnessed women being targeted as scapegoats when problems come up at ceremonies and have even seen the occasional removal of women from ceremonies. One incident involved a young

Nakota girl whose father was Sun Dancing. She had started her menstruation and he left her alone in a neighbouring, and hostile, white community to face possible racialized sexual violence while the rest of the family returned to the ceremony.

In many cases, such as this one, it is clear that Christianization — especially through residential schools — transformed our traditional law into Christianized traditional law, which is very rigid, punitive and demeaning towards women, for Christianization reinforces the role of She No Speaks. This transformation is often unknowingly carried out by people with good intentions who are ambitiously rediscovering their culture. In order to stop the ongoing transformation, we must acknowledge the values, principles and beliefs that formed a core psyche for children in residential schools and in missions and the tremendous effect on us of having been forced to use English as our first language.

Much of the residential school testimony expresses horrific public humiliation of girls by nuns and priests, especially of girls who were menstruating. Relationships between brothers and sisters were forbidden in residential schools, a legacy that has deeply affected the relationship between Indigenous men and women and that has shaped men's psychological attitudes towards women. These same men, now Sun Dancing and returning to Longhouses, have brought this legacy of historical trauma with them into their work as healers and spiritual leaders. Unfortunately, the public and private tensions that these men hold towards Native women result in experiences that reverberate far more powerfully for Native women than does any other abuse, because they are happening in men's and women's spiritual centre — the sacred space where we go to heal.

SHE NO SPEAKS IN THE NEW AGE MOVEMENT

The co-opting of healing initiatives by New Age middle-class white women is also a growing phenomenon, so much so that Pine Ridge Tribal Council passed legislation banning non-Natives from participating in Sun Dance ceremonies or from carrying pipes.[11] Throughout my marriage to a Lakota spiritual leader, I witnessed first-hand how middle-class white women monopolized the grassroots healing movement by controlling the spiritual leaders of the movement through money, networks and power. The poverty of many of our traditional leaders makes them utterly dependent on non-Natives in order to pursue their goals,

which can leave them highly vulnerable to the New Age movement. In turn, the New Age movement demands more "rights" with each "gift." Unfortunately for Native women, the presence of these white women within the grassroots cultural revitalization and healing movement is helping to entrench She No Speaks as the ideal traditional woman.

Many New Age women are unaware of their role in revictimizing Indigenous women. They feel it is their right to have spiritual experiences, yet they do little to relieve the suffering of the people they proclaim to admire. In my own experience, I have had white women constantly entering my home to "help" me with my work, and they have tried to appropriate my own sense of power on other occasions. At the recent Healing the Spirit World Wide Conference, for example, I visited with a Navajo Elder. Over the years, I have been helping him in a variety of ways to achieve his goals. I care for him dearly. A wealthy white woman, who has also been helping him, was there at the same time. She refused to acknowledge me or my three children who were with me and refused to demonstrate even the most basic human civilities.

My daughter really felt her dominance and reacted by asking, "Why do they always have to have such awful women around them?" I tried to explain to her how Elders wouldn't be able to fund their work without these women. However, these white women do not respect strong Indian women because we threaten them. If we were to lobby our communities as well as Indigenous professional people and organizations to assist the Elders, we would take away these women's power base. My daughter understood but lamented that we were being treated so rudely. I told her that one day these women will be just another part of our colonial history and, more importantly, she must remember to speak up at youth gatherings and describe how badly this woman made her feel. I told her how important it is that she encourage her peers to help their Elders and, in turn, this would restore our own power.

As Native women, we need to protect and nurture our traditional knowledge carriers, our homes and our children. And yet, for some of us, the consequences of challenging New Age women can be as lethal as our grandmothers standing up to an Indian Agent! When we do challenge these women, as often as not, we are treated as the Villainous Woman — not only by New Age women themselves but also by the traditional people in our own communities that they control with their resources. Many times I have witnessed New Age women revictimizing Indigenous women in their own homes, communities and, even worse,

ceremonies. As Cynthia Kasee notes, privileged non-Native women are appropriating the very tools that disadvantaged Native women need to recover from the traumas they endured.[12] Indigenous women's access to traditional healing is crucial to our families' very survival. We are the backbone of our communities and Nations, and until this is acknowledged and dealt with, our Nations will continue to struggle with these issues. Again, not all privileged white women are perpetrators of emotional, psychological or spiritual violations towards Indigenous women. Many, in fact, are dedicated to helping Indigenous women achieve their goals of healthier communities; from these women, I have only received respect.

RECLAIMING SACRED WOMAN

What is the state of Aboriginal women today? What are the "stakeholders" attempting to silence? Why should we remain silent? Who benefits from our enforced silence? Do our Nations not understand that to oppress their women is to oppress themselves? If She No Speaks could speak, what would she speak of? Perhaps the undeniable pain of experiencing a holocaust in her homeland, a holocaust the world around her denies ever happened.[13]

In light of the five hundred Native women missing in Canada today and the fifty plus women missing and murdered in Vancouver, British Columbia, it is not an exaggeration to suggest that Native women continue to be oppressed and to be seen as disposable.[14] The state turns a blind eye when it is open season on us, justifying the murders through labelling us as prostitutes, street people and addicts. We are not seen as victims of the oppressive colonial regime that institutionalizes racism and sexism against us. As Indigenous women in this country, we even lost the basic human right to raise our very own babies! Where are our Indigenous leaders on this issue? Nowhere. But we cannot continue to be silent on such devastating issues. While Aboriginal women continue to live out the residual effects of the North American holocaust, we are also seeking solutions.

Many of the experiences I have described make sense once they are positioned within the paradigm of historical trauma. The impact on our Nations' psyches is exacerbated by the mainstream's denial. The first step towards reconciliation is nested in the acceptance of our own stories, our own realities and history — a history of genocide. Aboriginal women

must begin to speak of their experiences and traditions. We must acknowledge each other as women, rather than seeking male validation. We must rebuild our relationships together as women and learn to respect one another's sacred spaces. We must respect She No Speaks traditional woman and appreciate what she has lived through: her pain, her wisdom and her endurance. She is the symbol of the Indigenous woman surviving a holocaust era. At the same time, we must attempt to revive Sacred Woman.

The promotion of women as sacred is essential for all of our Nations. One of the ways I have begun to promote Sacred Woman is through meeting with various leaders of the Unity Ride and the grassroots healing initiatives, in order to discuss the treatment of women. The leaders have been extremely co-operative with my requests. Two sacred ceremonial staffs are now carried on the Unity Ride in honour of women. One of these is carried in honour of justice for women. These are steps towards healing.

We must also realize that Aboriginal women have been participants in our own oppression. We, as women, tend to position traditional male Elders, healers or spiritual guides on a pedestal, which fuels an oppressive relationship. It is not men we must elevate, but our Creator, spirit guides and children. Our men are our equals, our partners — we should cherish one another mutually. We need to turn to our grandmothers and restore their position in our communities.

It is Aboriginal women who must begin to heal their relationships with one another — with our aunties, our extended female family and our cousins, and within our recreated families in urban centres and in our political and academic institutions. Our project must be a collective effort to restore the balance of female energy we once exercised, which was once and still can be powerful. Sacred Woman's ability to love and be loved is her power. As mothers we are not servants but teachers. Assuming our traditional roles as Sacred Women will strengthen our families, communities and Nations. Through our collective efforts in the academy, the arts, grassroots organizations and healing movements, we must construct a traditional woman to lead us through the project of true intellectual, spiritual and emotional decolonization. Sacred Woman belongs to the people who refuse to allow the principles embedded in their traditional law to be co-opted by Western ideologies. Sacred Woman has a song and a bundle, children, land, health and power.

I have begun to reveal Sacred Woman to my three daughters and my son. Her beauty, endurance, strength, perseverance and power are in their eyes now. She is not crying, she is dancing, laughing and living. These words are for those that have gone and those yet to come.

I am done. *Donato. Onen.* In peace.

NOTES

1. Ward Churchill, *A Little Matter of Genocide: Holocaust and Denial in the Americas* (Winnipeg: Arbeiter Ring Publications, 1998).

2. Paula Gunn Allen, *The Sacred Hoop: Recovering the Feminine in American Indian Traditions* (Boston: Beacon Press, 1986); Kim Anderson, *A Recognition of Being: Reconstructing Native Womanhood* (2000; reprint, Toronto: Sumach Press, 2001).

3. Peacekeepers are community members who try to maintain the peace.

4. Dawn Martin-Hill, "Aboriginal Women and Diversity." A report funded by Heritage Canada, 2000. Unpublished.

5. Rayna Green, "The Pocahontas Complex: The Image of Indian Women in American Culture," in Susan Lobo and Steve Talbot, eds., *Native American Voices: A Reader* (New York: Longman, 1998); Dawn Hill, *As Snow Before The Summer Sun* (Brantford, ON: Woodland Cultural Centre, 1992).

6. Churchill, *A Little Matter of Genocide.*

7. Ashley Montagu, ed., *The Concept of the Primitive* (London, ON: Collier-Macmillan Limited, 1968).

8. Gunn Allen, *The Sacred Hoop.*

9. Sally M. Weaver, *Making Canadian Indian Policy: the Hidden Agenda, 1968-1970* (Toronto: University of Toronto Press, 1981); Anderson, *A Recognition of Being;* Wade Davis, *Light at the Edge of The World: A Journey through the Realm of Vanishing Cultures* (Toronto: Douglas and McIntyre, 2001); Churchill, *A Little Matter of Genocide;* and Annette M. Jaimes, ed., *The State of Native America: Genocide, Colonization and Resistance* (Boston: South End Press, 1992).

10. Personal Notes, Second Annual Elders' Conference, Victoria, British Columbia, July 2002.

11. Birgil Kills Straight, Personal Communication with the author, August 15, 2001.

12. Cynthia R. Kasse, "Identity Recovery and Religious Imperialism: Native American Women and the New Age," in Judith Ochshorn and Ellen Cole, eds., *Women's*

Spirituality, Women's Lives (New York: The Haworth Press, 1995).

13. See Churchill, *A Little Matter of Genocide;* Davis, *Light at the Edge of the World;* and Jaimes, *The State of Native America.*

14. See Linda Diebel, "500 Missing Native Women," *The Toronto Star,* 30 November 2002, A1, A20–21.

APPROACHING THE FOURTH MOUNTAIN:

NATIVE WOMEN AND

THE AGEING PROCESS

Bonita Lawrence

I always think about what my grandmother said to me —
"You're being made ready for your real work."

— EDNA MANITOWABI (OJIBWAY)

· THIS ESSAY IS A SERIES of reflections about the ageing process in the lives of Native women. The impetus for writing this is personal. In the past four years I have faced a number of life transitions. On the happier side: after thirteen years of struggle, I completed a PhD and began an academic career as a professor, by then in my mid-forties. On the sadder side: completing the PhD coincided with the sudden death of my mother. While struggling with shock and grief, I was forced to come to terms with the tremendous personal cost of my academic achievement. The long years of academia had distanced me from my family, destroyed the ten-year relationship I had maintained with my partner, profoundly

challenged all of my values and destabilized how I saw my own identity. My youth was gone and my health was seriously impaired. Perhaps most devastatingly, my childbearing years had slipped away without me having taken the time to come to terms with it. Having to leave home to start my career and living in a new city without family, friends or community, I struggled to come to terms with all of these changes. Staring me in the face was the bittersweet acknowledgement that I'd achieved my goals, but at the cost of almost everything important to me.

In rebuilding my life, one problem I faced was that as an urban mixed-blood Native woman beginning a new phase of life, there was no model for who I should *be* inside. After the shock of so many changes, the only way to "find myself" again was to try and pick up where I had left off — to reconnect with the thirty-one-year-old woman that I had been before my life was overturned by the juggernaut of university life. Inside, I still felt thirty-one. Outside, however, I was forty-four, and physical signs of ageing were becoming impossible to ignore. More profound, however, were the changes from within my body — affecting my menstrual cycle, my sleep patterns and my emotions. The final step was having to undergo a hysterectomy, to deal with the health problems that I had ignored while I was a student. While I was able to keep my ovaries, so that I could continue to experience the regular ebb and flow of a menstrual cycle, I no longer bleed every month. In a way, this instantaneous and ambiguous passage from fertility into non-fertility is typical of how I have had to grapple with the sudden realization of ageing.

In approaching this subject, I have wrestled with the idea that my concerns are too individualistic. And yet, facing the changes of ageing alone in a new place, what I have felt most keenly is the absence of a Native community around me to normalize me, the absence of aunties and grandmothers to provide role models and to advise me as I come to terms with all of these changes. I began to wonder how it would have been to undergo these changes in the middle of a Native community. I wondered whether our communities have adopted the mainstream habit of dismissing ageing as individual weakness. Seeking guidance and answers to my questions, I decided to talk to Native women my age about their life changes. I also spoke with a handful of Elders, both informally and through interviews, about their lives and the personal changes they had experienced. So much has been written about white women and ageing, but very little attention to date has been paid to the changes that Native women go through as they age. Considering how

our communities are held together by older women, I am hoping that this essay will encourage older Native women to talk more openly about the various life changes they have experienced and are experiencing.

HONOURING THE REALITIES OF
OLDER NATIVE WOMEN

In talking to older Native women about their lives,[1] one thing became clear: many of us as we enter our forties are carrying massive burdens. Responsibilities for children, families and communities are taken up by women when they are young adults, and as they grow older and stronger, they take on more and more. Some of the women I spoke with had raised large families as single parents while working full-time and were now raising *their* daughters' children, to enable their daughters to move ahead in their own lives. "On the side," they were belatedly pursuing their own dreams, usually by attending university. It was clear that there wasn't much choice in the matter — older Native women carry these burdens so that their families can survive and thrive in the face of a society that does not value them.

I also spoke with other women who are not biologically mothers but who have for many years carried on the work of mothering the urban Native community through their work in social service organizations. By their mid-forties, at the height of their careers, these women had spent years making a difference within organizations dealing with homelessness, poverty, sexual abuse of children and women and addictions that have devastated the urban Native community. For some of the women I spoke with, the cost on their bodies has been high. A lack of balance and reciprocity between meeting the demands of family and community and having their own needs met by others was clearly something that many Native women have had to grapple with.

Despite the intensity of their workload, most of the women around my own age were conscious of a feeling of being at the peak of their productivity in doing what they do best. Some spoke of a sensation of nearing the culmination of their current work, which would draw this phase of their life to a close. Others were simply aware that within the next ten years or so, age would begin to factor into their lives more and more. In the face of this, some women spoke of a powerful sense of urgency and a sense of responsibility towards the tasks they had set themselves, especially in the area of cultural survival. And yet, as

important as their work was, this was not all that I wanted to speak with the women about. In the middle of my own struggles to negotiate my sexuality in an older body, I wanted to know about their personal lives.

OLDER WOMEN AND SEXUALITY

Waiting to enter a Sweat Lodge one day during a traditional gathering, I heard one older woman speaking casually to another: "Well, I managed to give up drinking and sex — but I'm finding giving up smoking a really hard one to deal with!" When I spoke to another older woman about sexuality, she commented: "I still have a mouth down there, you know, and it wants to be fed ... but you can't live on sausage all your life. You need to get over it." I wondered at these comments. Their humour and resiliency hid a possibility that terrified me: the notion that as I grew older, my sex life would draw to a close, long before I wanted it to. Did ageing mean giving up on sex?

One woman, who took years to heal after her husband left her after twenty years of marriage for a younger woman, shared valuable insights with me:

It's not that we give up on sex — it's that we give up on men. Or maybe, more to the point, it's that men give up on us. Many of them are afraid of ageing, so when they look at older women, it reminds them of their own mortality. Most of the men my age are with younger women. If I really wanted a man at this stage, I'd have to make a lot of changes, in myself and in my life, to accommodate one. But for me, it's just not worth it. I'm fine on my own.

Another woman made it clear that for her, the most important step to healing was about choosing to care for her own body, rather than somebody else's:

I'd been giving and giving, and suddenly, I didn't have any more to give. You know, the milk is gone, the well has run dry. And I felt that rejection, of being discarded, thrown out, like a dirty dishrag ... It was when I was feeling that rawness, and that emptiness and that sense of being all used up — I had to literally take myself and soak in the tub, to nurture myself. I had to mend, to baby myself. It took a long time. I'd do little things. I'd get my hair cut, or go and get my hands manicured. I would go and get a massage. Somebody had to bring me back to life. And so, I worked on the body. As I mended the physical aspect, I was able to get in touch with my sexuality —

just being sensuous again, and caring about myself. When I was by myself at home, I would do exercises — I got into yoga, and I got into listening to music that would sooth my soul. And I would walk around naked! And I started realizing that there's nothing wrong with my body. I had to relearn how to love myself, and embrace myself, and learn that I'm okay, I'm still a beautiful human being, you know. So I had to heal my body, my sexuality — and feel attractive again.

For these women, recovering their sexuality did not mean going back out and finding other relationships with men. They felt that the risks were far too high for the rewards. While in an ideal world they would not have chosen to live without sex, they were sustained in part by an acknowledgement of the power that women have, relative to men — that while men need to find their wholeness through women, because that's the source they come from, women do not need men in order to be whole.

Other women talked, more philosophically, about the changes or endings of relationships that they had experienced as they got older. One two-spirited woman described how the teachings of the Elders in her community had sustained her, by teaching her about the need for women to be resilient and independent in life, rather than automatically expecting that they would find a life relationship:

> I can remember being really young, and hearing them talk about my grandmother's sister — that she was getting a new husband. That was the nature of the conversation. And the way that it was expressed was that "some clans are not made to stay together." And at the time, I thought that just meant that "you know, Auntie's moving on, she's getting someone new." But now, forty years later, I wonder if they weren't really saying, "Don't get into this Cinderella/princess/fairytale stuff, you know, that you'll find the right guy and its gonna go on forever and forever and that kind of thing." I think what they were really saying was that "some clans mate — and have a good time — and go on with life." I think that's what they were saying.

Despite the difficulties many older Native women have faced with being able to have their sexual needs met, most of them made it clear that they saw no time in which they would be "too old" for sex. One woman described how ageing and sexuality were seen in her family:

There were four of us, sitting around a table in my auntie's kitchen on the rez — friends of mine from the city, two-spirited women. And Auntie was making us tea biscuits. My friends had been talking on the way down, and they were saying, "When do you think we don't think about sex anymore?" And they said, "Ask your auntie." Now my auntie must have been in her early seventies. I remember asking her, "Auntie, when is it in your life when you don't think about sex anymore — we're very interested in knowing?" My auntie whipped around, and she had, you know, tea biscuits in her hands, and she said, "You're gonna have to ask someone older than me about that! You better go ask your great-aunt Cora." Who was in her nineties. So we all laughed, and we all thought "Okay!"

In talking with older Native women about sex, one thing that became very clear was that in the face of hard-life experiences, their positive outlook and resiliency had a good deal to do with their ability to talk openly about sex. In most Native settings, it is very common for older women to have such open, explicit conversations about sex that most men — and younger women — are shocked and embarrassed to hear them. One woman I interviewed commented that this was one of the ways in which Native people have to heal. After the scarring of their sexuality, which so many women and men experienced in residential schools, Native communities have to re-learn how to be more open about the physical and sexual side of life, to bring back the balance to our communities. It is older women who have the humour and the honesty to speak most openly and graphically about sex — and in this respect, the openness of many Native women who are willing to talk about sexuality, especially as they move into and beyond menopause, is part of the healing that we need as a people. Being silent about our experiences of menopause, then, can have deep repercussions for our communities if it forces silence on those women with the most knowledge and experience in speaking about sexuality and other aspects of physicality.

MOVING INTO MENOPAUSE

There is a story, about a woman who was crying throughout her menopause. She cried all the time, because she knew absolutely that from then on, she would not have any children. And she hadn't had any children of her own. Her whole life, she was too busy looking

after other people's children, and after the community. So she cried in the bush all the time, all by herself. And then finally, one night, the full moon came down and sat in her arms — and that was our first hand drum.

— Jacqui LaValley (Ojibway)

The women I spoke to who were my age described a wide range of changes they were going through as they moved into their change of life. Some spoke of chronic physical exhaustion. Others described a heightened physical awareness during their periods. One woman said that she was no longer able to tolerate using electronic equipment while she was menstruating and preferred to not even talk on the telephone. She spoke of feeling a powerful energy radiating from her hands during her menstrual cycle, and compared her openness and receptivity during these times to how she had felt immediately after giving birth. Some women mentioned experiencing powerful dreams. Others were struggling with sadness about the end of their menstruation. They wondered how they would feel when they were no longer grounded by the regularity and physicality of its cycle. One older woman spoke about the grief that had accompanied her change of life, with the realization that she could no longer have any more children.

These conversations all highlighted the reality that the ending of menstruation is not simply a matter of no longer shedding monthly blood — it is only the most obvious signifier that as women we are entering a new terrain, a transition perhaps as big to us as the onset of menstruation was during our adolescence. If beginning menstruation signifies an entrance into adulthood, the end of menstruation signifies a transition into something beyond that stage. But what lies beyond? Below, one Elder described the profound changes that menopause had signified for her:

When my menopause started, it was like I had become old, eh? But what happened to me then, was a dream of giving birth. I was an old woman, giving birth! I tried to fight it, in my dream, I was holding it back ... but when a baby is being born, you can't hold it back ... so I just let out a big push, and the baby was born. And it was the moaning and the groaning that woke me up. And I woke up, and I thought, "Oh my goodness, what's going on here?" And I went to a grandmother, and she took one look at me, and said, "What's wrong, my daughter?" And with that, just because she said "my

daughter," I just broke down, and started to cry. I said, "I don't know what's wrong with me, my nerves, my emotions are just all over the place." And I told her about the dream. And she said, "Oh … you've been given a great blessing. The spirit is getting you ready, for your new work …" She said that who I gave birth to was myself. And she said, "You're gonna feel like a young girl again — you're gonna dance, and you're gonna enjoy life. You're gonna feel brand new."

Physical changes are obviously part of the process. Women spoke about either learning to live with — or learning how to manage and minimize — the cosmetic changes of ageing, such as whether or not to dye their hair. More importantly, most of the women I talked with spoke of feeling a growing need to treat their bodies with more respect. Some, after years of neglecting their health, began to take seriously the possibility of diabetes and loss of mobility through weight gain. They began changing their lifestyle so that they lost weight. The need to adapt a busy work schedule to accommodate regular exercise and proper eating became important considerations in their lives. In every sense, the women I spoke with began to acknowledge that ageing meant taking responsibility for their health in ways that had not been necessary when they were younger.

And yet the physical changes are in some way only a small part of the transition which older women spoke about. Emotional changes were also evident. One Elder commented to me that it is important for women, as they enter menopause, to lay aside old griefs, the emotional baggage of their youth:

> Those times you got wounded in your life — you should have put them down already. It's clutter! The only time we look back at those things is if we're going to share that with someone else. We do not take that baggage home with us and open it up. It's like slicing open a bag of maggots! So do not harbour those things. Throw them away! Just use them when you have to, in sharing.

She also addressed the struggles that women face around sexuality as they age. She commented that women often wrestle with strong and confused emotions of desire and loss, rebirth and renewal as they enter into their change of life:

> When I was finished with the change, and that takes a number of years — about seven years of living with the hot and the cold, and the sexual frustration. Sometimes it's like you go through a couple of

days where you just hate sex, and then all of a sudden, it's like "Oh god, I want to have it right now!" And you just live with the ebb and flow, and you watch what's happening around you. So what happens is, we become watchers. And everything we see, we take it home and process it. Everything we see and experience, we're taking it all in, and we're processing everything.

She explained that this intense struggle around emotions and sexuality is part of the training for the work of being an Elder:

That's the beginning of it — it's like watching and seeing things, and not saying anything, and not doing anything about it, right? Unless it gets out of hand, and you're there, and you're mature enough to go and do something about it. But most of the time, we just watch. And that's preparation, for listening. Because that is our job, as we get older, to listen. Everything you're doing now, and going through now — it's part of that process.

Another woman spoke of the extreme highs and lows of her experience of menopause as providing her with some of the empathy and caring needed to be a grandmother:

When you come out of that roller-coaster ride, you come out into light, and it's like a veil lifts, and you have that sense of clarity, and your vision is different. And because of your life experience, you're able to be that gentle grandmother, to have that compassion. I have learned to find my gifts, and whether it's opening your ears and eyes, and opening your senses — it's like some of those things that happen when you're out fasting, when you weaken the body. Because actually, physically, you're not as strong. I'm a little bit more fragile, in terms of bones that I've broken, so I'm afraid that I'm going to fall, or things like that, eh? So, physically you're not as strong, when you get to a certain stage. But what happens is that the spirit is stronger ... everything is heightened, eh?

TRADITIONAL TEACHINGS ABOUT MENOPAUSE

The more I spoke with different Native women, the more I began to see that maintaining balanced communities has everything to do with acknowledging the physical and sexual side of life in a healthy way. I began to wonder, if ageing and menopause are part of the wheel of life, where are the traditional teachings to give us a direction, and show us the larger framework?

One individual I spoke with described how the changes forced upon the Haudenosaunee by colonization had affected the Longhouse. She felt that the influence of the church and the difficulty in maintaining traditional practices in the face of contemporary community realities had all brought about subtle changes, so that the deeper levels of understanding about women's power and women's ceremonies and teachings regarding women's life stages and fertility could no longer be easily found in her tradition. Teachings about sexuality itself, about the importance of sexuality to life, and the notions of a peaceful sexuality embedded within concepts of two-spiritedness, had also been neglected. She concluded that all this had affected how the changing life cycles of women have been viewed in Haudenosaunee ceremonial life.

However, this woman also felt that demographic changes themselves were having a significant effect on the ability to share teachings about women's life cycles:

> Times have changed, and the pace is different — certainly, with the residential schools, the churches, girls training schools, child and family service groups, gender definitions by outsiders — all those kinds of things have certainly had an impact on us, so times have changed very quickly. But I think what's also happening to us as a whole people, is that there is such a large proportion of us that are young. And for people of my generation, when we were young, there were numbers of people we could go back to as touchstones, who were our grandmothers or aunties in the traditional sense of the word, but they're no longer around. And so those responsibilities are now ours.
>
> Now, my grandmother was very comfortably a grandmother in her sixties, seventies, eighties, into her nineties. But my sister is a grandmother in her forties — and friends of my nieces and nephews are now grandparents in their late thirties. I think that this is putting pressure on us as women, to really have lived a life and had experiences and had teachings, but at thirty, forty or fifty years old.

The other problem, she noted, has come from the fact that our grandmothers were so intent on teaching the youth what they needed to survive and change the world when they were young — there was simply no time for them to share the teachings about ageing:

> And now we're trying to sort of stretch the stories out and fill this whole medicine wheel[2] that we have. When we're really probably

only good at a couple of the stages of our life, because that's all we've experienced so far. The wheel can't turn if the other parts aren't there now, but the older women have passed on. And so now people are expecting me at my age to say to them, "What are these things, how do you do them, whatever." And the thing is, we didn't ask the elders about the teachings for older women. And I don't think they asked THEIR elders when they were young. They were all so busy getting us up as young people, and putting us on the path where we needed to go and dusting us off — so they weren't taking care of themselves. And so now they're gone, and people are asking, "What are the stories, and what are the songs, and what are the issues?" — especially around this change that we're dealing with. But you know, at eighteen or twenty, you're not asking those questions.

Many of the women that I spoke with affirmed that both in Haudenosaunee and Anishinaabe traditions, women enter into new ceremonial roles after their change of life. They begin taking part in ceremonies that they could not do while they were still in their childbearing years. These women felt that clearly there must have once been ceremonies to mark that important transition time. But the ceremonies and teachings about the transition stages have been lost.

One woman asserted that there was a great need for women to create new ceremonies to mark the change of life:

> There are the celebrations that we gave when a woman was announcing her sexuality — maybe we're supposed to give another celebration when she's re-announcing her sexuality, when she now says, "I'm changing." I wonder what would happen to us? Would we see healing moving into the next phase if we invited women to come to a feast at our house, to a celebration, that we're going to have a giveaway — because we're announcing that we're changing? Women might share those kinds of things with one another, the same way we do when we're aunties and we give the teachings to the thirteen-, fourteen- and fifteen-year-olds with the berry fast.[3] Like maybe, "Now, I'm gonna fast for the berries again. In a different way. Because now I know what I'm fasting for." It's a different kind of woman. And there was a time, when you were going to the moon lodge, when you could acknowledge those things. We don't do them anymore.

Another woman I interviewed (Eartha), who felt strongly about the need for women's ceremonies, also spoke about the dangers of modifying "tradition" and the loss of cultural identity, particularly for the youth, which might result:

> I think it's really important for us to not be confused, to know what's ours, and what isn't. To know that this is Haudenosaunee, you know, and that something else is not — it might be Ojibway, or Cree — but it is not ours. Because I think that one of the weapons of the mainstream culture in destroying us has been to confuse us, and to mix it all up in a great big pot and say "there's the Indian." And what happens is, because there is no clarity, it's a non-identity. It's like offering somebody this big cultural soup and saying "this is your identity," when it's a bit of everything — and so it's really nothing! So I think that that kind of cultural confusion, that cultural mishmash and mixing together of different kinds of Native cultures is a continuing weapon in keeping us confused about who we are.

But as the first woman pointed out, since Native communities are facing tremendous demographic change, recreating the old lost traditions in a new form is something that will inevitably have to be done:

> The women who could have taught us — they're not there anymore. I think those women looked as far as they could look for us, they dreamt as far as they could dream; they interpreted everything that they still had their hands on, and we've now arrived at that point. So, what are we going to make of this next life? What are we going to do for half of our population that's under the age of sixteen, and who in forty years will reach where we are at now. Is it going to be the same kind of celebration? Could it be? And in doing that, does this create a different kind of sisterhood, a different kind of grandmother's lodge? The question is, Do we have something else for them?

It seemed clear, in talking to women about the ageing process, that the change of life represents a powerful set of transitions in Native women's lives — and that much of our knowledge about the ceremonies that once marked this transition, in our different Nations, has been sacrificed in the interests of survival and expediency. It is clear that an ongoing dialogue is needed, as the women who are now reaching menopause share the teachings that they have managed to obtain throughout their lives. Meanwhile, the voices of the grandmothers who

have just moved through their changes, ahead of us, are giving us guidance about what immediately lies ahead.

APPROACHING THE FOURTH MOUNTAIN

A whole generation of Native women, many of whom were central in the struggles of the 1960s and 1970s to reclaim our traditions and take back our lands, are now our Elders. Especially in urban settings, this generation of women is playing a vital role in providing a source of identity and knowledge for the younger generation. One Elder described the work she now did as "her real work":

> The spiritual knowledge — it's here, and I'm able to give that to the young people, so I'm still nurturing, I'm still giving life through those teachings and those songs and those stories. The stories feed the young people — and that's the way I look at it, that's the way I feel — and so, yes, this is my work, this is my bundle. It's not just creating human beings, you know, its giving life to the people.

In the Anishinaabe tradition, these women are beginning to climb the fourth mountain, the mountain that those of us who are entering the change of life are beginning to approach. Many of us have learned to fear that mountain, and the long, hard and lonely climb that it represents. However, this woman described the tremendous emotional richness of this stage in her life:

> I've got time to enjoy life, now, and to play, which is something I've never been able to do. I've come to the realization that my grand-children are my good medicine! They are my power, they are my strength, they are my motivation, they are my extension in life. Because that's important — the first few years of a child's life, you give them good life. The first few years of my life was good life, but then by the time I was six I was sent to a residential school, and something happened there — there was that sense of something being severed, cut off — and so when I see my grandchildren, I see so much, I see how life is so precious. So ... it's the connection and the relationship that we have with them, and the responsibility that we have, in terms of passing on knowledge to those little ones ... I'm able to do things that I never had time to do, or thought I wasn't good enough, or smart enough to do. I'm free is actually what I'm saying. I'm free to do, to be and to celebrate what I have in terms of that knowledge.

I'm moving into my last hill in life. I'm just beginning to climb, because I'm not an old grandmother, I'm a young grandmother. And so I'm just moving into that last hill — and I'm looking forward to this climb. And I'm looking forward to ageing, because it is the last hill, you know, you go through all the different stages in your life, your adulthood, and now this is the last one, and I want to live a good and full life, I want to celebrate life; I want to leave good moccasin tracks for my grandchildren and my great-grandchildren. And to be remembered by them and to leave a good legacy, a beautiful legacy for them.

Older Native women carry the knowledge of the body's long journey — the joy and suffering, the transitions, contradictions and frustrations — and the knowledge and resiliency of how to survive life's crises with humour and grace. It is clear that our aunties and grandmothers have a wealth of personal knowledge to share with us as we approach our change of life. How we mark this transition will be important for our communities and for the generations of women who come after us.

NOTES

1. All of the quotes used here are taken from these interviews and discussions. One individual requested that her words be attributed to her; the rest preferred anonymity, and so the quotes are mostly unattributed.

2. The traditional teachings of many Native cultures use the concept of a "medicine wheel" as a teaching tool in a variety of ways, including as a way of understanding fundamental relationships within nature and within human society, as the philosophical framework enabling us tell a range of traditional stories, and as a way of describing the life cycle. The reference here is to the medicine wheel teachings about the stages of human life.

3. The berry fast is a traditional ceremony which a young woman enters into when she begins puberty, wherein she abstains from eating any form of berries for an entire year. Among other benefits, the berry fast teaches young women valuable lessons about self-reliance and self-control, and generally builds their self-esteem. For more information on the berry fast, see Kim Anderson, "Honouring the Blood of the People: Berry Fasting in the Twenty-first Century," in Ron F. Laliberte et al., eds., *Expressions in Canadian Native Studies* (Saskatoon: University of Saskatchewan Extension Press, 2000), 374–394.

CHAPTER NINE

ARTS AND LETTERS CLUB:

TWO-SPIRITED WOMEN ARTISTS

AND SOCIAL CHANGE

Nancy Cooper

Write, not just for your academic community, not just for the art
elite, but for a broader audience. Recycle your writing. Bring art out
of the closet ... Teach people that art tells us who we are. Art
enhances life.

— JAUNE QUICK-TO-SEE SMITH[1]

NATIVE LESBIANS, OR TWO-SPIRITED[2] WOMEN, have long been involved
with political action in practically all facets of our community. Where
there are issues to address and resolve, there are dedicated women con-
cerned with maintaining community wellness. In this chapter, I examine
how Native lesbians contribute to political action through the arts.

Art has always been a vehicle for political change, and artists have
often been the first ones brave enough to hold a mirror up to a com-
munity or a society and bring to the fore issues such as racism, the effects
of colonialism, classism and homophobia. Two-spirited artists hold up
this mirror in a variety of ways. The primary ways are through visual art

and writing. Using the saying "the personal is political" as a framework, I discuss my experiences as part of a lesbian art collective in Toronto and how I endeavour to make the issues facing two-spirited women and the larger Native community more visible through my artwork. I also discuss the writing industry, how inaccessible this industry is for Native lesbians, and how one writer, Chrystos, works to change this.

CREATING COMMUNITY

As a two-spirited artist and writer, I have many creative role models, many of whom are also two-spirited. These are women I look up to and whose art I use as my models. It has not been easy finding them. I've really had to search them out and follow their work. Women like Beth Brant, Chrystos, Beverly Little Thunder, Muriel Miguel, Lena Many Arrows, Gloria May Eshkibok, Janice Gould and Carol LaFavor, to name but a few, are all very talented artists and dedicated community activists doing important work. But they are not names you will find in an everyday context. Two-spirited women artists are not the household names they should be, considering the impact their art has had not only on the Native community but also on the mainstream community. These women and their art have affected the work that I do both artistically and politically.

For the past two years I've been involved in a Toronto-based group called the Lesbian Art Collective, which is made up of a core of six artists. Other artists join the collective during particular projects or shows. Initially, I had some reservations about joining a collective. I had viewed my artwork as a solitary pursuit and had not really spent a large amount of time thinking about the cultural or political statement I was trying to make through it. But joining the collective turned out to be a good decision — it has been a very challenging and wonderful experience. It has helped me to grow as an artist and has forced me to see that my creative journey is, at times, a very political one. Many of the artists in the collective have been making art for many years, and they have helped me to hone my skills as an artist and to think strategically about the details of showing and writing about my art, as well as teaching me the very practical and important details of researching and writing grant proposals.

ASKING QUESTIONS

The Lesbian Art Collective has held two shows in the last two years. In 2001, the 519 Community Centre, in the heart of the queer community in Toronto, hosted our show called LesImages. It was at this show that I hung my piece called *What Do the Elders Say?* I work with photography and a process called Polaroid transfer, which basically uses Polaroid film to transfer a slide image onto watercolour paper or other receptor surfaces such as handmade Japanese paper, birchbark, cotton or linen. This particular piece is made up of five pictures. Four of the pictures are of two-spirited women, but only of their torsos. Their heads are not in the pictures. The fifth picture is a photo I took of some graffiti I found in Toronto's Kensington Market that says "Smile and avoid eye contact."

What Do the Elders Say? is my response to having heard a well-respected Elder say to a large group of people that Native lesbians did not exist before contact with Europeans. This belief renders lesbian realities invisible and, I feel, undermines our rightful place in our community. First Nations traditional culture is based on the teachings, ceremonies and history held by traditional people and their Elders. This is what makes our culture unique and wonderful, because we rely on this oral history and embodied knowledge to help make our communities strong and healthy and rooted in our culture. Many of us are raised from a young age to go to the Elders for teachings and guidance. If we are having a problem in our life and need advice, we are often encouraged to go to an Elder with tobacco and ask for help. This is a very important part of our community development, not to mention our individual development as healthy human beings. This is how we learn about our responsibilities at the various stages in our lives — as individuals, as members of a family, of a community and of a nation, thus making all of these parts of the whole much stronger.

The belief that lesbians did not exist before contact is very damaging in many ways. Because Elders play such an important role in our communities, their beliefs often become our beliefs, which, before too long, can become undisputed truths. Hearing that lesbians were non-existent in pre-contact society sends the message that there is no place for two-spirited women in Native communities today. This gives rise to a lack of understanding and to homophobia, which plays itself out in a myriad of ways — from people being shut out of community gatherings, being disowned or kicked out of their communities, to harassment and even beatings. Homophobia also leads to many two-spirited people leaving their communities and congregating in larger urban centres to escape the consequences of being queer and misunderstood at home.

By making art that questions the belief that some Elders hold about Native lesbians and gays and that comments on the consequences of those beliefs, I feel that my community is forced, in a way, to come to a greater understanding about the lives and realities of lesbians and gays. I hope it makes them question their own beliefs and assumptions and learn about the roles that Native lesbians and gays played in traditional society as well as the roles we play today. This kind of art also makes a political comment on how Native lesbians are made doubly invisible by our own community and by the larger mainstream community.

The Lesbian Art Collective continues to plan for upcoming shows,

one of which includes an idea for large format art to be showcased on certain streets in Toronto during Pride Week in 2003. In this way we can continue making lesbian art visible to larger and larger numbers of people, and we can continue to challenge people's assumptions about the lives of lesbians through the art we create.

WRITING AND ACTIVISM

As Time Burns with Hatred
by Chrystos

and killing is a constant drone of horror
She begins to gather love
 into the heart of spirit
weaving, shaping, singing, willing
 these flowers into shields
She is sheltering us in our red pulse
 She is sitting with us
 and watches
She is parting this curtain of noise
 She is handing us
a brilliant bowl of aqua water
She is breathing our cares into wind
She is smoothing our earth for dancing
 Her shawl whirls
tomorrow grows longer
 cradling us
and all our fragile worlds
 are risen with light

Winter Solstice
for Nancy Cooper[3]

Chrystos is a well-known Menominee lesbian poet and political activist based in Washington State. Her poetry is known for its beautiful descriptions of love between women as well as its hard-hitting commentary on racism, homophobia and classism in society. Chrystos is one of the few two-spirited women writers who have been published. She is the author of several books of poetry and essays and her work is published

in many anthologies. She is a strong supporter of Native lesbian and gay writing and a tireless advocate for various political issues.

Her experience with the publishing industry has made her very aware of just how limited publishing opportunities are for Native lesbians. She believes that when Native people and people of colour are published, it is a very political act because it challenges the status quo and provides an opportunity for many communities to see their realities in print, often for the first time. The publishing industry is controlled, for the most part, by white men, who in turn, control what the public gets to read. It seems sometimes that there is one generic novel being published again and again. This is very similar to how the television industry is controlled. As a result, only a certain class, race and sexuality is reflected in the print and television media.

Chrystos has a "three-strike" theory about how two-spirited people get published. This means you can be queer and get published, but you must be white. Or you can be brown and get published, but you must pretend to be straight. Or you can be queer, but you can't be a woman. As a result, it is very hard to find two-spirited women's writing. In fact, it is very hard to find any writing by Native people and people of colour in mainstream bookstores in the United States and Canada. Interestingly, Chrystos sees American xenophobia wiping out any chance for writers from other countries to be sold, especially queer writers and writers of colour. If she wants to purchase books written by Canadian writers, she needs to drive up to Vancouver because this writing is not making its way across the border.

In the States and in Canada, there are no nationally known and cherished queer brown authors, with the exception of Tomson Highway here in Canada. There are certainly no women writers who are queer and brown and known nationally or internationally. The glimmer of hope in Canada is the support being given to two-spirited women's art and writing by provincial and national art councils, both having specific streams of funding for the creation of Native art and literature. The results so far have been the creation of quite a lot of Aboriginal art, two-spirited art included. Take, for example, the groundbreaking video work of a young two-spirited woman named Thirza Cuthand. Cuthand (Plains Cree/Scottish) has produced several videos, which include *Through the Looking Glass* and *Helpless Maiden Makes an "I" Statement.*

Another important arts organization is the Toronto-based Native Women in the Arts (NWIA), founded by Sandra Laronde in 1993. The

only organization of its kind in Canada, Native Women in the Arts works at supporting the development of Native women's art in all forms. In addition to hosting dance, visual arts, multimedia and literary events, NWIA has published three volumes of writing and art from Native women artists all over the world. These anthologies are entitled *In a Vast Dreaming* (1995), *Sweet Grass Grows All Around Her* (1997) and *My Home As I Remember* (2000). A fourth volume is due to be published in 2003 and will be based on the theme of heroes. This kind of support has resulted in many more two-spirited women writers and artists having their work published — some for the very first time — and read by a larger, more diverse audience. NWIA plays an important role in increasing access to publishing opportunities for two-spirited women artists.

On the whole, however, there is little financial and emotional support for two-spirited women writers, which means we are not writing as much as we could be. When we aren't published, we aren't heard, and the realities and experiences of Native lesbian lives continue to be made invisible. For example, there has never been a mainstream review of works by Janice Gould, Carol LaFavor or Chrystos, despite their wonderful and prolific writing. More people need to know about these and other two-spirited women writers.

Ask yourself, Where are the authors who are writing with me and my community in mind? Why don't I see myself reflected more in print? The issue becomes this: We may be writing for our community, but because of the lack of access to funding and publishing, our community never gets to read our work and therefore the whole community suffers. The challenge for all of us is to ask for more writing by two-spirited writers. Insist on two-spirited texts being included on high school and university reading lists. Teach Native lesbian writing if you are a teacher or adult educator. Buy more Native writing in general. Get bookstores to carry two-spirited women's writing. And, if you are a two-spirited woman writer, continue writing for yourself and your community. Know that there is an audience for your work. Know that there are others who live in isolation who will benefit from reading your words and perhaps even find the courage to write themselves and get published.

An excellent example of this ripple effect is the groundbreaking book *A Gathering of Spirit* edited by Beth Brant,[4] a two-spirited writer and grandmother from the Tyendinaga Mohawk Territory. So many women writers cite this book as a life changing event in their lives that gave them the courage to pick up a pen and start writing. I know that it

had this effect on me. I credit Beth and her book with helping me believe that what I had to say mattered and that others may want to read my words.

Envision a day when there are as many Native writers who are published as there are white writers. Continue bringing art out of the closet. Having various and different voices to choose from is an important part of the development of ourselves as individuals and as communities. The more we read, the more we understand, and the more we will accept and support the lives of others. Reading about them makes their realities less scary.

*

Art is such a powerful vehicle for social and political change, and art created by two-spirited women is no different. Art, be it writing or the visual arts, shows us who we are with all the wonderful and horrible parts showing. Two-spirited women artists and writers continue to work for change and to make space for others like us to come up behind them and carry on the creative process in a forum that is more accessible and understanding. This way, arts-based activism becomes firmly rooted in community-based activism. Artists like Chrystos and others work for change in many ways. It is up to us to search this art out, consume it and listen to the message it is conveying.

NOTES

1. Jaune Quick-to-See Smith is a Native American artist of Salish, French-Cree/Shoshone descent. This quote was taken from a poster for the conference "Beyond Survival: An International Conference of Indigenous Writers, Performing and Visual Artists," Ottawa, 1993.

2. The term two-spirited includes lesbians and gays, bisexuals, and transgendered people in the First Nations community. Each First Nations culture has different terms for queer folk and the term two-spirit is a kind of universal all-encompassing term to include all First Nations groups.

3. Unpublished poem by Chrystos. Reprinted with permission of the poet.

4. Published in 1984 by Firebrand Books.

THE HEALING POWER OF
WOMEN'S VOICES

Zainab Amadahy

"The Role Of Music in Aboriginal Social Change Movements" was the title of the workshop presentation I was asked to give a while ago. Quite a mouthful! So there I sat, in front of a group of mainly white graduate students and academics, on a very esteemed panel of musicians and Elders in Toronto's Aboriginal community. I was genuinely honoured and anxious to speak about the different roles music plays in the dominant and Aboriginal cultures.

In my presentation, I noted how various oral histories illustrate that our music, dance and other arts in pre-colonial times were not perceived of as "separate" from anything else we did. Rather, they were integrated into our daily lives, from the Sunrise Ceremonies that started the day to the Thanksgiving Prayers at sunset. Making music, drumming and dancing were ceremonies in and of themselves — spiritual acts that connected the "artist" to her own spirit, her community, her ancestors, all her relations and certainly the Creator. Music, as any other art form in our pre-colonial societies, was not a commodity to be bought, sold, owned or collected. It was not to be performed by "experts" for the "entertainment" of others. It was not something that one could listen to or produce in isolation from the rest of Our Relations.

Our music had a function. It was (and is) used in the ceremonies of every medicine society from the False Face of the *Rotinoshoni* (Iroquois Confederacy) to the *Haatali* of the *Dine* (Navajo) people. Music was a medium for passing on values, history and news. It was a form of communicating thoughts and feelings. Music required people to develop social skills and engage in community activities. Through music, we collaborated, co-operated, co-ordinated, laughed and healed.

It is noted that women in some of our Nations did not publicly sing or drum, particularly in ceremony. In the stories of many Nations, such as the Lakota and Anishinaabe, drums were initially given to women who passed them on to men to use in ceremonial and prayerful ways. In other cultures, women had a different role vis-à-vis music. In the Creation Story of the *Rotinoshoni* people, "Sky Woman first brought the drum to Earth, and as she sang and sounded her little water drum and walked around on the turtle's back, all of life began to grow and to spring up from the ground. Women have sung since the time of Creation, maybe even before."[1] Imbued with the feminine spirit, drums became instruments of peace and unity, the beat signifying the heartbeat of our Mother, the Earth, from where we all come.

The use of voice in healing is well known to all people of the Four Directions, from Buddhist chants to *Vodun* invocations. Elders tell us that vocal, drum and dance vibrations go out into the world like any other sound vibrations and that they affect everything — matter, energy, life and so on. To illustrate, think of what happens when you drop a stone into the water. The circular ripples move out from the point of impact, growing larger and changing patterns when encountering something in their path. Two stones dropped from each hand create two sets of circles, engaging and dancing with each other, forming new ripples and water patterns. Just like the ripples created by stones dropped in water, musical vibrations touch and transform us on physical as well as emotional and spiritual levels. It is argued that when we use our bodies or our instruments to create vibrations from a place of good mind and spirit, those vibrations will have "medicinal" powers.

Many Elders, cultural teachers and traditional healers maintain that specific sounds and musical notes correspond with particular organs or systems (e.g., circulatory, nervous, endocrine) in the body. Consequently, the vibrations of a particular musical note or a specific sound will help heal its corresponding organ or system. Likewise, there are sounds that can create vibrations that have negative effects, thus

causing imbalance and illness. Certainly, we all experience negative emotional reactions to certain sounds, particularly when they are loud or unexpected. Many of us can "feel" sound vibrations, for better or worse, physically as well as emotionally.

Mainstream medicine has recently accepted this notion. Over the past fifty years, music therapy has been increasingly legitimized. It is now an accredited practice in many hospitals, hospices, seniors homes and institutions across North America. Music therapists work with the physically disabled, elderly, terminally ill, developmentally delayed, brain injured, learning disabled and those recovering from post-traumatic stress disorders. Today, music therapy is used to improve cognitive, communication and social skills; improve academic skills; improve motor skills; improve attention span; manage pain; reduce stress; and improve the quality of life for institutionalized or traumatized individuals. Methods used by the music therapist include composition/lyric writing, improvisation, vocal or instrument instruction, vocal or instrument exercises and listening for discussion or imagining purposes. Thus, concepts that our ancestors understood and integrated into their daily lives are now recognized, advocated and used by a non-sectarian, science-oriented medical establishment.

Brenda MacIntyre has been singing professionally for sixteen years. Currently a producer, musician, singer and songwriter with the Toronto-based Spirit Wind, Brenda takes the notion of music as medicine further by describing the creative process as a tool of community development; a cycle that involves learning, growing, sharing and transforming oneself as well as Our Relations. To Brenda, the gift of musical talent is given for the purpose of healing; it is meant to be developed and shared:

> There's always at least one person, sometimes maybe ten or a hundred, but always at least one person [whose face] you can look at and tell that they got something really huge out of [a performance]. That circle keeps going around. I just became a part of that person's healing journey because of my music. Then it just becomes a big circle. The music is coming *because* of that. That's the way it works.
>
> In my neighbourhood, I sit with my friends and I teach them songs and drum and sing. You look up and see someone doing drugs and someone else selling them and it's like we're here on the Earth healing them, 'cause that area is really toxic right now. The men like it. The kids like it. You see in the playground everyone is happy ... they're all smiling and everybody feels good. They look up and see us

singing and you can see that it affects them in a positive way. You know it's healing the community because of the vibrations and the voices going out.

The drum is what is going to heal the Earth right now and what's going to heal the people.[2]

These are the concepts I shared with the workshop participants that day. From their comments, I concluded that they felt enlightened, uplifted and grateful for the presentation. However, there were issues I did not discuss, including some of the stories, feelings and barriers that Aboriginal women experience today in our own communities when we engage in the ceremony of making music.

For example, I recently received a flyer from a Toronto community centre calling for "Aboriginal singers & dancers" and offering a free, all-expense paid trip to India to promote a new airline. The airline was footing the bill. When I called to get the details, a paid staff person clearly stated they were not looking for women singers, only women powwow dancers. "Not even Iroquois water drum musicians? Hand drummers?" I asked. No, they were not looking for hand drummers of any gender. He did not seem to know what an Iroquois water drum was.

This example illustrates several attitudes that Aboriginal women encounter in our communities. These include (1) the denial of a woman's need to sing, (2) a lack of understanding of how women's music affects the community's well-being, (3) an emphasis on powwow culture to the exclusion of others, and (4) a collaboration in promoting stereotypes of Aboriginal culture or people. The question is, How prevalent are such attitudes in our communities and how are they affecting us?

HONOURING WOMEN

I was honoured to be the member of a group that made history as the first women's drum to host a fifteen-year-old annual gathering in Toronto. And I remain honoured to have been a part of that, even though I was told by one of the organizers that getting approval for us to be paid as much as the invited male drums was a "fight." In addition, during the gathering, we had to remind organizers about our traditional tobacco offering on the last day of the gathering and were told they had run out; a contingent of Elders, male and female alike, overturned an agreement we had with an invited male drum group to share an equal

number of songs during the opening ceremony; and the MC continually fumbled over our name when introducing us, often confusing us with one of the male drums. Throughout the weekend, I heard male Elders chastise women for not wearing skirts or for not respecting feathers on their regalia and dispensing assorted other "teachings" on "appropriate" behaviour. The irony of all this was that the theme of the gathering was "Honouring Women."

I want to convey to the reader that, although I have had my moments of anger (a natural emotion the Creator gave us), I am not angry as I write these words. Nor do I write from a perspective that does not recognize the value of gender balance and gender roles. Rather, I am saddened.

I often had to ask myself during this gathering why, within the theme of "Honouring Women," several Elders and cultural teachers focused on condemning male violence almost to the exclusion of addressing other expressions of power imbalances we have learned from European socialization. The summarized message of "it's not traditional for men to brutalize women" is certainly not one with which I would disagree. However, it hardly covers the entire spectrum of the spirit of "honouring women."

Cultural activities in our communities illustrate how current attitudes and concepts of gender roles have been corrupted since colonization. Music, drumming and voice are powerful medicinal tools. This is evidenced by the experiences of men who speak eloquently, poignantly and often on how "hearing the drum" changed their lives. Terry Sakoieta Widrick, male Mohawk Elder, cultural teacher and musician, says, "Both singing and drumming have been inseparable in allowing me to continuously connect to the life energies and creative forces." Sonny McDow of the Mi'kmaq Nation plays the big drum; he told me, "Drumming opened my eyes. Before, I used to drink and party all the time. But I didn't want my boy to see his dad as a drunk. So I used to stand behind the drum and sing a bit. Then I sat in on a practice one time. That got me started. [Drumming] keeps me clean — away from alcohol and drugs." [3]

Singing, drumming and dance form a significant component of "cultural programming" in community centres and activities across Turtle Island. Male drummers are rightly recognized at powwows, nationally and internationally, as spiritual role models and purveyors of cultural history and values, as well as creative artists. Women who drum

and sing traditional music are equally empowered by the experience. The following comments come from women who sing and use hand drums in Toronto's Aboriginal community:

> [Drumming] has really accelerated my healing journey. Sometimes there's a lot of feeling I just can't articulate into words ... I pick up my drum and start drumming and I just feel good ... I found an empowerment within myself in connecting my heart with my voice.

<div align="center">*</div>

> There's a camaraderie that goes along with [drumming]. You meet other women. You're sitting there drumming and laughing and sharing stories and feeling good. It really brings our women to-gether and it turns into a support thing as well. It's bringing the community back together. That's how powerful a drum is.

<div align="center">*</div>

> Drumming brought me home, 'cause I didn't know anything about my background. It [gave me] confidence in myself ... to be able to play an instrument as well as use my voice.

As an adoptee, Brenda MacIntyre learned of her Aboriginal heritage as an adult. It was then that she was introduced to traditional music. Brenda contrasts the experience of singing traditional music with popular forms:

> Musically, I've grown as a person since I started singing traditional music. I could do rap and reggae and folk, but I never knew how to do First Nations music. When we sing it takes a lot of vocal power, more than to do the R&B stuff, which I thought was complex at the time. I listen to Aretha Franklin and I think "wow," but the truth is I think she'd have a hard time singing our songs. There's a lot of breath control involved. There's a huge spiritual element involved. It's not like an artist singing something that someone else wrote. It's like a traditional song that you feel in your bones and your blood, that has always been there and you sing it from that perspective and that sense of *knowing,* so you sing it from your spirit and not from a piece of paper where you have to pretend to feel what the song is saying. So there's that piece of the music that connects you to your ancestors.

Clearly, Aboriginal music today, as in pre-colonial times, is crucial to the physical, mental, emotional and spiritual well-being of women, children, men, families, communities and the Earth. However, there is concern about whether this is recognized in our communities and whether the concept of gender balance, one of our most treasured values, is respected in the musical arena. Below, Aboriginal women in Toronto describe experiences where contradictory hand-drum teachings tend to discourage and exclude women's musical participation.

One teaching I find particularly abusive, given to me by a man, is that a woman shouldn't tie [make] her own drum or she will "tie her life up in time." He gave an example of a woman who made a drum and then her son drowned.

*

When I first started learning about my heritage I didn't have any idea, so I just did what I was told. I was given rigid teachings back then: you're not allowed to be in the circle when you're on your moon [during menstruation], you have to be this far apart from the circle, or you can't touch sweetgrass but you can touch sage, or you have to put cedar in your shoes … there's all these little rules and it's like I don't know whose rules they are. Everyone has their own way of doing it. For me what resonates is not always the same. I might enter a circle and feel like leaving right away because I'm not sure how they do things. It's limiting.

*

Some teachings say that women shouldn't drum on their moon time. Yet they say women are very powerful at that time. So there's a bit of a conflict there. One of the teachings I got about my drum is that it's my Grandmother — a Grandmother Drum. It used to be when a woman was on her moon time that she would go to the Moon Lodge and the Grandmothers would look after her. They would feed her, rub her back and give her teachings on womanhood. Also the drum brings healing. Now, if a woman is having a hard time on her moon — maybe her lower back is sore or she has cramps — for her to be denied the healing energy that the drum can bring is ludicrous. It's denying somebody a healing tool. Our Grandmothers help us during that time. Why would we not turn to our Grandmother in a time of need?

While there are different practices and beliefs among nations, geographic regions and medicine societies, it is clear that the diversity of teachings around women's hand drumming is being experienced by learners as confusing and discouraging. Diversity among our people is something to be acknowledged, appreciated and celebrated. The following Cherokee teaching, which is paraphrased here, illustrates the beauty and necessity of diversity:

> Mother Earth and all her children teach us that diversity is necessary to our health and well-being. You do not see the trees insisting that they all bear the same fruit. You do not see the fish declaring war against those who do not swim. You do not see corn blocking the growth of squash and beans. What one plant puts into the soil, another takes out. What one creature leaves as waste, another considers food. Even death and decay serve to nurture new life. Every one of Mother Earth's children co-operates so that the family survives.[4]

Intolerance of difference is not part of the Aboriginal world view. Unfortunately, the manner in which diverse practices around women's hand-drumming is communicated often leaves women feeling excluded, disrespected and afraid of committing a cultural faux pas.

The emphasis on powwow culture has a similar impact, since men exclusively play powwow drums in most cultures. Below, women musicians from the Toronto community comment:

> We sang during the break [at powwow] and the men drummers, who usually show their support by hitting their sticks on the big drum, were absolutely still. The people loved it. But it was like the men were cheesed-off that we stole their thunder or something.

<div align="center">*</div>

> We were at a powwow where all the men on the big drums were singing. One of the women in our drum group knew the MC and asked if we could sing on the break. He said, "Yeah, right after this song." Well, they finished that song and another and another, totally not caring that we were just standing there waiting.

<div align="center">*</div>

> I was singing with a women's singing society on an Iroquois water drum. Singing societies are non-profit and we put what money we

make back into the community. Anyway, we were invited to sing at this powwow a few years ago. We dressed up in regalia, packed up our kids and drove in from wherever we were — some of us lived a couple hours away. We weren't doing it for the money, because we weren't getting paid. Not like the men on the big drum. They get paid. Anyway, we waited around all day and the MC never let us sing. He said, "Women don't sing at powwows." In fact, when he announced a hand-drumming contest, he specified that it was for "men only."

Not only do some of the attitudes, teachings and practices in our Aboriginal communities discourage women's participation in music, they also negate, deny and discourage community support for women's voices and therefore deprive the community of another "healing" tool or source of community development.

"Women are the Strength of the Nation"

It is often repeated in our communities, that "Women are the Strength of the Nation." Many of our Elders speak of women being the foundation of our families and communities. They talk of the importance of women's traditional roles such as nurturing children, cultivating food and providing leadership. The truth is, it doesn't take a special spiritual connection to figure out that if one woman in a family is ill — whether mother, grandmother or daughter — it will affect all other family members and, since we are all connected, the community.

We learn about the significance of women's roles in our communities through our oral histories, such as the Great Law of Peace of the *Rotinoshoni* people. In all accounts, Hiawatha grieved over the greatest loss a man could experience: the death of his daughters. The oral stories do not speak to whether Hiawatha even had sons, as though the matter was of little relevance. We are told the Peacemaker spoke for the Creator in handing down a governing structure that gave the Clan Mothers significant political, economic and social power.

This essay is not an argument for reversing power relationships among men and women or for eliminating all gender roles. However, I put forward the observation that some men and women in our communities have not appreciated the inherent power of women and the notion of gender balance. We underestimate the importance women held in a social structure that depended on responsibilities mandated by kinship,

a social structure that served our ancestors well for millennia. With the coming of Europeans, women were forced out of our traditional roles as Clan Mothers who chose the male leadership, decided (with the help of Grandmother Moon) on the timing of the ceremonies that structured our annual life cycles, and (with the support of the men in our lives) carried out responsibilities essential to the well-being of the community. Our Elders teach that gender balance existed to the benefit of all in precolonial societies. Women (and men, through their own roles) knew and wielded power successfully in our cultures, not just for personal aggrandizement but also on behalf of our children, youth and Elders.

Through official government policies and actions, such as the *Indian Act*, Aboriginal women were systematically disempowered. As Kim Anderson illustrates in *A Recognition of Being: Reconstructing Native Womanhood*, Aboriginal women were a particular target of disempowerment as a prerequisite to ensuring the disintegration of our social structures and gaining access to our lands. Yet, as Sharon Menow, a Cree activist who has been hand-drumming for three years, puts it:

> The government oppressed us and now our own men are taking over … Now men are in powerful positions of being healers or counsellors or chiefs or whatever and they're afraid. They don't want the women to be strong because they think it threatens their position.

Brenda MacIntyre provides another perspective on the issue of gender imbalance:

> Women have the inherent connection with the Earth and men don't. So, I think what happens is they try to take [music] over because they don't have that and it's hard for them to get it. The way society is today, men are supposed to be dominant and controlling, which is not their natural role. Roles are all over the place right now. It's really confusing, but it needs to settle down.

Many agree that gender imbalance is a significant barrier to restoring health to our communities. That is not to say that men and women must take on the same roles in every aspect of life. Nor is it meant as a judgement about what roles men and women must assume. As Anderson notes, the pre-contact tasks that men and women performed were as fluid and interchangeable as need dictated.[5] Women hunted when necessary (oral histories record female warriors, though not many), and men looked after children and participated in agricultural activities if the situation warranted.

Today, women are welcomed into sweat lodges, vision quest ceremonies and Iroquois Singing Societies, even though our female ancestors did not participate in these activities. Though there are still some detractors, this opening of ceremonies and activities to women is widely recognized and accepted as a necessary change to recovering the more "traditional" ways of life in the interest of healing our communities and restoring balance after centuries of being brutalized by colonization, genocide and assimilation. This challenges the notion that "tradition" is a set of practices that is frozen in time, static and unyielding. Even our oral histories speak of traditions changing over time. The entire political and economic structure of the nations of the *Rotinoshoni* was transformed with the coming of the Peacemaker and the establishment of the Great Law roughly a thousand years ago. At that time, women started to assume the role of appointing *Royaneh* (male leadership) and holding them accountable, removing them when they failed to serve the community's needs. Our societies were not static. We learned, grew and evolved like any other people.

Because tradition is alive, evolving and flexible, it enables us to survive and flourish as a people. Cultural and musical expressions need to be a part of this process. As Terry Sakoieta Widrick reminds us, "All music should be supported, since it is music for the people and the created order." Sonny McDow echoes his sentiments: "Out west they have women who sit at the big drum and women's big drum groups. I notice the Iroquois women and men both play the water drum and sing together and there's a balance — high voices, low voices sounding together. It could be the same with the big drum."

The following changes advocated by women in our community are offered with a vision of restoring balance and health:

> Women have to stand up and bring this to [men's] attention. We should be uniting, gathering together, supporting one another and discussing how we should approach our organizations to bring more awareness. We should question why there is no balance, in a good way, so they can come to the answers themselves.

<div align="center">*</div>

> Women need to realize we can be allies. It doesn't have to be a big competition. We need to come together as women and hold onto the drum and get the message out that Mother Earth wants to speak.

<div align="center">*</div>

It would be really interesting to have men and women drumming together. It would be a good teaching for both the men and the women. The men would be able to pick up the vibrations that we send out as women and we would also be able to pick that up from them. It would be a really interesting balance — really healing for all of us.

To conclude, I submit that the notion of gender balance is an efficient, productive and powerful ideology that will effectively serve our communities' needs across Turtle Island (as it did for centuries prior to European contact). Striving for such balance in the arenas of cultural expression is completely consistent with other efforts in this regard. While it is no one's responsibility to tell another what her or his roles should be as we redefine ourselves and restructure our communities in the aftermath of surviving colonization, genocide and assimilation, we can ask questions about the values behind the teachings offered to us by our leadership. Let us hope that we all are honoured with opportunities to recognize, encourage and support the development of women's music with as much vigour as we support the recovery of our languages, ceremonies and men's music.

Clearly, many Aboriginal women feel unsupported and discouraged, yet it is to our credit that more women than ever are picking up the drum. This is a wonderful time to be an Aboriginal musician, singer and dancer. As Sharon Menow puts it, our hopes and intentions can shape a future where "men's and women's drums sounding together will resonate healing throughout the community."

NOTES

1. Terry Sakoieta Widrick, Mohawk Elder, musician and cultural teacher, e-mail to author, n.d. Subsequent quotes are drawn from this correspondence.

2. Brenda MacIntyre, interview with author, Toronto, n.d. Other women musicians were also recorded during this interview; their quotes in this essay are drawn from this interview.

3. Sonny McDow, phone interview with author, n.d.

4. The words of this teaching are mine and are based on varied oral teachings and stories.

5. Kim Anderson, *A Recognition of Being: Reconstructing Native Womanhood* (2000; reprint, Toronto: Sumach Press, 2001).

ABORIGINAL WOMEN'S ACTION NETWORK

Fay Blaney

THE OPPRESSION THAT Aboriginal women in Canada face on a daily basis has, until fairly recently, resulted in their lack of access to both formal and informal education and, therefore, to their very limited production of knowledge. This is one of the barriers that prevent many Aboriginal women from finding our voices and including our perspectives in the decolonization struggle. Plenty of non-Aboriginal researchers from a variety of disciplines have offered explanations for the marginal status of Aboriginal women. Yet despite these numerous scholarly accounts, the victimization of the majority of Aboriginal women and children, coupled with the normalized "cover up" and silencing, continues to encode our lives.

The work of the Aboriginal Women's Action Network (AWAN) has taken the production of knowledge from a grassroots Aboriginal

women's perspective as a starting point for ending our oppression. This chapter provides a brief history of AWAN and the many progressive actions its members have taken. The primary focus is on the women who have participated in AWAN's actions and projects.

AWAN is about Aboriginal women finding a voice. Through our activism, each of us has been exposed to new means and new opportunities to help us find our voices. AWAN women firmly believe that this process is key to our emancipation from the generations of suffering that Aboriginal women have endured. This chapter is dedicated to these women and to the women who are inspired to act as they read about these women. This is especially so for all of our daughters, our granddaughters and our great-granddaughters.

ESTABLISHING THE ABORIGINAL WOMEN'S ACTION NETWORK (AWAN)

AWAN was founded in November 1995 in response to the firing of several women from various Aboriginal organizations in Vancouver. One woman was fired because of the questions she was asking about the organization's constitutional requirement to hold elections. Others were fired because they signed certification forms to unionize. Some of the firings took place to open up positions for family members or friends of the employer. What began as a weekly drop-in and support group for these women at the Vancouver Status of Women office became a network of women involved with social responsibility and political action.

Following our inception, we held a daylong visioning workshop to reflect on who we were and what we wanted to do. What was clear to us was the magnitude of the forces at work to silence Aboriginal women. Equally clear was our strength and conviction to resist that silencing. We came up with our logo[1] at that meeting, bringing our vision to life. We envisioned ourselves as salmon swimming upstream, against the flow of the river and with a determination to create new life and to renew hope for our future generations. Our logo is an image of the salmon in the circle of life, transforming into a woman.

As Aboriginal women, we continue to face a colonial system that is deeply patriarchal. Because of this, and because our own communities have been affected by generations of enforced patriarchy, AWAN has concentrated much of our attention and work on increasing our understanding of Aboriginal feminism.[2] While we struggle for our

Aboriginal rights, we also work to make visible the "internal oppression" against women within our communities. For example, many of our women continue to be affected by their disenfranchisement as a result of section 12(1)(b)[3] of the *Indian Act*. Many of our modern-day political leaders and systems have adopted patriarchal ways. The Native Women's Association of Canada has identified these problems, stating that our matriarchal forms of government and matrilineal ways have been forgotten or abandoned and that patriarchy is so ingrained in our communities that it is now seen as a "traditional trait."[4] Resisting this ingrained sexism is central to the work of the Aboriginal Women's Action Network.

AWAN women are mothers, grandmothers, aunties, educators, anti-violence workers, academics, students and others with full schedules. The range of socio-economic status, education and life experience among AWAN members is varied. Because some of us have been raised in our First Nations and Métis homelands, there is a strong connection to our cultures and communities. Some of our members are of mixed ancestry and/or have grown up displaced in urban centres and struggle to find a sense of culture and community. In addition to cultural identity issues, we have examined and reflected on same-sex issues with several of our two-spirited members. Our diversity has, at times, resulted in our near implosion. At the same time, however, it has created such an enriching worldview that we try to share this model with other Aboriginal and non-Aboriginal women's communities.[5] Part of that worldview involves teaching and learning from one another, and using collective and consensus-building processes. While this is a difficult path to follow, it has been invaluable in the sharing of skills, knowledge and motivation among AWAN women.

The skills and experiences that we have acquired as a result of our volunteer work in AWAN have been an integral part of finding our voice. Within our interactions and organizing efforts, we have learned such skills as researching, writing, interviewing and distributing press releases. AWAN members have worked through the challenges of negotiating with Aboriginal agencies and non-Aboriginal allies on issues that are important to us. We have written submissions and briefs to various government ministries. We have met with ministers and government committees at the federal and provincial levels, including the annual Justice Consultations of the Canadian Association of Sexual Assault Centres, the Status of Women Canada's Aboriginal Women's Roundtable,

the (now defunct) BC Minister for Women's Equality[6] and the Attorney General. Our members are frequently found in demonstrations against government policies or organizing against cuts that negatively impact Aboriginal women. Often, when our schedules permit, our members can be counted on to attend court hearings to support Aboriginal women in cases of violence or child apprehension.

AWAN members sit on various boards, committees and community organizations, including unions, anti-violence agencies, women's groups, Friendship Centres and anti-poverty groups. Since 1996, there have been four AWAN women on the executive of the National Action Committee on the Status of Women (NAC). Participation in the largest national women's organization has been key in our bid to identify our own Aboriginal form of feminism as it applies to our struggles. These mutually beneficial involvements have been extremely enriching as they have provided us with stronger strategies for creating a more feminist and just society. These strategies have permitted us to carry out anti-racism work and to deliver our feminist and decolonization message to various cabinet ministers, social justice-seeking groups and the Aboriginal leadership. As well, these groups have offered immense support in such areas as networking, public relations, fundraising and in-kind donations.

Without this networking on a national level, we would be far less effective in dealing with the constant pressures and problems that besiege our communities. In one instance, a young woman approached us for support because her baby had been apprehended at birth. In a few short days, we managed to organize a lunchtime rally that brought out over two hundred people, including government officials. In addition, we uncovered the false allegations of medical professionals and social workers that this young mother was an active addict who had been "unco-operative during labour."[7] Similarly, we organized a vigil for Pamela George outside the Vancouver courthouse while the sentencing of the murderers was taking place in Regina.[8] And we worked collaboratively with NAC to bring Aboriginal women from the communities to the 2002 Annual General Meeting of the Assembly of First Nations (AFN) in Vancouver to lobby on issues of importance to Aboriginal women. We also brought in speakers from Saskatchewan and Quebec who generated media attention on the issues of Bill C-31 and prison rights for Aboriginal women, and who helped us draft a fact sheet to circulate among AFN delegates.

Ending the Silence Around
Violence Against Aboriginal Women

In the early 1990s, in the face of the large numbers of Aboriginal women who had died violent deaths in Vancouver's downtown eastside, family members began an annual march in their honour. It has become known as the Valentine's Day Memorial March. Without this event, all there would be to mark the violence that these Aboriginal women faced would be the ten-minute funerals that the Ministry of Social Services provides for them. Since we have become established as a network, AWAN has actively participated in this event. We find our voice through defending the interests of women in our families who are trapped in that lifestyle. For many of us, our own "inner child" knows intimately what that world is.

In March 2002, the remains of the bodies of fifteen women, the majority of them Aboriginal, were discovered on a pig farm in Port Coquitlam, BC, owned by Robert William Pickton. Pickton has been charged with fifteen counts of murder and is a suspect in the disappearance of fifty other women, mostly Aboriginal, who have been vanishing from the streets of downtown Vancouver since the 1970s.[9] Shortly after the story broke on the "Missing Women," AWAN put on a series of workshops and spiritual ceremonies for the Aboriginal women from the downtown eastside. Our primary objective was to create a safe space in which women could speak openly and freely — and speak they did!

At the same time that we were attempting to address the horror of the violence that we face, the Aboriginal Victim Services Program (operating under the umbrella of the Vancouver Police Department) openly opposed our series of workshops. This does not do much to increase our faith in the system. We had already heard about the discrimination of both the Aboriginal and non-Aboriginal policing systems from the women who participated in the "Journey for Justice" project. During this project, we held focus groups with women along the Fraser River on the subject of alternative justice and heard many stories about police misconduct and negligence, as described by these participants:

> RCMP, Tribal police and other services have different judgments and beliefs about you. When children are apprehended, a lot of women are not allowed to express themselves if it doesn't conform to social workers. [For example,] if they are angry they get anger management, frustration around poverty is seen as a budgeting issue so

they have to be silent and jump through hoops.

*

Police said I was drinking and partying because my abuser hit me over the head with a full bottle of beer so I smelled like a brewery — drunken Indian again.

*

My son was brutalized last week. They left their footprints on his back. I told my son they should have charged the officers. They bust all these people on the street and take all their money. I think the police take the drugs and alcohol themselves. My nephew was beaten last year real bad and it was terrible – he was just stumbling home because he didn't take the bus. They didn't get away with it, he got help from the UNN [United Native Nations]. It's still going on, my son getting it for nothing — it makes me so upset. It happened to a young woman, she had kids too and they pulled her pants down until she was naked in front of everyone at the bar.[10]

AWAN women saw the need for workshops that would allow the women to speak. If a huge number of participants is a measure of success, we did an outstanding job on this project.

The divisions among us are an ongoing reality as we organize around the violence we face. For example, each year during the Valentine's Day Memorial March, issues pertaining to class, race and gender are debated during the organizing of the event. Class issues come up when our right to participate in the organizing of a downtown east-side event is brought into question. This has to do with "turf wars" and issues of representation. We acknowledge that AWAN women do not meet the criteria of residing in the downtown eastside, but we feel we have a place because of our common history of colonialism.

In a different way, organizing for the march creates stress around race because we need to draw upon the leadership and spiritual practices of Aboriginal women while maintaining the active participation of non-Aboriginal women in the march. Race tensions can escalate. For example, during one meeting, a non-Aboriginal woman resorted to saying, "We bought this land fair and square." Our challenge is to continue bringing new Aboriginal women into a process in which they are subjected to these kinds of comments. And while the utterance of these

words causes us to shudder, we are mindful of the insidious lateral violence that pits poor non-Aboriginal women against us.

There are additional tensions involved with the participation of Aboriginal men in organizing the Memorial March. The colonial process has had a very different impact on Aboriginal women than it has on Aboriginal men. Present-day systemic and institutionalized patriarchy ensures that the privileged male status in mainstream Canadian society is mirrored in Aboriginal communities. Men have considerable power in the political, economic and social spheres, and this enables violence against women and children. Many of us would argue that those masculine sites of power and influence are uncaring when it comes to violence and child apprehension in the lives of Aboriginal women, many of whom end up dead or disappeared in the mean streets of many urban centres across this country. Yet Aboriginal men continue to demand involvement on the organizing committee and have deliberately scheduled their own separate activities at the same time as the annual Memorial March.

Other divisions arose during our workshops to address the issue of the missing women. Some Aboriginal groups, as well as the media, were intent on conveying a single-minded message that the culprit responsible for the disappearances of these women had been apprehended, and that it was now in the competent hands of the police. Our view, which we declared at a press conference, was that the police had mismanaged these cases for several years and they therefore had to be kept under close scrutiny. A Member of Parliament registered a complaint to the Police Complaints Commissioner on the handling of the "missing women" file, but the Commissioner chose to suppress this complaint. When the Commissioner came under pressure to resign, an Aboriginal leader from the downtown eastside came to his aid. This leader is quoted in the *Vancouver Sun* as stating that the Commissioner had acted appropriately despite his dismal record in cases involving Aboriginal people.[11] Such circumstances can clearly be described as "neo-colonial," when Aboriginal and non-Aboriginal authority figures collude against powerless Aboriginal people.

Another neo-colonial characteristic that we saw developing was the way the issue of the "missing women" was framed. The focus on the "families of the missing women" was detracting from a more critical aspect, namely, that this is an issue about "male violence against women." Having Aboriginal male relatives of the "missing women" as

spokespersons is akin to having non-Aboriginal colonials delegated as our spokespersons. Nothing has changed for the women who continue to face the same reality in the downtown eastside, in spite of the police investigation into the crimes that are related to some of the missing women. In our workshops, women named instances of family members who had not even been declared missing and therefore were not under the purview of the police. Compounding this life-and-death situation are the harmful and misguided "deficit-reduction" policies of the provincial Liberal government towards social services, which are implemented at the expense of these women.

We acknowledge that these divisions of class, race, gender and ongoing colonialism that exist among us are not accidental and should not be glossed over. They are crucial to the manner in which Aboriginal women have been oppressed and silenced for so long. For this reason, how we do what we do is in many ways as important as the concrete things we have managed to accomplish.

GRASSROOTS EMPOWERMENT THROUGH RESEARCH

Through our organizing, we have learned that bringing about social change among severely oppressed people requires that we learn new ways of relating to one another. We know that many of us are familiar with the work of Brazilian educator Paulo Friere, and so we brought his methods of popular education into our AWAN work. Another educator, Rita Bouvier, also articulates critical pedagogy in the ways we apply it. She acknowledges the important role of each individual and the necessity for honest communication and co-operation in relationships, decision-making and conflict resolution. She writes, "Above all, community education development requires a willingness to accept change."[12]

Change is precisely what we aim for. We have come to recognize that there is an urgent need for a deeper level of analysis and goal setting to end sexism and neo-colonialism, both within Aboriginal communities and in the larger society. For this reason, we have adopted a form of "research for social change" known as participatory action research. This approach to our projects is our way of working towards attitudinal changes around sexism, racism and poor-bashing, as well as consciousness-raising around the concepts of patriarchy, colonialism and misogyny. Central to this process is the privileging of the voices of Aboriginal women who are forced into the margins of Aboriginal and Canadian society. Feminist and Indigenous research methodologies,

along with critical theory, have also been very informative in this process.[13]

A critical aspect of participatory action research is the equal value that is placed on process and end results. For example, as "insider" researchers, we break down the separations between our research subjects and ourselves. Outside researchers normally have goals and objectives that are external to the community, namely, the accumulation of knowledge for their own benefit. AWAN is able to identify our commonalities as Aboriginal women, and hence, we can work together through social action and networking to improve conditions in all of our lives.

Like the women of Tobique, New Brunswick,[14] on the other side of the country, AWAN identified Bill C-31 and violence as the most pressing issues facing all Aboriginal women. Our organizing around the murders of Aboriginal women had already made it very clear to us that this was the level of violence we faced. During our work, however, the issue of Bill C-31 continued to come up. At one point, a young woman came to our meeting and shared her experiences of being denied her rights by her band. Her mother had been reinstated under Bill C-31, but the young woman had not grown up in her community. Each time this young woman tried to access education funding, she felt ignored. We knew of other situations in which students' funding was cut halfway through their school semester, without any explanation from chief and council and without any recourse being available to the students. Hence, we began working towards obtaining research funding for both of these issues. We began our Bill C-31 project in 1998 and completed it in December 1999. Our second project, "Aboriginal Women, Violence and the Law," overlapped with the Bill C-31 project, beginning in the summer of 1999 and concluding in 2001.

AWAN's goal for each of these projects was to prioritize inclusive decision-making. For the Bill C-31 project, we brought grassroots Aboriginal women together from all parts of the province to identify the research focus. These same women conducted interviews in their own communities. Although a different process was followed in the "Aboriginal Women, Violence and the Law" project, a great deal of effort was made to bring in women from the grassroots level to participate in the policy analysis process on alternative justice issues. At the same time that we AWAN women educated ourselves on federal and provincial anti-violence policies and legislation, we also invited other women to join us

in a series of sixteen workshops. During the "Journey for Justice" project, we held focus groups along the Fraser River as a way of seeking out the voices of women on issues of alternative justice models. Once a draft report was prepared, focus group participants and other women were once again invited to a provincial symposium. The magnitude of each of these projects has been daunting, but we have placed the spotlight on some very insightful and capable Aboriginal women who otherwise would not have been heard.

Our lived experiences as well as our political involvements reinforce our belief in the importance of the work of these two projects. We recognize that while bands and Aboriginal agencies are funded for gender-specific programs and services to women, they lack a critical consciousness about and analysis of sexism. The result is internal oppression or "double jeopardy." This experience was identified by one of the participants in our Bill C-31 project:

> They are not willing to help females. In fact, [despite] all of the paperwork that I supplied, my Indian band pushed my brother's status through and totally ignored mine. In the end I had to get [the name of person] to give a little shove to hurry mine up because we ended up in the dead file.[15]

Our politicization leads us to conclude that the federal government is the author of the exclusion of women and children that resulted from section 12(1)(b). But it is evident that Aboriginal leaders collaborated in this exclusion, as another participant expressed it:

> I know I'm part of the band now, but at first, when they were first talking about this bill, [C-31] I remember being at a band meeting and some of my own people were saying that they didn't want these women to come back to the reserve, and that really hurt me. I went to school with these people.[16]

The confusion surrounding identity from section 12(1)(b) was not resolved with Bill C-31. The powers of this bill were shared between the federal government that controlled "status" and the band that controlled "membership." For some participants, this perpetuates the same problems:

> When I got married, I was told I wasn't an Indian anymore. I had no rights as an Indian. And that made me feel, well, who am I? I'm not a White person. So when Bill C-31 came along, it was ambiguous. I have mixed feelings about what my identity is.[17]

The personal crisis associated with identity confusion can be traced directly to systemic discrimination and internal oppression. This silences Aboriginal women and thereby increases their level of vulnerability.

While policies and legislation surrounding the "Aboriginal Women, Violence and the Law" project are different than the Bill C-31 issue, the similarity lies in women's marginalization and the struggle to gain voice in the decision-making process. Aboriginal women are at greatest risk of harm in each of these issues, and yet we are the least represented in positions of power and influence.

CHALLENGES, CONSIDERATIONS AND LESSONS LEARNED

In our work, there have been many challenges and many lessons learned, but there are a few specific ones that stand out. The first has to do with our motivations for doing this work. We have had to ask ourselves, Are we only willing to work when there is pay, or are we willing to work as volunteers because of our belief in the need for profound social change? A second issue relates to our "insider" status during our research. Because we share the lived experiences of colonization with our research subjects, we also feel the pain that they describe and write about. The dilemma surrounding self-care constantly came to loggerheads with institutional requirements and deadlines. Another challenge has to do with the use of Aboriginal traditions for healing purposes, in the face of the colonized misogyny that we sometimes found within those philosophies and practices. And finally, we have had to deal with our subject positions relating to our Aboriginality. These are the issues we still struggle with and learn from.

Debates around work for pay have been ongoing in our group and elsewhere. The feminist movement has long fought for women's right to be remunerated for the work we perform. Yet we have had to ask whether we can afford to leave the work aside if there are no funds. Those who know Aboriginal collective ways have resisted putting a dollar sign on the struggle for liberation. Other comparable liberation struggles include those of the Palestinians and the Irish, many of whom willingly make sacrifices without asking for a per diem or an honorarium. There was conflict among us because some AWAN women had struggled long and hard to obtain funding for the work we wanted to

do; however, limited finances meant that certain aspects of our projects went lacking unless they were taken on by volunteers or people who donated time to the cause. My conviction is that the non-profit societies can be a strategy for liberation, and that accepting state funding is sometimes what results in our demise.

The pinch between our collective worldview and modern-day individualism was another area of struggle for us. And yet, increasingly, we concluded that the issue of setting clear personal boundaries was a privilege that we could not afford. Those that argued for financial remuneration were the very same women who were critical of those of us who volunteered, due to our "lack of boundaries." We came to recognize that the concept of an "individual boundary" was clearly a Western concept that collided with our collective ways of being. The magnitude of the tasks before us in each of our research projects meant that many of us had to work without pay, with a level of devotion to the issues that merged the personal with the political. If we all shared the value of setting personal boundaries, as well as only working for pay, the work would not have gotten done. The reward had to go beyond those sets of values.

One of the many contradictions related to personal boundaries and healing relates to traditional values and belief systems. The best defence against assimilation is to sustain culture and tradition, but what are we to do when reinstated tradition is steeped in misogyny? Scholar Emma LaRocque describes this contradiction for Aboriginal women:

> We are being asked to confront some of our own traditions at a time when there seems to be a great need for a recall of traditions to help us retain our identities as Aboriginal people. But there is no choice — as women we must be circumspect in our recall of tradition. We must ask ourselves whether and to what extent tradition is liberating to us as women.[18]

The lesson we learned is that Aboriginal peoples cannot abandon our spiritual practices because of the contamination of imposed Christianity. Likewise, Aboriginal women cannot abandon our spiritual practices because of the contamination of imposed Aboriginal versions of patriarchy. We have adopted Shirley Bear, of Tobique, as our role model, and we emulate the feminist ceremonies she has developed.

Identity politics is also a big issue for us. We advocate for women who have been pushed out of our communities, whether through the

child welfare system or Bill C-31. During our work together, as women coming from different locations, we have come to realize the need to be mindful of our own behaviour and practices. The Bill C-31 project showed us how Aboriginal people can discriminate against one another. For example, one of the participants said:

> The way I see it, Bill C-31 people are the stronger of the Nation. Many had to previously live off-reserve and they were not given the freebies that were given to status people, so they worked harder to become the more successful people. They had to work for what they had before 1985.[19]

This perspective of reserve life has been prevalent in non-Aboriginal Canada, and has evidently been taken up by some Aboriginal people. The reality is that we now have racism coming from within our communities. And we are divided by differences of appearance and experience, and by the varying levels of privilege and opportunity or discrimination that result. A Métis friend of mine has made a distinction among Aboriginal peoples by identifying "Aboriginal Peoples of Colour." At a moment in history when we are finally making gains in our social standing in Canadian society, there is a dramatic increase in the numbers of people claiming Aboriginal identity. How can we work together? In this era where racism factors into hiring practices — and privileges some Aboriginal people over others — this topic must be interrogated.

Ultimately, decolonization cannot be achieved with a top-down approach. Capitalist systems ravage our collective ways of being. And within that capitalist framework, collectivities rank low in priority. Capitalism sustains patriarchal models, and patriarchal models that uphold nuclear families also ravage our collective ways of being. As Aboriginal women, who simultaneously experience colonization and neo-colonialism, misogyny and poverty, our challenge in resisting each of these forms of oppression is great. Our political activism teaches us that one form of oppression is never the same as another form of oppression. Differences in forms of oppression result in different strategies, and often these strategies contradict each other. These contradictions wage war in our hearts and spirits. Finding our voices to articulate our realities, despite the contradictions, is our way to liberation. AWAN will continue to struggle against the top-down approach that has been

imposed upon our communities and work towards achieving a collective model that affords Aboriginal women a place from which to speak.

NOTES

1. Our logo was designed by Clo Laurencelle.

2. Our understanding of feminism can be described as "a sociopolitical theory and practice that aims to free all women from male supremacy and exploitation or a social movement that stands in dialectical opposition to all misogynous ideologies." Taken from Roger Scruton, *Dictionary of Political Thought* (London: Macmillan, 1996).

3. Section 12 (1) (b) of the 1951 *Indian Act* removed Indian status from any Indian woman who married a non-Indian (by comparison, an Indian man who married a non-Indian was able to confer his status onto his wife). While similar legislation had existed in previous Indian Acts since 1869, section 12 (1) (b) effectively severed all connections between a woman and her band; one Supreme Court judge termed the 1951 legislation "statutory banishment."

4. As quoted in Sally Weaver, "First Nations Women," in Sandra Burt, Lorraine Cody and Lindsey Dorney, eds., *Changing Patterns: Women in Canada* (Toronto: McClelland and Stewart, 1993).

5. This will be discussed more in the final section, "Challenges, Considerations and Lessons Learned."

6. Liberal government policies merged this ministry with other ministries, including Aboriginal Affairs.

7. Anonymity of this woman prevents me from citing legal documents. But according to her grandmother, whom she lived with, she had been clean and sober for two and a half years prior to the birth of her baby.

8. In 1995, Pamela George, a mother of two from Saskatchewan who worked occasionally as a prostitute to make ends meet, was raped and beaten to death by two young white middle-class men on break from university and who habituated "the stroll" for kicks. At the trial, where George's social standing as a prostitute was emphasized and where the murder was constantly downplayed as an out-of-character accident caused by drinking, the killers were convicted of manslaughter and were sentenced to six years in jail. Rob McKinley, "Pamela George Trust Fund," *Alberta Sweetgrass* (July 1997), 2. For further information on the Pamela George case, see Sherene Razack, "Gendered Racial Violence and Spatialized Justice: The Murder of Pamela George," in Sherene Razack, ed., *Race, Space and the Law: Unmapping a*

White Settler Society (Toronto: Between the Lines, 2002), 121–156.

9. This is far from an isolated incident. Serial killers are suspected or have been convicted of the murders of Native women in other parts of British Columbia as well as Saskatchewan and Northern Ontario. One estimate is that over five hundred Aboriginal women have gone missing in the past fifteen years. Experts have clearly identified Aboriginal women as a marginalized group vulnerable to being preyed on by serial killers, and suggest that the numbers of missing women add up to an epidemic of violence against Native women that is encouraged by social attitudes and police indifference. See Paul Barnsley, "Aboriginal Women at Risk: Disinterested Authorities Big Part of Problem," *Windspeaker* (December 2002), 3, 6.

10. Wendy Stewart, Audrey Huntley and Fay Blaney, "The Implications of Restorative Justice for Aboriginal Women and Children Survivors of Violence: A Comparative Overview of Five Communities in British Columbia" (Vancouver, 2001). Unpublished document in possession of the author.

11. Frank Paul, a Micmac man, died shortly after being released from custody. Police dropped him onto the street, knowing that his life was in danger. The Commissioner blocked this investigation too.

12. Angela Ward and Rita Bouvier, *Resting Lightly on Mother Earth: The Aboriginal Experience in Educational Settings* (Calgary: Detselig Enterprises, 2001), 57.

13. For feminist research, see Patricia Maguire, *Doing Participatory Research: A Feminist Approach* (Amherst, MA: University of Massachusetts, 1987); Sherna Berger Gluck and Daphne Patai, *Women's Words: The Feminist Practice of Oral History* (New York: Routledge, 1991); Sandra Burt and Lorraine Code, eds., *Changing Methods: Feminists Transforming Practice* (Peterborough, ON: Broadview Press, 1995). For Indigenous research, see Linda Tuhiwai Smith, *Decolonizing Methodologies: Research and Indigenous Peoples* (London: Zed Press, 1999). And for critical educational theory, see Paulo Friere, *Pedagogy of the Oppressed* (New York: Continuum Publishing, 1985), and bell hooks, *Teaching to Transgress: Education as the Practice of Freedom* (New York: Routledge, 1994).

14. Janet Silman, *Enough is Enough: Aborignal Women Speak Out* (Toronto: Women's Press, 1990).

15. Stewart, Huntley and Blaney, "The Implications of Restorative Justice for Aboriginal Women and Children Survivors of Violence," 41, 43.

16. Audrey Huntley and Fay Blaney, "Bill C-31: Its Impact, Implications and Recommendations for Change in British Columbia, Final Report" (Vancouver, 1999), 44. Unpublished report in possession of the author.

17. Ibid., 39.

18. Emma LaRocque, "The Colonization of a Native Woman Scholar," in Christine Miller and Patricia Marie Chuchryk, eds., *Women of the First Nations: Power, Wisdom and Strength* (Winnipeg: University of Manitoba Press, 1996), 14.

19. Huntley and Blaney, "Bill C-31," 46.

REBUILDING
OUR
COMMUNITIES

CHAPTER TWELVE

VITAL SIGNS:

READING COLONIALISM IN

CONTEMPORARY ADOLESCENT

FAMILY PLANNING

Kim Anderson

CHILDREN *Are the Heart of Our Nations* and *Our Children Are Our Future* are familiar sayings that adorn Aboriginal organizational logos and letterhead, T-shirts and bumper stickers. We adopt these sayings as powwow or conference themes and print them on banners to welcome participants. But after the meetings, the speeches and the MC's platitudes at the powwow, where do our children really stand? If children are the heart of our communities, I think we need to take a serious look at our heart condition.

I have been looking at these questions over the past few years through my work with the Ontario Federation of Indian Friendship Centres (OFIFC).[1] In the fall of 2000, we published *Urban Aboriginal Child Poverty*, which documents the widespread and devastating conditions of contemporary urban Aboriginal family poverty.[2] This report is but one indicator that our children are not living the good life that is

due to them. Aboriginal children are suffering today because colonization has robbed us of the capacity for building healthy communities, and modern-day economic and social policies exacerbate this problem. We need to lobby various levels of government and make them take responsibility, and the OFIFC is doing just that. In this essay, however, I would like to focus on what *we* can do as Aboriginal communities to breathe life back into those old sayings about the value of children. I think a good place to start is with the beginning: conception and the necessity of good health and well-being of the parents, planning, preparation and choice. What can *we* do that will ensure our children have a healthy start in life?

While doing the research for the OFIFC family poverty report, I was troubled by both the size of the families I was interviewing and the young age of many of the parents. At one point, I interviewed a sixteen-year-old mother of a toddler. She was almost due to have a second child and had been living in various homeless shelters for over a year. The day I interviewed her, she was on her own and was worried because she had nothing to feed the toddler for dinner. I wondered how it was that she was expecting a second child so soon, and in such dire conditions. Who was there to help? Had anyone talked to her about sexual and reproductive health or family planning? What types of messages had she received about sex, pregnancy, parenting and children, and how would this influence the choices she would make about having children in the future?

With the understanding that adolescent parenting is a surefire recipe for concurrent child and youth poverty,[3] the OFIFC hired me to write a second report, this time on Aboriginal teen pregnancy. In the spring of 2002, we published *Tenuous Connections: Urban Aboriginal Youth Sexual Health and Pregnancy*.[4] Our research pointed to many of the classic risk factors that have already been documented as causes of adolescent pregnancy: poverty, low self-esteem, sexual abuse and poor family history, to name a few. But there were also several distinct characteristics that relate to our history as Aboriginal peoples. This has allowed us to identify the distinct solutions that are necessary if we are to reinstate that traditional reverence for life, the health and well-being of children and youth and the sanctity of women. In this essay, I will discuss the findings of the OFIFC youth sexual health and pregnancy report, but will begin by taking a look at how our long-term and recent history plays into the family planning issues among Aboriginal peoples today.

Risky Business:
Talking Family Planning in Indian Country

It is difficult to raise questions about family planning in the Aboriginal community, or, I suspect, in any community of people who are poor and marginalized. We have come through several decades of a political climate built on poor-bashing. Right-wing governments in Canada and the U.S have encouraged the mainstream to believe that the poor are to blame for their misery. The poor, so this reasoning goes, are too lazy to work and therefore use "the system." "Welfare mothers" (and their children) are seen as a burden on society; single mothers are blamed for the social and moral downfall of the modern world. Any dialogue around family planning must therefore begin by distancing itself from judgements about parenthood based on the income or status of the parents.

The morality and class issues may be generic, but there are many other family planning sensitivities that are distinct to Aboriginal peoples. The first has to do with genocide. It's simple: when a people are under siege, it becomes imperative to reproduce. Aboriginal peoples across Turtle Island have come through wars, slaughter, smallpox, forced relocation, starvation and assimilation. I believe that both conscious and unconscious efforts have been made to keep our families alive by continuing to produce children and replenish the population in times of great loss. If efforts like this hadn't been made, it is possible that I wouldn't be sitting here today.

A sense of desperation about the need for drastic measures to keep our people from disappearing is still present within many contemporary Aboriginal communities. I think this is because some of the greatest losses we have experienced in relation to our children have happened in this century — that is to say, losses that are within the memory and experience of family members four to five generations deep. The residential school system ran from the late nineteenth century up until the late twentieth century. By the 1940s, half the Indian student population was enrolled in the seventy-six residential schools across the country, and some communities had *all* of their children forcibly removed at once.[5] Many were away for their entire childhood and never came back. Some died, and many of the children that did come back home had lost their ability to communicate with their own people.

The child welfare system followed on the heels of the residential school system, with a staggering number of Aboriginal children being

removed from their homes in the infamous "sixties scoop." Authors Ernie Crey and Suzanne Fournier have called child welfare during this period the "wolf in sheep's clothing," stating, "Only 1 per cent of all children in care were Native in 1959, but by the end of the 1960s, 30 to 40 per cent of all legal wards were Aboriginal children, even though they formed less than 4 per cent of the national population."[6]

Following this horror, Native women became victims of forced sterilization.[7] During the 1970s, many Native women went into the hospital to have children and came out with tubal ligations or hysterectomies.[8] Various studies reveal that the United States Indian Health Service sterilized between 25 and 50 percent of Native women between 1970 and 1976.[9] This was done through coercion and misinformation and often without consent or knowledge on the part of the patient. The mostly white, Euro-American male doctors took it upon themselves to decide whether Native women would have children, their rationale for sterilization being "to enable the government to cut funding for Medicaid and welfare programs while lessening their own personal tax burden to support the programs."[10]

All of these experiences build terror through individual and collective memory, instilling in parents and communities a profound insecurity about children and a fear of further personal loss. More generally, there is a strong awareness that, as peoples, we face an ongoing threat of extinction. Aboriginal peoples have recent memory, collective/historic memory and everyday experiences that continue to feed these insecurities. There is always the threat of someone coming to judge one's parenting, someone coming to take the children away, someone scheming to erase us permanently. The political, social, emotional and practical response to these issues has been to reproduce in spite of it all.

There are also spiritual and cultural underpinnings that factor into the larger and younger families that characterize Aboriginal peoples.[11] We are noted, historically, for having a great love for our children and for providing them a place of reverence in our communities. When the European colonists first arrived, they were struck by this and wrote that "the savages love their children extraordinarily."[12] The Jesuits remarked on the way Aboriginal peoples indulged their children and loved them "excessively."[13] The sayings I refer to at the beginning of this essay come from this time when children truly were the heart of our communities. Similarly, at one time there was a reverence for mothers and motherhood, and a recognition of woman's power as the root of the

family, community and Nation. These notions and ideals are still part of our collective psyche, providing a sense that, as women, it is part of our "roles and responsibilities," our purpose, as it were, to have children.

This history and tradition can interfere with family planning if we do not take a critical and informed look at where we have come from. When I began my research, I found that front-line workers were happy to talk about the need for family planning, but I also met with resistance among some community members who told me I had better "go and get the teachings." I had heard of young people saying "I'm traditional, so I don't use birth control," and I wanted to find out what they meant. After some searching, I realized that part of this may come from the Code of Handsome Lake, an eighteenth-century Seneca prophet who has many followers among the Hotinonshonni today. The Code acknowledges that women had abortive and contraceptive practices, and goes on to prohibit these practices, calling on women to have multiple (that is, ten to twelve) children.[14]

This notion that it is "traditional" to have large families is found among other Aboriginal nations as well. We hear people across the country talking about the cultural or traditional imperative to have many children. Maria Campbell, a Cree/Métis Elder from Saskatchewan, puts the roles and responsibilities of woman as child-bearer into perspective. She says:

> I have talked with many old women over the years about the traditional role of women. They say it was holistic as was everyone else's. In olden times you were taught skills that you would need as a woman and you were valued for those skills because they meant "life" for your people. You were valued for how well you could skin and cut up a buffalo or a moose and preserve it. How well you could tan a hide, sew clothing and make baskets. Later it was also how well you could garden and preserve the food. You were also valued for your dignity, kindness, generosity and courage. Sometimes you were valued as a hunter and protector. All of these skills and characteristics were needed to nurture and protect life.[15]

Maria asks the question about what we mean when we say "traditional," suggesting that a lot of what is considered traditional is steeped in Christian thought, morality and ethics. What do we find in terms of family planning if we take a look at pre-Christian thought and practice?

LOOKING BACK AT OUR HISTORY OF FAMILY PLANNING

Native women's history demonstrates that family planning was women's business that incorporated knowledge about sexual and reproductive health systems. "Traditional" family planning took into consideration community economics, social and health concerns and harmony with the environment.

Our ability to manage family planning is evident when we consider the reports of the relatively small Aboriginal families in some Nations at the time of European contact. Valerie Mathes has written that birth control must have been present among the Chippewa "because of the often noted fact that Indian families had only two or three children, whereas white families had thirteen or fourteen."[17] Missionary reports testify that, after being told "of the fecundity of the Europeans," Aboriginal Greenlanders "compare[d] them contemptuously with their dogs."[17] I have asked some Elders about family size and they have noted that, historically, our families were fairly small.

> When you talk to the elder women about what it was like a long time ago — before we became shackled by the church — [they say that] in order to survive, and because people travelled to follow the game, it wasn't their way to have a large family. Children were spaced … So maybe two or three was the size of their families. Two or three children. Because life was hard, really hard back then.
>
> — EDNA MANITOWABI (OJIBWAY)[18]

> The old women I have known said that we never had more children than we could grab and run with if there was a battle. How many children can you grab? Probably no more than two.
>
> — MARIA CAMPBELL (CREE/MÉTIS)[19]

The church was instrumental in introducing large families to Aboriginal peoples, because of the opposition to birth control and the edict placed on women to continue producing. Maria Campbell points out that we have adopted some of these morals as Aboriginal "tradition." She says, "Today we hear lots of people say that it is cultural to have lots of children. We were responsible people and we loved children, we never had more than we could look after."[20]

The shift in economic systems also factored into the size of Aboriginal families. Large families may be impractical for nomadic people, but they make sense for farmers. Gerti Mai Muise, a Mi'kmaw from

Newfoundland (and the nineteenth child in her family) talked to me about the history of her people, stating that large families were the result of religious and economic pressures after contact. She jokes about the ability of her people to adapt to the demands that were being made of them: "They wanted us to be farmers and we farmed. They wanted us to have lots of kids, and we were good at it!"[21]

If families were smaller historically, how did our peoples manage this? Long-term breastfeeding and infant mortality rates can account for some of the population control. In addition, nomadic lifestyles and hunting patterns resulted in long absences of men from some societies. Some cultures were polygamous, which meant that individual women were birthing fewer children.[22] Some cultures had restrictions around intercourse with women who were pregnant, menstruating or nursing an infant.[23] But it was also the extensive knowledge about women's health and the direct influence of older women that ensured the well-being of women and children through family planning.

At one time, there were systems and ceremonies in place that allowed older women to pass on their knowledge of women's bodies and cycles. Young girls were taken to ceremonies and guided through rites at puberty where they learned about sex, pregnancy and parenting — as well as about work expectations and other adult responsibilities — from community aunties and grannies.[24] They also learned how their bodies were connected to the cycles of the land and the sky world, as menstruation and fertility patterns could be measured according to the cycles of the moon.

Birth control in the form of traditional medicines was also in use prior to interference from the dominant Euro-Western culture. This is documented in literature[25] and has been confirmed by a number of Elders that I have talked to. Mohawk midwife Katsi Cook shared her knowledge with me:

> Using reproductive hormones (the Pill) to alter the fertility cycle is not new to Indian people. Throughout Native America, women controlled their fertility through prolonged breastfeeding, sexual abstinence and the use of several hundred natural plants, which suggest that our ancestors had a better understanding of the physiology of the menstrual cycle than that of the Western world at the time of contact. A tea made from the desert plant Stoneseed *(Lithospermum ruderale)*, for example, was used by the Commanche and Shoshone

of the Southwest to manipulate fertility. In the mid-twentieth century, Western scientists studied this medicine and found that it inhibited the estrous cycle. The activity of stoneseed as an efficacious contraceptive was expressed by these researchers in P.P.U.s (Papoose Preventative Units). Further research based on these findings and the study of other indigenous plants, such as the Wild Yam, led to the development of the first oral contraceptives.[26]

Both contraceptive and abortive medicines were used, although many Elders that I have spoken to have indicated that abortion was only practised when the health of the mother or child was in danger. Katsi Cook identified a period during Seneca history when abortifacients were used:

> One historic period where we see great change impact reproductive practice was the desperate times of the Seneca People in the post-American Revolution era described by Anthony Wallace in his classic *The Death and Rebirth of the Seneca*.[27] Domestic abuse, drunken brawling, abandonment of families, rape, suicide and wretched poverty were the legacy of whiskey and the powerlessness of a people deprived of their fertile lands and political autonomy. So prevalent was the use of abortifacients (which can also cause permanent sterility) among their down-hearted women, that Seneca Chief and Prophet Handsome Lake preached against their use so that the People could continue to live. Today, followers of the Handsome Lake Code teach their daughters that abortion is a great evil. A woman who has purposely induced abortion through whatever means cannot handle sacred ceremonial food.[28]

A number of Elders have told me of medicines that brought on menstruation if a woman missed her cycle, and of teas that were used on a daily basis, likely as a contraceptive measure. There are older women who still have the knowledge of these medicines, but much of this information has gone underground or has died out as a result of repression from the church and fear of exploitation. Women throughout the Americas have been threatened because of this knowledge. Some communities restricted certain knowledge in the face of the large-scale exploitation of traditional environmental knowledge by Western practitioners. Shawani Campbell Star told me about her experiences, as an Indigenous person growing up in Guyana:

> When I was young, it was general knowledge that some women used

herbs when they didn't want to get pregnant and other herbs when they did. I have been told that these medicines had to be picked at a certain time, but nobody knows how to do that anymore. What it did was regulate whether you wanted to be pregnant or not. When certain outside people began following our women around to see what plants they were picking, they just stopped doing it because they didn't want to give that knowledge away.[29]

The church was undoubtedly the greatest obstacle to the practice of traditional birth control. Maria Campbell talks about how Catholic morality prevented her grandmother from saving her mother:

My Mom had eight children. When she had her fourth child the doctor told her she would die if she had more, but she did because she was a Catholic and the church said it was a wife's duty to have babies. My grandmother, who was a traditonal healer and midwife, told her she would make her some medicine so she would never get pregnant again. My mom wouldn't take it, she went on to have three more children. Each one left her weak for months. On her eighth pregnancy my auntie and grandmother pleaded with her to take the medicine; she refused and died, leaving 8 children. My grandmother helped many women live to see their grandchildren. She used local plants which were dried and made into a tea.[30]

From stories like this, we can see how older women once had a good handle on women's health systems and the family planning needs of the community. This once commonplace knowledge has been attacked and suppressed to the point that it is now hard to find. It was replaced by Christian morals and a Western medical paradigm that gave birth, pregnancy and female sexual and reproductive health matters over to male doctors.

Aboriginal family planning issues are also coloured by the degradation of sexuality throughout our histories.[31] Residential schools introduced both sexual repression and sexual abuse to the masses of Aboriginal children who attended them. Christianity condemned traditional understandings of sex as a natural part of life and introduced the dichotomy of virgin and whore as the only options for women's sexuality. Where does all this history leave our youth today?

Contemporary Youth Sexual Health and Pregnancy

The OFIFC youth sexual health and pregnancy study allowed us to explore questions of sexual practices, contraceptive use, abortion, sex education, family patterns and beliefs, reasons for pregnancy, program and service needs, pregnancy histories, and experiences of parenting.[32] We collected data through a youth questionnaire, individual interviews with youth parents, front-line workers and Elders, and focus groups. We conducted research in twenty-three urban centres around Ontario, and had a total of 340 participants.[33]

Sexual Practices of Youth

Our study demonstrated that sexual intercourse is part of peer culture for youth and children who are still in grade school, and that by high school it is almost the norm. Almost half of the interviewees suggested that adolescents are becoming sexually active at thirteen or younger. They indicated that sexual intercourse typically happens when there is "partying," that is to say that it happens regularly on the weekends when teens are drinking or doing drugs.

We explored the question of why adolescents are sexually active. Sixty-eight percent of the male and 69 percent of the female question-naire respondents checked off "I like sex; it feels good." But by contrast, very few of the interviewees talked about pleasure as a motivating factor for sex. Their primary reasons were peer pressure, substance abuse, wanting love and "to try it."

Sexual abuse came out as a big factor in the lives of these youths. The incidence among our questionnaire respondents was distressing, with 61 percent of the females and 35 percent of the males reporting sexual abuse. Sexual abuse has been shown to have a direct influence on the higher rates of sexual risk-taking and pregnancy among Native women,[34] and several studies have shown the correlation between childhood sexual abuse, sexually risky behaviour and teen pregnancy.[35] We found the same to be true of the youths we surveyed. Both genders were three times more likely than their non-abused peers to report having sex because they desire love. Both were more likely to have six or more partners and less likely to have monogamous relationships. Almost 30 percent of the sexually abused males reported never using contraception, as opposed to 16 percent of the males who had not been abused. Males

and females who had been abused were much more likely to become pregnant or to cause a pregnancy.

Contraceptive use was inadequate at best. Among the questionnaire respondents who were sexually active, only 38 percent indicated that they always used contraception. Another 26 percent indicated that they never use contraception, while another 21 percent indicated that they use it rarely, or only sometimes. These data indicate that more than 50 percent of the sexually active youth we surveyed were at risk of contracting a sexually transmitted infection or becoming pregnant.

Attitudes towards abortion were divided among the interview participants. While not exactly "pro-choice," half of the participants mentioned that people in their communities were using abortion services. Another half reported negative feelings about abortion among their peers. The attitudes thus ranged from casual approaches to abortion to moral interpretations against it. Female questionnaire respondents were asked "Would you have an abortion?" and 51 percent said "no," while 20 percent said "yes." Another 26 percent indicated that they would have an abortion in certain situations, including if they were raped.

Youth Pregnancy and Parenting

A central question in our research was "Why do Aboriginal youth get pregnant?" The top reasons for interview participants who had been pregnant were: "we didn't use birth control"; "I didn't believe I would get pregnant"; "I was drunk or on drugs"; and "the birth control didn't work." The youth indicated that substance abuse is a major factor. Substance abuse may also be an indirect cause for adolescent pregnancy in that it appeals to some girls who are looking for a way to straighten out. One interviewee told us:

> I'm glad that I had my girl when I did because I found that I was starting to get too involved. It's like a washer that I can't get out of and I keep getting spun under. When I'm trying to get out, it just pulls me back in. She was like this little person who came and helped me out of it. I started working and quit drinking and I'm really glad for that.

Twenty-two percent of the youth interviewees said they started using alcohol and drugs and having sex because there is "nothing to do." Many of the youth used the word "boredom" when describing the reasons for adolescent pregnancy. Workers and youth indicated that

extracurricular activities are either unavailable or unaffordable to the majority of Aboriginal youth. As for substance abuse during pregnancy, 17 percent of the mothers reported using alcohol, 21 percent reported using drugs and 58 percent reported smoking.

Forty-four percent of all interviewees commented on teen pregnancy as a social norm in their communities. One worker commented, "It's almost strange not to have a kid by the age of twenty in our community." Research participants stated that there are some negative attitudes about teen pregnancy in their communities, but in many cases people are non-judgemental. Some communities reported a laissez-faire attitude to the prevalence of teens in their community becoming pregnant.

Many interviewees talked about how problems in the family can lead to adolescent pregnancy. Poor or neglectful parenting was cited as a major reason:

> A lot of parents are gone at night with unsupervised houses. People know which places are unsupervised so they all hang out there. When it's unsupervised, everything goes on. It's a known hang out and people do what they want.

Some young female participants talked about pregnancy being appealing because it offers them a way to get away from their own families. It seems to provide a way out of dysfunctional or abusive situations that these girls are experiencing in their parents' homes, and they believe that having a family of their own will enable them to find housing and assistance to live independently.

Some of the Elders talked about abuse as a motivating factor. Early pregnancy may appeal to youth as a way of immediately transferring out of the "problem teen" stage and into the adult circle. For some, this is a way of seeking higher esteem and worth in the community:

> I have observed little girls, some as young as eleven or twelve, who, upon geting pregnant, were suddenly accepted into the women's circle. They could sit at the kitchen table with the women and talk and be listened to. Everyone cared about their health and if they had enough to eat. They were teased and loved and for the first time in their lives they were treated as if they were worthwhile.
> — MARIA CAMPBELL[36]

Because of a natural longing to be liked, youth may fall into sexual relationships that may result in pregnancy. This initially becomes a

claim to fame — "I'm somebody in the community now and not just an ignored teenager." The older people notice them. And so, without preparation or training, they are in the situation of parenting. Soon, however, the glow fades and when they can't get out to socialize, parenting becomes a burden and the baby may be neglected and possibly seized and another cycle begins.

— SHAWANI CAMPBELL STAR[37]

Support and involvement of the families was divided. About half of the youth parents said that their families were helping them. There were equally as many comments, however, to suggest that the parents of these youth were unsupportive.

Many of the workers commented on the poverty of their clients and, in particular, on the inadequacy of social assistance. Workers talked about adolescent parents coming to Friendship Centres for formula, food and diapers because of insufficient funds. Such support programs are the only source of emergency support for many youth who do not have extended family. In many cases, the extended family cannot help because they are also struggling with poverty.

Interviewees were asked how pregnancy and parenting had changed their lives. Four of the twenty-eight parent interviewees talked about the joy they experience as parents. But most parents talked extensively about the challenges that pregnancy and parenting had brought them. This included challenges to achieving goals like completing school, and dealing with isolation and the loss of freedom.

ETHICS, CULTURAL INFLUENCES AND ATTITUDES TOWARDS FAMILY

When asked about spirituality, 43 percent of the questionnaire respondents identified exclusively with Native spiritual tradition. Participants who identified with Native spirituality were less likely to have had a pregnancy.

Interview participants were invited to discuss whether they thought Native or Christian ethics influenced the sexual practices or attitudes among Aboriginal youth. Only three of the youth parents talked about the application of Native traditional knowledge in their own lives. Over half of the interviewees surmised that Aboriginal youth are not greatly

influenced by Native culture and tradition, and certainly not in the areas of sex and sexuality. None of the workers or youth had heard traditional teachings in this area.

Thirty-five percent of the interviewees suggested using Elders and cultural teachings as part of a strategy to encourage healthy sexuality and prevent unwanted pregnancies. Although many youth identify with Native spirituality and tradition, they are lacking in concrete teachings about sex and family planning.

Youth who participated in the study were asked to share their opinions about the best age for starting a family as well as the ideal size of a family. The majority of respondents indicated that they believe the best age for women to begin their families is after the age of twenty-five. Participants repeatedly stated that men and women should be established and stable before they begin a family. They spoke about the need for maturity, work and/or financial stability, and the completion of school. Participants also placed importance on having completed their "fun and partying," having straightened out, being young enough to have children, and having an established relationship.

The youth participants talked about small families of two or three children as an ideal. The reason most gave for only having two or three children was related to cost.

*

To look at this picture of youth sexual health and pregnancy is frightening, but perhaps not surprising. It is the manifestation of our colonial history and of the modern-day poverty that is the result. These are the vital signs of our future, and we need to pay close attention to them.

We have arrived at a place where youth are engaging in high-risk sexual behaviour at a very young age. Childhood sexual abuse is rampant and is directly linked to promiscuity, careless sexual behaviour and early pregnancy. There is a high correlation between substance abuse and sexual activity, and this is seen by the youth as a primary cause for pregnancy. The youth in the study expressed feelings of boredom, hopelessness and neglect. Elders talked about how pregnancy becomes one option for a way out. I found it jarring when Maria Campbell told me, "In one community where I worked, the young girls were either getting pregnant or committing suicide."[38] Are these the only options we can offer our youth?

How can we bring back the sacred place for children and the enthusiasm, vigour and hope of adolescence? By voicing their ideals about family, these youth have told us that they want to live out the freedom of their teen years, and they want to be ready to provide good lives for their children. What can we give them to help them with these ideals?

The OFIFC is working on a comprehensive strategy to address the issues that came out of this report, including community-based and peer education, work on sexual abuse and healthy sexuality, access to birth control, recreation, youth employment and training, anti-poverty work and supports for young parents. They are also responding to the need for Native cultural and spiritual traditions that can help our adolescents to understand their emerging sexuality and the profound and sacred responsibilities of parenting. Modern day Aboriginal family planning must take into account all of these elements. As adults, it is our duty to the children and youth of our communities to see that this happens.

Hai Hai.

NOTES

1. The Ontario Federation of Indian Friendship Centres (OFIFC) is a provincial Aboriginal organization representing the collective interests of twenty-seven member Friendship Centres located in towns and cities throughout the province of Ontario.

2. Ontario Federation of Indian Friendship Centres, *Urban Aboriginal Child Poverty: A Status Report* (Toronto: OFIFC, 2000). This study is available through the OFIFC Web site <www.ofifc.org>.

3. In terms of demographics, chances are that the poverty will keep growing. Fifty percent of the Aboriginal population is under twenty-four years of age (Statistics Canada 2001 data) and there are much higher rates of teen pregnancy in Aboriginal communities than among the mainstream. Nine percent of Aboriginal mothers are less than eighteen years of age, as opposed to 1 percent of non-Native mothers (Department of National Health and Welfare, *Health Status of Canadian Indians and Inuit* [Ottawa: Department of National Health and Welfare, 1991]). Young Aboriginal women between fifteen and twenty-four years old are more than three times as likely to be single mothers as other young Canadian women (Jeremy Hull, *Aboriginal Single Mothers in Canada 1996, A Statistical Profile* [Ottawa: Research

and Analysis Directorate, Indian and Northern Affairs, 2001]). With almost 40 percent of single Aboriginal mothers earning less than $12,000 a year (Statistics Canada 1996 data), Aboriginal teen mothers are surely among the poorest of the poor.

4. Ontario Federation of Indian Friendship Centres, *Tenuous Connections: Urban Aboriginal Youth Sexual Health and Pregnancy* (Toronto: OFIFC, 2002). This study is available from the OFIFC Web site <www.ofifc.org>.

5. Aboriginal Healing Foundation, *The Healing Has Begun: An Operational Update from the Aboriginal Healing Foundation* (Ottawa, May 2002).

6. Ernie Crey and Suzanne Fournier, *Stolen From Our Embrace: The Abduction of First Nations Children and the Restoration of Aboriginal Communities* (Vancouver: Douglas and MacIntyre, 1997), 83.

7. I have only found reference to these practices in the United States, although I have heard of sterilizations happening to Native women in Canada as well. In any case, I have included this information because the fear that comes out of these practices most certainly travels across the border.

8. Sally J. Torpy, "Native American Women and the Coerced Sterlization: On the Trail of Tears in the 1970s," *American Indian Culture and Research Journal* 24, no. 2 (2000), 1–22; Jane E. Lawrence, "The Indian Health Service and the Sterilization of Native American Women," *American Indian Quarterly* 24, no. 3 (2000), 400–419.

9. Lawrence, "The Indian Health Service and the Sterilization of Native American Women," 410.

10. Ibid.

11. Health Canada 1999 data ("A Second Diagnostic on the Health of First Nations and Inuit People in Canada") and Statistics Canada 1996 census data indicate the following: 12 percent of Aboriginal families are headed by a parent under twenty-five vs. 3 percent in the general population; 27 percent of Aboriginal families are headed by a single parent vs. 12 percent in the general population; and 10 percent of respondents in the First Nations and Inuit Regional Health Survey had over four children up to eleven years of age living at home versus zero percent of the respondents in the National Longitudinal Survey of Children and Youth.

12. Ursuline de l'Incarnation, quoted in Fournier and Crey, *Stolen from Our Embrace,* 52.

13. See Crey and Fournier, *Stolen from Our Embrace,* 52.

14. Chief Jacob Thomas with Terry Boyle, *Teachings from the Longhouse* (Toronto: Stoddart Publishing, 1994), 38.

15. Maria Campbell, personal interview with the author, Gabriel's Crossing, Saskatchewan, July 9, 2001.

16. Valerie L. Sherer Mathes, "A New Look at the Role of Women in Indian Society," *American Indian Quarterly* 2 (1975), 133.

17. Cranz, D., Appendix: *Narrative of the first settlement made by the United Brethren on Greenland,* 2 volumes (London, 1820) as quoted in David A.Scheffel, "The Dynamics of Labrador Inuit Fertility: An Example of Cultural and Demographic

Change," *Population and Environment: A Journal of Interdisciplinary Studies* 10, no. 1 (Fall 1988).

18. Edna Manitowabi, personal interview with the author, Peterborough, Ontario, September 21, 2001.

19. Campbell, interview.

20. Ibid.

21. Gerti Mai Muise, personal interview with the author, Toronto, Ontario, November 27, 2002.

22. Scheffel, "The Dynamics of Labrador Inuit Fertility: An Example of Cultural and Demographic Change"; Virginia Driving Hawk Sneve, *Completing the Circle* (Lincoln: University of Nebraska Press, 1995), 11.

23. Mathes, "A New Look at the Role of Women in Indian Society"; Walter L. Williams, *The Spirit and the Flesh: Sexual Diversity in American Indian Cultures* (Boston: Beacon Press, 1991), 101.

24. For further discussion on puberty rites, see Kim Anderson, "Honouring the Blood of the People: Berry Fasting in the 21st Century," in Ron F. Laliberte et al., eds., *Expressions in Canadian Native Studies* (Saskatoon: University of Saskatchewan Extension Press, 2000), 374–394.

25. Michael A. Weiner, *Earth Medicines, Earth Foods: Plant Remedies, Drugs and Natural Foods of the North American Indians* (New York: Collier Macmillan Publishers, 1972); Virgil J. Vogel, *American Indian Medicine* (Norman: University of Okalahoma Press, 1970); Beverly Hungry Wolf, *Daughters of Buffalo Women: Maintaining the Tribal Faith* (Skookumchuck, BC: Canadian Caboose Press, 1996).

26. Katsi Cook, e-mail correspondence with the author, February 13, 2003.

27. Anthony F.C. Wallace, *The Death and Rebirth of the Seneca* (New York: Vintage, 1972).

28. Cook, e-mail correspondence.

29. Shawani Campbell Star, personal interview with the author, Toronto, Ontario, November 2, 2001.

30. Campbell, interview.

31. I have written more about this in Kim Anderson, *A Recognition of Being: Reconstructing Native Womanhood* (2000; reprint, Toronto: Sumach Press, 2001).

32. The complete study is available on line or can be ordered from the OFIFC at <www.ofifc.org>.

33. Because of the nature of our data collection, the realities of the more marginalized youth may be absent.

34. For example, a 1998 study of Aboriginal and non-Aboriginal women in Winnipeg found that Aboriginal women were more likely than non-Aboriginal women to have experienced sexual abuse (44.8 percent vs. 30.1 percent). Women who had been sexually abused were younger when they first had sexual intercourse, had

multiple partners, and had a history of sexually transmitted disease. Among Aboriginal women, those who had been sexually abused were more than six times as likely as those who had not been abused to have had more than twenty sexual partners. Among all women, those who had been sexually abused were more than likely to have been pregnant five or more times. See T. Kue Young and Alan Catz, "Survivors of Sexual Abuse: Clinical, Lifestyle and Reproductive Consequences," *Canadian Medical Association Journal* 159, no. 4 (1998), 329-334.

35. D. Boyer and D. Fine, "Sexual Abuse as a Factor in Adolescent Pregnancy and Child Maltreatment," *Family Planning Perspectives* 24 (1992), 4–11; Janet. W. Kenney et al., "Ethnic Differences in Childhood and Adolescent Sexual Abuse and Teenage Pregnancy," *Journal of Adolescent Health* 21, no. 1 (1997), 3–10; Alex M. Mason, "Sexual and Physical Abuse Among Incarcerated Youth: Implications for Sexual Behaviour, Contraceptive Use and Teenage Pregnancy," *Child Abuse and Neglect* 22, no. 10 (1998), 987–995; David Y. Rainey et el., "Are Adolescents Who Report Prior Sexual Abuse at Higher Risk for Pregnancy?" *Child Abuse and Neglect* 19, no. 10 (1995), 1283–1288.

36. Campbell, interview.

37. Star, interview.

38. Campbell, interview.

CREATING A
COMMUNITY-BASED SCHOOL

Jean Knockwood

SEVEN YEARS AGO, a handful of parents in our community at Indianbrook First Nation in Nova Scotia pulled our children out of the town school because of the racism they were encountering there. We then started our own school on the reserve, a community of about twelve hundred people. In five years, this school grew to a community-based organization in which parents had full involvement in their children's education. It became a source of community economic development, which employed seventeen community people in addition to thirteen teachers. Most important, it provided a homey environment where 170 Mi'kmaw students received a culture-based education. In this essay, I want to tell you the story of our school.

HOW WE GOT STARTED

It all began with cultural renewal. At Indianbrook, we had been getting involved in our traditions again. We had set up a group of young men to become drummers and a lot of the young women had started dancing. We would talk to them about Native spirituality and how important it was to stay away from alcohol and drugs. As a result, the young people began to develop a really strong sense of pride and identity.

After this had been going on for about a year, there was an incident in which a Grade 7 Mi'kmaw student complained to some of the drummers that a white upper-grade student was picking on him. The drummers politely asked the upper-grade student to stop, but the harassment continued. This went back and forth until finally our young men had had enough. They said to the white student, "We don't want you hurting him anymore. If you hit him again, then we have no choice but to take matters into our own hands." When that happened, the white student went to the principal and reported them.

The principal responded by announcing over the PA system that all of the Mi'kmaw students from Grade 7 to Grade 12 had to meet with him. As the Mi'kmaw were going down the hallway, a group of white kids made fun of them, and by the time they got to the principal's office, they were really disturbed and angry. The principal then suspended the students that the young white man had identified, called the buses and ordered all of the Mi'kmaw students to go home for the day; they had to endure more racist remarks as they walked out to the buses. That's when the young people who'd been involved in our drumming and dancing programs decided that they weren't going back to school.

I heard the story from my daughter who was in Grade 10 at the time, and I told her, "You're not going back there. I went through that when I was a kid, and I'm not going to let you go back and go through that." But before we made that decision, I wanted to see the chief and council. So a group of parents asked the chief and council for a community meeting.

At the first meeting, the community was divided. Some parents wanted their kids to go back. Others felt that their children should no longer be exposed to that kind of racism. There was a lot of controversy, and it didn't help that the school principal and personnel were at the community meeting. When the chief and council finally said that the children were going back, I announced that my daughter was not. Some of the parents demanded that the principal and school personnel leave, yet even after they were gone, we remained divided. I consulted with my daughter and then announced that we were going to do home-schooling. After the meeting, parents came up to me and said, "Will you home-school my children?" Then the drummers came up and said, "We're going to come and be home-schooled with you." By the end of the evening I had about fifteen or sixteen kids that wanted me to home-school them. I was thinking, *What am I going to do? I can't home-school*

all of these kids. But the parents were saying, "We're not sending them back."

At the time, I was doing a master's degree in educational administration. I called some of my friends who were on faculty at Dalhousie University and told them what was happening. One of them suggested creating a school on the reserve. And so I took the first step by contacting people about setting up a school.

It was November and it was time to write exams, but we didn't want our children going back under those conditions. Our tuition agreement was with the Colchester-East Hants School Board, so we told the board members that we wanted them to provide us with instructors to prepare the kids for the exams and that they had to administer the exams on the reserve. They were shocked, but we persisted, telling them, "We know that you have our tuition money, so you have to provide them with the services they need." And so the school board arranged with the chief and council to give us two substitute teachers. We set up classrooms in the church basement for the forty Grades 7 to 12 students who weren't going back.

The parents began volunteering right away. Some came every morning to prepare coffee and tea and toast for the kids. Others drove around the community to pick them up. The chief and council had told us they couldn't break the contracts they already had with the bus company, so we didn't have busing. But with the parents' involvement, we got it all working.

THE NEXT STEP

We had solved the immediate problem, but we needed to figure out what we would do next. We didn't have accreditation to run a school ourselves. The school board had told us, "We'll provide the substitute teachers until December, but come January, your kids are going to be back in our school, whether you like it or not." They didn't like our response, which was that under the *Indian Control of Indian Education* policy, we had a right to decide where our kids would go to school. That's when another colleague of mine suggested having a tuition agreement with a First Nations school board.

We called the only two bands in Nova Scotia that had Grade 12, Eskasoni and Wagmatcook, and Wagmatcook agreed to put together a tuition agreement for our band. They rented us trailers to house the school, they provided us with the curriculum, the texts, and the salaries

for teachers — everything that was needed to operate a school. In return, they charged us a monthly fee, so much for every student.

We started right on time in January. We had advertised for teachers over Christmas and received two hundred applications! Because this was a community effort, we made sure that the parents were involved in selecting teachers. Over the Christmas holidays, they screened the applications and chose who they wanted interviewed. The interview board consisted of the chief and council, people from Wagmatcook and one of the elders from our community.

We hired four teachers for the forty students. Grades 7 and 10 each had their own teacher, and there was a teacher for Grades 8 and 9 together, and another for Grades 11 and 12 together. The students went to school for the rest of the year in the trailers. By June, more parents were interested and so we petitioned the chief and council for the use of the community centre.

There was another big debate in the community about whether this should be allowed. But we reasoned that the community centre at the time didn't have an operating and maintenance budget. It had a loan that had to be paid every month, and the band was running bingos to pay the loan. We felt that if we took over the community centre as the school we'd be able to pay the loan and take over its operation and maintenance. It was a really tough debate, with lots of angry words in the community, but we finally got the chief and council to agree to let us use the community centre for the school. They gave us the upstairs, which would allow us to provide classrooms for Grades 7 to 12. There was even a gym for the students.

While we were doing this, a group of parents of children from the elementary school came in to ask us about schooling for their children. We agreed to start with Grades 5 and 6, and it expanded from there to include the primary grades. We had explained to the parents that our arrangement with Wagmatcook demanded that we could only start taking students if there was a minimum of ten students per classroom. When we told them, "If you can get ten other kids to join up, then we can have that class," they went out and did the recruitment. That's how we ended up with about fifty students in the elementary school, as well as about fifty in the high school that first year in the community centre.

When we began to hire teachers, our priority was to hire Mi'kmaw teachers from our community, then Mi'kmaw teachers from outside the community, then any First Nations teacher. Unfortunately, we only had

two Mi'kmaw teachers — one from our community and one from another area. The rest of the teachers were non-Native and were mostly young and inexperienced. The Wagmatcook school board arranged for their principal to come two or three days a month. I worked as the co-ordinator of the school, and ran it on a day-to-day basis.

Operating a Community-Based School

We wanted to get the whole community involved with the school, so we hosted fall and winter mini-powwows. We had community volleyball tournaments and tried to encourage the involvement of kids who weren't attending our school through sports. But most of all, we wanted the parents to be active partners in the school.

When we received funding to renovate the community centre, we met with parents to show them the financial statements and explain how the money for renovating would be used. We also talked to them about school policies. When we expanded the school to include the elementary school, the parents screened the applications and chose who we would interview to teach the younger children. The day that the teachers arrived at the school, we invited the parents in for a big breakfast so that the teachers and parents could eat together.

From the start, we had a policy that parents could come into the classrooms at any time, providing the students weren't writing a test or something like that. That kept the kids on their toes and made them feel important. Then we opened a restaurant at the school. We put in a breakfast program, and had two prices at noontime: one for the kids at the school, and one for the community. If a parent came in, I'd arrange for them to stay for lunch for free because I wanted them to feel comfortable and to know that their opinion counted. Being able to eat there made them feel a lot more at home.

Once a month, I would get the restaurant to do two birthday cakes: one for the high school and one for the elementary school. And then we would put the names of all the kids who had a birthday that month on the cake, sing *Happy Birthday* to them and give the cake out. I did the same thing for Valentine's Day.

We found that some parents weren't coming to parent-teachers meetings, so we changed the procedure. To address the power dynamics of parents having to meet on the teacher's territory, we hosted potlucks in the gymnasium, with big tables of food. The parent-teacher sessions

would start at about eleven o'clock. Parents who were working could come for lunch, and talk to the teachers afterwards; they felt better about meeting the teachers informally, over food. It was as though the teachers were meeting them halfway.

Every Friday, as the students came down the stairs, I'd stand by the door and say to every one of them, "Have a good weekend! See you Monday!" I didn't want them to see me as somebody always off in an office, who'd they'd see only when they were in trouble.

THE SCHOOL AS COMMUNITY ECONOMIC DEVELOPMENT

Since one of our goals was to promote community economic development, we decided to pay teachers between $3,000 and $4,000 a year less than the provincial average so we could hire classroom assistants from the community. The elementary school had two classes in each room, so we hired two parents as classroom assistants. While the teacher was teaching one class in the room, the parent would look after the other. We also managed to have a computer budget and were able to hire someone to do programming and look after the computers.

There are many ways a school can generate wealth for a community. When you do renovations, you hire local people to fix the buildings. When you employ staff, you hire teachers, secretaries and administrative support, classroom assistants and janitors. When you want an arts program, you bring people in to do beadwork or make drums. All of these jobs give people an income. Also, you need someone to write the funding proposals needed to cover these expenses.

I wrote proposals all the time. It is really important that somebody do this for a community-based school. You can get extra dollars from Health Canada, from education authorities, from band programs, from people who are putting together libraries. If you get money from different places, you can do a lot! Our extra funding gave us a bit more room to manoeuvre and expand.

For example, we expanded when I learned that the province was funding adult learning programs. Since the school sat empty from 4:00 in the afternoon until the next morning, I submitted a proposal to start an adult high school. It was approved. Most of the people who came to the adult high school were women. They would attend from 4 p.m. to 8 p.m., and the restaurant would stay open until 6:30 so they could

have their dinner there. We taught academic subjects such as math, biology, chemistry, English — and Mi'kmaw language! We even had courses in physical education, because our science teacher had a physical education degree.

After five years of operating, we had a staff of thirty: thirteen teachers and seventeen staff people from the community. We kept our tuition agreements with Wagmatcook for three years, and then we negotiated our own. When the federal government recognized us as a school, we started to get the right amount of money for tuition, as well as money for operation and maintenance, which meant that we could hire janitors.

CULTURE-BASED EDUCATION

We knew that we couldn't operate the school without elders. We would often bring them into the school, sometimes to discipline the kids through talking circles, just to do talks or to visit, and other times to sit in on our parent-committee meetings. We had two school elders who came on a regular basis, one male and one female, and we provided them with a small stipend of $100 because we knew that they were on pensions.

Our approach to discipline was to promote responsibility in students. When students were out of control, I would take them into my office and we'd talk for a few minutes, and then I'd send them home and ask them to come back with their parents the next day when they were clear-headed. We'd send homework with them, and would check the next day to make sure that they'd done it.

When we first started, we took in a lot of kids that had been kicked out of the public system. There were some kids with ADD (attention deficit disorder). Others had reading problems or really difficult situations going on in their lives. We found that their education had been neglected because they'd been put into detention or suspended so often. Nobody had taught them how to read, so we created the Community-Based Learning Program for the kids who were having a really difficult time, and hired a reading specialist and two special-needs teachers, one for the elementary program and another for the high school program. The high school special-needs teacher developed the practical work experience program, because it wasn't unusual for these kids to go out to the community for different kinds of ventures since they were the ones

who had a lot of problems sitting inside the classroom. The special-needs teacher also created a home curriculum for our students with physical and developmental disabilities. This curriculum included life skills such as how to grocery shop, how to cook and how to do household chores.

Mi'kmaq cultural teaching was integrated into the core curriculum. Students were taught Mi'kmaw language for one or two periods a day. We taught a course in powwow etiquette. We also made sure that we had a drumming group, so whenever we had a mini-powwow, that group would be our drummers. We got a drum for the school and hand drums to use in the Grade 10 Mi'kmaw class. We went by the traditions — the boys learned to play the big drum — and the older boys taught the younger boys in the younger grades, as part of their culture class. Occasionally the girls would use the hand drums, but they were more into dancing, and bead work.

When we started the school, we would play *O Canada* in the morning. But then some of the parents came to us and said, "We do not want our children singing to an oppressive government. We want them to sing something from their own culture." And so we got the Mi'kmaw Honour Song — and every morning we would play it on tape over the PA system, even outside. And when it was played, people could not talk, they had to stand and listen. We found that the primary and first grade students picked up the Mi'kmaw language fast, so fast that they could sing along to the Mi'kmaw Honour Song.

We found that if we expanded the day by about thirty-five minutes, we could finish school in the first week of June. We had no air conditioning, so it was too hot for students to be inside the community centre, and if there were classes in June, the kids were all out powwowing anyway. So we talked to the parents about it, and they agreed to adjusting the school year.

PROBLEMS THAT DEVELOPED

As the school went on, there were some situations that we couldn't easily overcome. The teachers were poorly prepared by the universities to deal with Aboriginal students. We don't have an Aboriginal Teacher Education program in the Maritimes, and we don't have enough Mi'kmaw teachers. The Mi'kmaw teachers we do have tend to go back to the communities they come from. So at our school, most of the teachers were white, and this was the first time they were the minority. They had to accommodate themselves to us, but the Bachelor of Education

program did not adequately prepare them to deal with diverse groups, with students with special needs, with reading challenges or to simply work with students who look at the world differently.

They were also really unprepared and unsure of the community-centred approach. They wanted to change the framework of the school so that it was what they knew and not what the community wanted. In the public system, teaching is very much teacher-driven. Whatever the teacher decides is what happens. But in our school, it was different. The community had far more influence on the day-to-day operations of the school than at the public schools. And so we had these power struggles going on. Some teachers wanted it teacher-driven, the parents wanted it community-driven, and the administration wanted a balance between the two.

We had another challenge when the chief and council became the school board. As the school became more financially successful, they wanted to have more control over how we operated. When the school first began, nobody saw it as something that was going to be long-term. It was thought that it might last maybe six months or a year, and then we would get tired of it and all the kids would go back to public school. But we didn't close; instead, we expanded, and we began to generate revenue. That's when the situation became political.

My philosophy is that in order to have self-government, we have to have self-reliance. A school creates self-reliance because you have control of how your children are being educated and how they are learning to see the world. The school was creating community self-reliance because it generated jobs. It became a huge economic success, and I think this scared some of the people in the community. Many of our people are used to failure, and success frightens them. And because we had so much success, and because I had been running the school for so long, I became someone to be frightened of or concerned about. Had I been somebody who came in from outside the community, perhaps they would have treated me differently. But I was well-educated and I really believed in community economic development. I was using terms that were probably alien to them, and I was pushing for things constantly, for ways to expand. I asked questions about the band administration because I wanted to know where the dollars were going, so I may have been viewed as a hindrance from the band's perspective.

As time went on, a few teachers who wanted the school to be teacher-driven began to do some politicking with people in the

community. I had always stated in the teachers' contracts that it was inappropriate for them to get involved with the day-to-day operations of the band, but it happened and they became very disruptive. In the end, the band tried to transfer me to another position in the middle of my contract. I fought back, and we eventually settled the contract, but I was on my way. And soon, I was out of the school altogether.

It has been a couple of years since I left. There have been some changes since then. When I left, they replaced me with a non-Native person as principal and that person's training fell into place. For me, the school became a non-Aboriginal school on an Indian reserve. It became driven much more by what the teachers wanted and not by what the community wanted. The student population decreased from one hundred and seventy down to eighty.

Because it became so teacher-driven, people have forgotten what they are doing there. We started the school because the students needed to be educated in a way that would make them feel good about who they were, and teach them the necessary skills that they needed to function in any society. But now the kids are being suspended, and that's what they had off reserve in the public school.

In addition, many of the parents have put their elementary school children back into the off-reserve school. It may be because the teachers implemented a work week which ended at noon on Friday. The parents were at work and the kids were home, so that may be why a lot of them put the kids back in the off-reserve school.

After I left, the restaurant closed. There wasn't a homey-type feeling any more, and so parents lost their involvement. Due to the budget restraints, the school recently laid off about two teachers and four support staff. Most of the people who have lost their jobs have been people from the community. So the school also doesn't really function as community economic development anymore, either. With nobody writing proposals, they've lost funding and the adult high school had to close too.

*

The school's framework we built is still there, and I firmly believe it could be revitalized if those involved could find an Aboriginal person who has a feeling for what needs to be done in the community. They need somebody who is willing to set the interests of the school first, who

will do things on a shoestring, who can find alternative sources of funding, and who is willing to be creative and a risk-taker. They also need somebody who can strike a balance between the community and the teachers and the band council. Finally, the band council shouldn't be the school board. We need to create a separate school board, elected by the community. That way, politics won't get mixed up in the running of the school.

I really would like people to understand that schools *can* be community-driven. You can have parents involved and you can bring them into the classroom. They don't only have to be the person who looks after the kids during recess. Parents can do a whole lot more than just being monitors in the classroom or schoolyard or cafeteria. Parents are ultimately where the child's education begins and they influence where it goes. They need to be inside the classroom, screening who will teach their kids, learning about finance and policies. They need to have the opportunity to say to the teacher, "This is how I want my kids educated." They need to feel welcome and given the opportunity to get inside that classroom. Because ultimately, they're the ones who are going to make a difference in their child's education.

The other day I was in the shopping mall and I met a young man who used to be a student in our community-based learning program. He'd had a lot of problems with all the other schools he had been in, but our school worked for him. He's working now, and when he saw me he gave me a big smile. To me, this is an example of the type of success we can have if we take control of our education. And if we can provide a culturally appropriate, community-based education, maybe our students can go on and become part of a governing body for our community — and in turn, make sure we have a school that makes a difference.

FETAL ALCOHOL SYNDROME: THE TEACHERS AMONG US

Rebecca Martell

If you are alert, a teacher will come to you. It's up to you to embrace the learning.

— ELDER EDWARD BELLEROSE, DRIFTPILE FIRST NATION

IN 1975, WHILE TRAINING in Native addictions at the Nechi Institute in Edmonton, I noticed an advertisement for foster parents in our Native paper. Interested, I applied. After undergoing endless interviews with social workers, I eventually gained foster-parent status.

Two weeks later, I opened the door and was struck by the elegant features of the seven-year-old boy standing in front of me. A matronly social worker stood behind him, there to deliver my first foster child. Little did I know that this moment would begin a lifelong journey of learning from many new teachers; a journey I could never have predicted.

When the caseworker left, the boy's dark eyes followed me as I moved around the house, but he never uttered a word. When I gently touched his shoulder to instruct him where to put his knapsack, he jerked away, moving out of my arm's reach.

Over the next month, my foster son did not speak to me. Not wanting to be touched, he kept his distance. He would willingly attempt

whatever I would ask of him, but he could also grow frustrated and angry, striking out at objects when he was unable to accomplish simple tasks. I began to realize that my idea of raising a child was more of a fantasy — one that was not going to become a reality with this small boy.

School, too, was a challenge. The day of registration I discovered that he had never attended school for more than a few months at a time and so would have to begin with the first-grade children. New clothes and a lunch pail seemed to soften the blow on his first day in school, but a teacher's note about his anger on the playground told a different story. From then on I received weekly reports of a child who was sullen and unresponsive in class, and my first parent-teacher interview found me agreeing with the teacher that my foster son had problems fitting into the school system. The school counsellor, who also attended that first interview, announced that this boy's problems could be fixed with more discipline and parental control. I left the meeting feeling defeated.

Two months went by. One day, as I was passing by the hall closet, I overheard my foster son whispering behind the closed door. I felt startled to hear him speaking, and I gently encouraged him to come out and tell me the story he was sharing with our kitten. This was a major breakthrough, and over the next few weeks he began to talk more frequently. He kept me busy trying to piece together the threads of his life from what appeared to be fanciful stories. He would say things like "I'm not scared of the dark because my mother used to make me wait outside 'til she came out at night," or "I got all our food and cooked for my sisters." These shreds and remnants of his previous life told the story of a fearless child, but it did not make sense. This brave-sounding boy was the same child who had me up repeatedly in the night to soothe his terrors. I would sit beside him, one hand resting on his racing heart, the other stroking his hair until he fell back asleep. Too many times I would have to change wet sheets and dispose of food squirreled away under his pillow before finding my way back to bed.

Despite the fact that he was showing progress at home, school emergencies continued. One Friday afternoon I received another crisis phone call from the principal — I was in such a hurry to reach the school that I was pulled over by our local police officer when I ran a stop sign. When I told him what the problem was, he offered to escort me to my foster son's school, lending me his strength until the crisis was settled. That evening, after I had gotten the small boy tucked in for the night, I sat at the kitchen table with a cup of tea. It had been three months of

living with my first foster child — three months of his rejecting my motherly attention or affection, of bed-wetting, of inappropriate social behaviour and an inability to cope in school. Believing it was my ignorance that thwarted his daily care and development, I felt inadequate and poorly trained to fulfill the role of a foster parent. I made the difficult decision to contact Social Services and ask them to find someone who could better provide care for this beautiful child.

I was reluctant to think about the call I was going to make on Monday morning, so that Saturday I buckled my foster son into the truck and we drove out to spend the day at the Stony Plain First Nation Powwow. Following me through the crowd all afternoon, he clung to my long skirt, seemingly unaffected by the swirling colours of the dancers or the sound of the drums around him. At the end of that long, hot day, we went back to the truck and found my uncle Ed Bellerose leaning up against the tailgate, sharing in the laughter of Elders. As I approached the old men to shake hands, Uncle turned and crouched down, drawing the boy out from behind my skirt. Looking gently into fearful eyes, he asked, "Who is this small man?"

I introduced the Elders to the boy, feeling bad about presenting a child who, in all likelihood, they would never see again. Rising to his feet, Uncle placed his hand on my foster son's silky black hair. He looked off into the distance and said simply, "Whoever takes care of widows and orphans shall be rewarded ten times in their life." Shame and embarrassment followed me home. On Monday morning, when I called Social Services, my uncle's words still rang in my ears. Instead of asking my caseworker to take the child away, I asked for help.

Within hours we found ourselves in front of Dr. Jane Silvius, a child psychologist and founder and director of the Child Development Centre in Edmonton. We briskly shook hands, and then she escorted my foster son into her office. I sat alone in the waiting room, trying to concentrate on magazines, all the while berating myself for my inability to care for this special child.

Some time later, Dr. Silvius emerged with my foster son tucked protectively under her arm. She asked a staff member to take him to the playroom and invited me into her office. It was 1975 and Dr. Silvius proceeded to change my life when she began to teach me about fetal alcohol syndrome. We met with her regularly, and one of the things I asked her was to interpret the stories he was telling me about his life before he came into care. To do so, she had to direct Social Services to

open his case file in order that we could understand his past, and so we began to explore five years of my foster son's life.

The file told us about his mother, a Native woman battling alcoholism, who was struggling to raise three small children alone in the inner city. My foster son was her first-born, and long before he was ready, he had been thrust into the role of protector of and provider for his two small sisters, the youngest of whom was developmentally challenged. Although she was valiantly trying to fight her addiction, his mother had lost her children to "the system" each time alcoholism consumed her.

Dr. Silvius showed me how the particles of a wounded child's memories had grown into exaggerated truths and an idealized family. She helped me to realize how his stories held clues that could help us piece together the picture of his fight for survival. The records reflected that his comment about not being scared of the dark spoke of the time Social Services found him waiting outside the doorway of a bar at midnight, and had taken him into care. His remark about getting food and cooking for his siblings referred to the time an anonymous caller contacted Social Services and a caseworker was sent to an inner-city apartment where he found a boy trying to fry uncooked rice for his two little sisters. The children had been left alone for three days and had no other food.

Under Dr. Silvius's tutelage, I began to understand how children are affected by trauma in their developmental years and that these traumas are magnified in a child affected by FAS/E. She taught me how the childhood experiences captured in my foster son's stories could be used as building blocks to maximize his abilities and develop his role as a protector and provider. With infinite patience, Dr. Silvius taught me how to understand FAS/E and gave me tools and coping skills that provided me with a strong foundation to work from. She was my first teacher and for the next ten years, she helped me raise a special boy into a young man.

By 1978, Native counsellors training in the field of addictions were being taught that FAS/E was a totally preventable birth defect. However, we soon discovered that prevention was not that straightforward. Discussions about FAS/E inevitably led us to explore the many factors woven into the fabric of a historical heritage that brought many Native people into the twenty-first century in pain. Our Elders taught us that alcohol was used as a guaranteed painkiller for those who drank to deal

with the generational pain of societal oppression, and women who had learned to use alcohol as an effective way to deal with their unhappiness brought the complex issues of substance abuse to their pregnancies. New challenges faced us.

I knew my foster son was not old enough to understand the concept of generational pain that we discussed as counsellors. I also knew that I needed more than counselling theories to help him and, instinctively, I realized that I would need to find a Native woman who would be willing to share from her heart, one who could teach me more of what I needed to know as a woman in order to mother this special child. With tobacco, I asked the Creator for help.

I admired a woman counsellor at the Poundmaker Lodge Native Treatment Centre. Eva Cardinal wove the Cree language into all her conversations and possessed a dignity and pride in being a Native woman that I did not have. I longed to ask her a thousand questions about being a mother, but was intimidated by the power of her presence. Lacking courage, I silently offered my tobacco to Mother Earth and prayed for direction.

A week later my phone rang in the Nechi office where I was working. Upon answering, I heard a very dignified voice say, "Mrs. Martell, this is the Charles Camsell Hospital calling. We would like to let you know your prosthesis is ready to be picked up." Stammering, I responded, "But I don't have one — or need one — I have no limbs missing!" Suddenly Eva's rich warm laughter broke out and I could hear the laughter of the counsellors behind her. She had seen a young woman in need of guidance, and with humour had reached out to me. The Creator had heard my cry for help.

Eva agreed to meet with me, and over lunch she shared my tears as a mother. She was only ten years older than me, yet her teachings of unconditional love as a wife and a mother gave me a glimpse into a compassion and kindness I had never before witnessed. She painted a picture that allowed me to understand how the multi-generational pain I had been learning about as a counsellor can cause not only individuals, but also families and whole communities, to turn to alcohol and drugs for relief. Sharing with me the teachings of the Elders, she spoke of being non-judgemental in the face of such knowledge. That afternoon, she gave me the answers I desperately needed, not just for my son but also for myself as a woman.

My mind was reeling as I went back to the Nechi office. Suddenly,

my work in Native addictions took on a deeper meaning. More importantly, that evening when I watched my foster son take a banana from a fruit-laden basket and hide it in his shirt, I began to see him in a new light. In that moment, I began to understand fetal alcohol syndrome from the heart.

Teachings from the Source

In 1980, I was led to new teachers on the northwest coast. Travelling into Tsimshian territory to facilitate workshops on Native addictions, I met Vera Henry, a community health representative in Lax Kw'alaams. Already a grandmother, Vera was intent on learning the skills she needed in order to become an addictions counsellor and gain new information on FAS/E so she could help her community.

Vera welcomed me into her home to share a meal of fresh oolichans with her family. That evening, she shared her hopes for the people and spoke of her fierce commitment to finding answers for the damage caused by addictions. The next day, we left Lax Kw'alaams and journeyed together for six weeks into northwest Native communities. In quiet moments, sitting in the back of the ferry or walking on the beach, Vera would speak about the need for First Nations to have special schools, trained Native teachers and their own community-based programs for children affected by FAS/E. She spoke to me of a future when each Nation would offer a lifetime of love and support for adults affected by fetal alcohol syndrome. My tobacco had brought a teacher with vision.

This experience made me want to explore the legacy of knowledge passed down through the women in my own bloodline. When I returned home, I approached my mother and asked her to share her own matrilineal teachings. She responded by sharing her knowledge of a spiritual source of goodness that comes simply from being born a woman. My mother helped me to realize that the foundation of a woman's power begins with her own creation. This power grows when we carry the future of the people under our heart and is magnified in our service to family and community. My mother was a woman who sacrificed her body to give life, and who gave a mother's unconditional love. She had revealed her own power as a woman through a lifetime of selfless care for others. Her teachings of the power of women echoed at a spiritual level within me.

I began to weave my mother's lessons on nurturing and care into my daily life with my foster son. Standing on a stool, stirring whatever was in the bowl, he learned the value of shared labour as we ventured into lessons on cooking. As I taught him how traditional foods nourish our bodies, he came to understand reverence for the animal that sacrificed its life to nourish our spirit. He began to enjoy the sense of completing a task and gained a new-found sense of achievement when we did the dishes together after dinner. As he learned to read labels in the grocery store, he learned the value of making good choices, and our laughter over spills taught him that it was okay to make mistakes. With each accomplishment, I saw the fear of not being able to succeed fade a little more from his eyes.

We had many successes, but it was not always easy. Seeing this, my mother quietly handed me a grandmother's gift of eternal patience. Patience is essential in child rearing, but it becomes even more important when dealing with a child who is challenged by FAS/E. Teaching him to do what I thought were simple things, like washing with a face cloth or brushing his teeth, had to be patiently retaught on a daily basis. The constant repetition required during long hours of homework each evening often found us both struggling for patience. I also discovered a brand-new opportunity to practise my patience when I had to make repeated visits to my foster son's school to educate the educators on the special learning needs of the FAS/E child. Our patience often stretched thin; time seemed to pass in a blur of constant challenges.

One evening when I was washing dishes, I felt my foster son touch me for the first time. Pressing his back up against mine, tucking his small head into my waist, he moulded himself into the safe warmth of a mother. We stood silently back-to-back. It had been almost a year of waiting — patiently.

It Takes a Community

In 1985, I gave a presentation on Native Addictions and Fetal Alcohol Syndrome at the Prince Rupert Friendship Centre. There I met Sandra Dan, a woman from the Stolo Nation who had married into the Haida village of Old Massett. Her education in social work and her background in addictions was a gift to the community. Sandra shared with me the work she was currently doing to address FAS/E within her community.

A number of years later, the chief and council of Old Massett asked Sandra to create specialized programs to address addictions. She invited me to participate and asked if I would develop a series of addictions-awareness workshops and a community plan of action for children who might be identified with special needs. I accepted, and asked my associates Sharon Brintnell and Sylvia Wilson of the Occupational Performance Analysis Unit of the University of Alberta to work with me on the project.

Building on what Sandra Dan and the people of Old Massett had already developed, we explored new solutions for children and adults affected by fetal alcohol syndrome/effects and designed a model that would combine the sophistication of Haida civilization with the modern techniques offered by the university. Our blueprint for problem solving and program planning focused on three sectors of the community: health practitioners, teachers and families. We flew to Old Massett and presented it to the chief and council, who directed us to work with Sandra and to present a series of community-awareness workshops that would provide information about FAS/E. Participants in the workshops exchanged stories, asked questions and became involved in a process of experimenting with the blueprint in order to develop their own unique community plan of action to deal with FAS/E.

On our first visit to Old Massett, Sharon and Sylvia were already creating solutions for the school children with special needs. We spent an afternoon with the children and counsellors at the Family Centre, where playtime found young boys climbing over each other in a concentrated effort to get the basketball into the hoop. They didn't hear the cries of the young men cautioning them to "go easy" and "be careful." Sylvia, who had been observing this interaction, rhythmically clapped her hands. The boys stopped in their tracks. When they turned to look at her, she said, "Let's take a juice break." Laughing, they rushed over for juice.

The sound of Sylvia clapping her hands symbolized the rhythm of Mother's heartbeat in the womb and became the foundation for a proposed "Haida classroom management model." She suggested that Haida men make hand drums for each classroom, and that when the voices and energy of the FAS/E children reached a peak during the course of the day, the teacher could pick up the drum and quiet the children with a call back to the heartbeat of the Mother. It seemed simple enough, yet it was a tool we had not known up until this point.

The university team eventually came to include two students who were supervised by Sylvia and who worked in the community under Sandra's direction. Sandra and I met them when they got off the float plane, took them to buy rubber boots and helped them move their things into an apartment provided by the Village Council. It was our task to help them fit into the community. We took them to their first meeting with the chief and council, instructed them in cultural protocol when dealing with Elders, and spent wonderful hours making home visits where we sampled the joys of Haida food and hospitality from one end of the village to the other.

The students immediately became involved with the community. They provided FAS/E education and awareness workshops to community members, developed an understanding of school dynamics and trained staff at the Family Centre. They also met with the band manager and economic development co-ordinator to address the immediate and long-term planning needs for individuals affected by FAS/E.

Upon completion of the project, the university team presented the chief and council with a final report and recommendations. One recommendation was that school children affected with FAS/E be included in regular classrooms in the morning, but spend afternoons in special learning areas to be created in the Family Centre. Here, specially trained teachers and aides would guarantee the low student-teacher ratio that is crucial for teaching children with special needs. The team recommended that special classrooms be constructed from natural materials, pointing out how environment plays a key role in learning for FAS/E children. Cedar plank walls from the forests of Haida Gwaii, stones washed smooth by ocean waves, natural light and private areas for individual or small group work would reduce the stimulus that hinders learning for these children who have difficulty paying attention.

The community was also advised to implement FAS/E intervention within their health, social and school systems and to address FAS/E prevention at a community level. It was recommended that Haida art and life skills be taught in the school curriculum and in FASE/E adult life-skills classes. Sharon addressed the long-term needs of individuals affected with FAS/E, pointing out the benefits of early intervention, specialized training and a supported living environment — elements that are necessary to live healthy, productive lives. From these observations came the final recommendation for a whole-community plan of action to address FAS/E.

We left Haida Gwaii with the realization that the Haida teach a cultural form of community development. With an established sense of identity, they stand secure in their own cultural foundations and are courageous in their willingness to embrace strangers and new information; an important dynamic in the development of any community. The meaning of collective power in community development came alive for me the night I watched the people of Old Massett adopt the University of Alberta team into Haida Clans and families at a community feast. I had learned from mighty teachers.

Taking the Challenge Home

When my uncle said "Whoever takes care of widows and orphans shall be rewarded ten times in their life," I did not realize the rewards would be stretched out over the course of a lifetime, or that they would come wrapped in the knowledge of many teachers. The boy who came to my door as a foster child was my first FAS/E teacher. In becoming my son, he forced me to look ruthlessly within, where I found the need for lessons on self and motherhood. His own daily struggles taught me the value of being alert to the teachers among us and committed me to a lifetime of being a student.

My foster son left to find his birth mother when he was eighteen. We learned of her origins in the far north and he made contact with new relatives. I remember how anxiously he prepared to meet an extended family that had just learned of his existence. The day he left to find a new identity and sense of belonging, my foster child gave me another gift — one of courage. He taught me how to have courage when you need to make yourself belong, when meeting new challenges and when creating a new life for yourself. My son's bravery was rewarded when he was welcomed and cherished by the family of his blood. His courage taught me to see that a person affected with FAS/E has far-reaching possibilities and gave me the wisdom of never setting limits on oneself or on others.

Many teachers have come to me over the years. More children affected by FAS/E have come to live under my skirts, each intent on teaching me new lessons about motherhood. Strong Native women have taught me to stand in my power as a woman, while Grandmothers have demonstrated the values of unending patience and sacrifice-of-self for family and community. Through my work with First Nations across

Canada, I have learned the importance of honouring each community's unique cultural and community spirit in finding their own answers for FAS/E. The commitment of countless individuals and the dedication of caring professionals have taught me how to synthesize the deep truths of many different cultures. These teachings, revealed through the creative insights of compassionate people whose courage is consistent with their most valued ideals, have motivated me to become a greater part of the solution.

I am grateful to have been rewarded with the knowledge of many teachers. Yet this journey is not over. Now halfway through my life, with sacred tobacco guaranteeing the prophecy of the Elder, I am eager to meet the new teachers of FAS/E and their lessons that await me.

* A different version of this article was first published in *Aboriginal Approaches to Fetal Alcohol Syndrome/Effects: A Special Report by the Ontario Federation of Indian Friendship Centres* (Toronto: OFIFC, 2002). Reprinted with the permission of the OFIFC.

FROM VICTIMS TO LEADERS:

ACTIVISM AGAINST VIOLENCE

TOWARDS WOMEN

Cyndy Baskin

She's a nine-year-old girl child lying in the late-night darkness. She ought to be asleep — there's school tomorrow — but she's wide awake. She wants to put the pillow over her head to quiet the noises coming from downstairs. But the little ones are waking up in the next room. They're calling for her in frightened whispers. She goes to them.

*

This girl is thirteen. She lies on the couch; her face buried in a corner. Her family has just received some tragic news. Her only uncle has shot and killed his wife and then done the same to himself.

*

The young woman is about eighteen years old: very thin, sad. Her face is bruised, but so are her arms where several tubes enter. Her throat hurts and her mouth is dry. A man enters the room, identifies himself as a psychiatrist, asks her if she ever hears voices. Later a

nurse comes in, checks all the machines, tells her she's lucky to be alive, lucky not to be "a vegetable," suggests that the next time she wants to kill herself she should try drowning. No one has asked about the bruises on her face.

<center>*</center>

A large, still room, filled to capacity with people writing. They're all there to write the exam for their three-year Bachelor of Social Work degree. Her face — mid-twenties — is creased in both concentration and pain as she awkwardly writes. She's right-handed. Her right wrist, wrapped and in a sling, is bruised and sprained. She's told anyone who asks, including her doctor, that she fell down the stairs.

<center>*</center>

By her late twenties, this woman is involved in therapy with a white social worker and is attending traditional healing ceremonies with women Elders. She works as a cultural therapist in a sexual abuse treatment program at an Aboriginal agency. A thirteen-year-old victim asks her why she has to come for healing when her adult brother who abused her does not. The woman has no answer.

<center>*</center>

ALL OF THESE STORIES ARE MINE. Many years have passed and I've grown into a very different person. I have not personally experienced violence for a long time, and I am honoured by having a loving partner and a young son. I have worked in the area of family-violence intervention for the past fifteen years. Although I am no longer a front-line worker, I continue to act as a consultant, trainer and advisor for many Aboriginal agencies and communities. My activism will continue until I pass on to the spirit world. I will forever do what I can to eliminate violence towards women and children.

I suppose I got into the work of anti-violence because of my personal background — both in terms of personally experiencing violence and in being helped to finally get away from it. I was called to the work in a spiritual way, I think. I am so conscious of the fact that I would not have lived this long if I had not received help and that I have a responsibility to give back in exchange for what has been given to me. I also believe that I personally experienced the pain of violence so that I would have the necessary understanding to assist other women in their healing process.

Let me locate myself. I am of Mi'kmaq and Irish descent, originally from New Brunswick, but I've lived in Toronto, Ontario, for many years now. My spirit name translates into something like "The Woman Who Passes On The Teachings" and my clan is the Fish (Salmon). I try to live my life and raise my son according to the traditional teachings and values of Aboriginal cultures. I do, however, have a foot in the mainstream world of work and school. I am an Assistant Professor in the School of Social Work at Ryerson University in Toronto and am working on a PhD in Sociology and Equity Studies at the Ontario Institute for Studies in Education/University of Toronto. I am straight, able-bodied, lower middle-class. My partner and I have a modest house and a car. I struggle with two mental illnesses. Despite debt and financial difficulties, my life is light years away from its origins of crushing poverty. I am the only one in my extended family on both sides to have gone so far in university. I am a clear combination of both oppression and privilege.

My activism in family-violence interventions focuses on my role and responsibilities as an Aboriginal woman, an auntie, a sister and a mother. It does not focus predominantly on liberation from male domination, but rather on liberation from colonial policies and oppression of Euro-Canadian society and governments. It includes the healing of our male abusers and the active assistance of our healthy men. This work ranges from challenging individuals on their abusive behaviours, to developing anti-family violence programs, to changing laws that continue to victimize Aboriginal women. It also includes educating and confronting non-Aboriginal society about the oppression of First Nations people. My goal is to help make the world a better place for my child and the next seven generations.

Family Focus

In family-violence interventions, it is clear that a community-controlled and culture-based approach is necessary. Such an approach must be holistic in nature and, therefore, needs to include interventions that provide community education, treatment for the entire family and an alternative to the current criminal justice system.

Aboriginal peoples choose to refer to abusive behaviour in intimate relationships as family violence because of the value we place on the family and on our holistic world view. The well-being of the family and community is valued above that of the individual, who is seen in the

context of the family, which is seen in the context of the community. Thus, from this holistic perspective, when an individual is harmed, it is believed that all others in that individual's family and community are harmed.

This perspective, then, means that interventions in family violence must focus on both victims and offenders — women, children and men. It does not negate the fact that, in Aboriginal communities as in wider society, it is usually women and children who are the victims of violence and men who are the perpetrators. However, it does mean that family violence is seen as a community problem that requires all members of the family to go through a healing process. Because I believe that family violence is learned behaviour which can be undone, I do not believe that the abuser in the family must be sacrificed.

An Aboriginal holistic approach to healing helps each family member to recover from the confusion, insecurity, powerlessness, anger, shame and inferiority that are a part of the violence. The approach teaches non-violent ways of relating to other family members that are based on Aboriginal values, which include the use of traditional teachings and ceremonies. Healing for families does not mean family therapy; it usually means healing circles and ceremonies with other community members who are in similar situations.

A holistic approach also aims to avoid isolating family members and the problems related to family violence. Mainstream service providers who work with abused women have been criticized for such isolation, because they are seen as having "a polarized understanding of violence against women":

> Women are seen as pure and blameless victims and men are seen as brutal, cruel victimizers who have never been tender. This approach not only tends to isolate battered women, but to fragment the services created to reach them ... Battered women may be isolated from the batterers and may be encouraged to view them as unreachable, hopeless and unchangeable.
>
> These stereotypes encourage polarized thinking and labeling, rather than more holistic solutions which take many variables into consideration.[1]

DEFINITION OF FAMILY VIOLENCE

In mainstream literature, the closest definition of violence in intimate relationships that fits with an Aboriginal perspective is a feminist defin-ition of violence against women. Both a feminist and an Aboriginal definition of family violence goes beyond individualizing it and links it to the wider society and the systems under which we live. From a femi-nist perspective, violence against women is defined as

> a multifaceted problem which encompasses physical, sexual, psy-chological and economic violations of women and which is integrally linked to the social/economic/political structures, values and policies that silence women in our society, support gender-based discrimination and maintain women's inequality.[2]

We can take this analysis one step further and see that inequality is based not only on gender, but also on race, class and an ethic of domination, as defined by the 1989 National Forum on Family Violence:

> The ethic of domination has allowed men to dominate women, par-ents to spank children, one class or race to devalue and control another ... We have come to believe that this is morally right because the "other" is of inferior rank in our hierarchy of values — due to gender, age, race, physical, mental or economic difference ... The right to use violence, if necessary, to maintain that domination is based on our belief that it is morally right to do so for the sake of preserving order and is made easier by the belief that the other is of inferior ability, responsibility or status.[3]

In defining family violence, Aboriginal peoples have applied this concept of domination to our specific history. Thus, family violence is defined as

> a consequence of colonization, forced assimilation and cultural genocide; the learned negative, cumulative, multi-generational actions, values, beliefs, attitudes and behavioural patterns practiced by one or more people that weaken or destroy the harmony and well-being of an Aboriginal individual, family, extended family, community or Nation.[4]

HISTORICAL CONTEXT

In order to understand the Aboriginal definition of family violence, one needs to have an awareness of Aboriginal history. Prior to contact with

Europeans, Aboriginal peoples had their own values based on their culture and spirituality, governments, laws and means of resolving disputes. Elders were responsible for collectively teaching the people their history, traditions, customs, values and beliefs and in assisting them to maintain their well-being and good health.

Aboriginal peoples believed that all life was interconnected, and one of their central values was conformity with the group and harmony within it. Thus, the individual was connected to the family which was connected to the community which was connected to the Nation. The Nation was connected to the earth and everything on it, all of which was connected to the spirit world.

This holistic worldview saw the individual as being made up of four aspects — psychological, physical, emotional and spiritual — and the focus was on keeping all four aspects strong. In Aboriginal belief systems, if the body weakened and was the only part that was treated, then healing could not effectively take place. If the body became ill, then the spirit, mind and emotions were affected and had to be treated as well.

European peoples came to this continent with a worldview, values and beliefs based on Christianity. The process of colonization grew in large part out of a Christian belief that humankind was to "fill the earth and subdue it, rule over the fish in the sea, the birds of heaven, and every living thing that moves upon the earth."[5] This worldview was in direct contrast to that of the interconnected, holistic one of the original peoples of this land.

The *Indian Act* of 1876 was the vehicle by which the goal of assimilating Aboriginal peoples was to be implemented, and it governed every facet of Aboriginal life. Through this Act, the Canadian government sought to make Aboriginal peoples into imitation Europeans, to eradicate Aboriginal values through education and religion, and to establish new economic and political systems and new concepts of property. Specific practices of assimilation included the outlawing of traditional Aboriginal ceremonies, the enforced training of men to become farmers and of women to become domestics, and a systematic indoctrination of Christian theory and practice through the residential school system, which equated Euro-Canadian socio-economic standards and materialism with success, progress and civilization. The establishment of residential schools was rationalized by the belief that these institutions would make Aboriginal children competitive with whites as moral, industrious and self-supporting individuals. In short, they taught

Aboriginal children to aspire to be more like Euro-Canadians rather than to be who they were.

An oppressive, bureaucratic system of government was imposed upon Aboriginal peoples at the cost of many of our traditional governing practices and spiritual beliefs. This, in turn, has created great social confusion within Aboriginal communities. Canadian-Aboriginal relations have provided the environment in which profound social and economic problems, such as family violence, have taken root. The issue of family violence cannot be separated from the larger issues in Aboriginal-Canadian relations because it has arisen from, and is in response to, these larger issues.

For example, residential schooling can be directly linked to family violence in Aboriginal communities. In addition to the widespread abuse of the children who attended these institutions, the schools led to the decline of parenting skills among the children because they were denied access to their appropriate parental role models. The removal of Aboriginal children from their parents, extended families and communities continued with the child welfare system well into the 1980s, which consistently placed children in non-Aboriginal families and communities. Hence, generations of Aboriginal children were deprived of the love and comfort of family life and they did not learn about the central role the family holds in our culture.

From an Aboriginal perspective, family violence in our communities is the result of, and a reaction to, this system of domination, disrespect and bureaucratic control. Aboriginal peoples have internalized this oppression and it has affected the family. The treatment of women and children within the family is a reflection of the treatment of Aboriginal peoples in this broader context.

The Criminal Justice System

Proportionate to other Canadians, Aboriginal peoples are over-represented in Canada's jails and prisons. Since the 1970s, Aboriginal peoples have found themselves increasingly engaged with the criminal justice system, which does little more than send them to jail.[6] Many Aboriginal peoples do not see the Canadian justice system benefiting them and are demanding their own separate system. There is a fundamentally different understanding of the justice between the dominant society's view and the Aboriginal perspective. In the dominant society, the emphasis is

on punishing the deviant as a means of making her or him conform and as a means of protecting other members of society. The purpose of the justice system in Aboriginal cultures is to restore the peace and equilibrium within the community, to reconcile the accused with her or his own conscience and with the individual and family that has been wronged.[7]

In the traditional way, wrongdoing is a collective responsibility, and the process of correcting the wrong involves all parties acknowledging the wrong, allowing for atonement and choosing reparation or compensation that restores harmony to the community. This could involve an expression of regret for the injury done by the offender or the presentation of gifts or payment of some kind.[8] The central cultural imperative is to prevent violent acts of revenge or retribution. In this way, responsibility is placed on the wrongdoer to compensate the wronged persons and makes the offender responsible for the maintenance of harmony. To Aboriginal peoples, incarcerating the offender or placing her or him on probation means relieving the offender completely of any responsibility for a just restitution of the wrong. It is viewed as a total vindication of the wrongdoer and an abdication of the duty of justice. Many Aboriginal communities are implementing this traditional way of justice. In addition to this process, offenders who have assaulted women are required to participate in culture-based programs that focus on healing family violence.

MINO-YAA-DAA PROGRAM

All of this theory — or what I prefer to call an Aboriginal perspective — went into the development and implementation of a family-violence intervention program that offered services to children, women and men in an urban Aboriginal community of about three hundred people. I was involved in all aspects of the program, which ran from 1995 to 2000. This is the work that I am most proud of and which has been the most rewarding because I was able to watch as people dramatically changed their lives.

Early on in the planning stages, women and children attended a circle to give the program an Aboriginal name. Since most of the community members who attended were Ojibway, an Ojibway name was chosen — Mino-Yaa-Daa — which means "healing together." The Mino-Yaa-Daa Program offered services to children on a rotating basis according to age. It was important that the children felt special, so the

facilitators were supportive and encouraging and the activities included learning the responsibilities of caring for sacred objects and lighting the fire and smudging, which helped them feel good about themselves as Aboriginal. Because the relationship between children and facilitators was equally as important, the development of trust, security and a safe environment were emphasized, as were firm but caring and consistent guidelines to help them feel safe and learn how to set appropriate boundaries with others. Respect for the needs of children and their ownership of the circle were also priority concerns. Thus, the children themselves, rather than the facilitators, set most of the boundaries and rules for the circle and dealt with the consequences of breaking them.

Activities for the children's circle were developed around these goals and objectives. Some of these were the development of self-esteem and a positive Aboriginal identity; learning appropriate expression of feelings and safety in the home and the community; letting go of self-blaming attitudes around issues related to family violence; learning healthy ways of coping with problematic situations; and resolving conflicts without violence. Other components included Elder's teachings and attending spiritual ceremonies such as the Sweat Lodge and Full Moon ceremonies.

All of these factors created an accepting, non-judgemental atmosphere where children could share their stories and feelings about their experiences of family violence; they knew that what was said in the circle, stayed in the circle (with the exception of child protection issues, of course). In doing so, they learned that they were not alone, that they were not the cause of their parents' actions and that breaking the silence helped to change how they felt about themselves.

The Mino-Yaa-Daa Program also brought the community's women together. Only through women joining together can the disempowering silence around issues related to family violence be broken. In the circle, women learned that they were not alone and that their situations and feelings were similar to other women's. They learned how to trust, take risks and both give and receive support, thereby building relationships and a community of empowered women, which can only be achieved by coming together in a circle; these cannot be achieved through individual counselling or therapy.

As with the children, the women needed a safe place of their own in order to express their needs and concerns and begin their healing process. Therefore, they negotiated their own boundaries for the circle

to meet their needs of safety and comfort. The most important boundary was confidentiality, which was respected by both facilitators and participants. All community women were invited and welcomed into the Program. There were no prerequisites — women did not have to abstain from alcohol and drugs (except when coming to the circle), they did not have to currently be in an abusive relationship and they did not have to live a traditional lifestyle in order to attend. And no one even had to talk if she didn't want to!

The circle implemented both culture-based and mainstream healing practices (as long as these were compatible with the values of Aboriginal cultures). Medicines for smudging, sacred objects for holding and traditional teachings on the topics raised in the circle were always available but never pushed on anyone; the choice of using them was left to each individual woman. Within the circle, participants and facilitators addressed areas of self-esteem and positive identity; healthy relationships with children, partners and community members based on non-victimization; identification, expression and appropriate release of feelings; conflict resolution; healthy and empowering coping behaviours; letting go of past experiences which interfere with today; decision-making; and planning for the future.

There were two important elements that were emphasized in the women's circle. The first one was for women to learn how to take the tools they learned in the circle into their daily lives. This was important because what was learned in the circle needed to have value to women in practical ways. The second was the need for women to support one another and develop friendships outside the Program. This was important to create the Aboriginal culture's value of interdependency, which emphasizes that everyone has their own internal gifts and resources and the natural ability to help others. The other services offered to women included Sweat Lodge ceremonies; Elders' teaching circles; Full Moon ceremonies; and individual crisis intervention sessions. Incorporated into all of these services was the Aboriginal belief in the healing powers of laughter. We had fun, too!

In order to fulfill the Program's goals and objectives of a community- and culture-based approach, it was crucial to implement an educational and healing process for the men. Eradicating violence towards women cannot be done without men changing their abusive behaviours and attitudes. In addition to holding a men's circle, all of the other services that were offered to children and women were also offered

to the community's men (except Full Moon ceremonies).

The principles and values of the circles for children and women, such as confidentiality (with limitations in order to ensure the safety of women and children), ownership and the negotiation of boundaries, were extended to the men's circle as well. The circle's facilitators were a man and a woman, which was important to the role modelling that the Program emphasized. The facilitators symbolized equality and respect between men and women and there was a strong recognition of the roles and responsibilities of both according to Aboriginal cultures. The female facilitator was often asked by participants to discuss circle topics from the perspective of an Aboriginal woman. In addition, participants valued the building of a relationship with a strong woman who usually took the lead in circle facilitation and in confronting the men on abusive behaviours. Both facilitators participated in the men's Sweat Lodge ceremonies and Elder's teaching circles. The Elders were also a man and a woman, again stressing equality between the two and the valuable learning that comes from female teachers.

Two key principles at the foundation of these services for men were non-judgement and accountability. In order for men to understand and change abusive behaviours, they had to feel safe enough to open up and talk about their behaviour. Although abusive actions are wrong, men were never viewed as "bad people." The second principle stressed that circle participants had to be accountable for their actions and take responsibility for the behaviour that had hurt their families and community. This, too, is in keeping with the Aboriginal view of justice.

Within the men's circle, facilitators and participants addressed the areas that were covered in the women's circle as well as identifying the physical, psychological, spiritual and emotional abuse; discussing attitudes around controlling and abusive behaviours; substance abuse; breaking the cycle of violence; origins of family violence; and appropriate ways of dealing with anger and other powerful emotions.

At the end of each year, an evaluation was performed to help assess the effect of the Mino-Yaa-Daa Program on its participants. Evaluation goals included assessment of attitudes around issues related to family violence; responses to specific services, topics and activities; and cognitive and behavioural changes in relating to others and coping with problem situations. Over the years, the evaluations showed us that the children, women and men were learning to solve problems, to live non-violent lives and to take care of themselves.[9]

The children, for example, reported that they had "learned what to do when a person approached them to try to take [them] away," and what to do when parents were fighting. They pointed out that in the circle they talked about how they felt it was their fault when parents were fighting and came to understand that it wasn't. Children learned what to do when a violent incident occurred, and "even though some people told them not to call the police, they knew it was best to call them." They also explained that they knew to leave the violent situation and go to another adult's place where they would be safe. Some children learned that "it helps to stay calm in such situations and to get someone that can help."

All of the parents reported positive changes in their children as a result of attending the circle. They described their children as "being more confident, mature and outgoing," "able to teach others about the medicines," "feeling special," "talking more," "having a greater interest in the culture and traditions" and "feeling proud of who they are." Some parents noted specific changes in how their children were relating and dealing with feelings and problems. These changes were described as "closer relationships" with parents, "expressing their feelings honestly" with them, "suggesting ways to work out situations at home" and "speaking up about what they want."

The parents added that they were receptive to these changes in their children because they had a positive effect on their family's relationships. Some commented that they were "able to correct unfair responsibilities placed on children" and that they had begun to "smudge together as a family." They saw their children "speaking to them and other adults with respect" and they were participating "in solving problems at home as a family."

The women who attended the women's circle also experienced positive results. One participant told us that attending an Elders' teaching circle had helped her to relate the traditional teachings to her life, which helped her to better understand a difficult situation she was going through. Another explained how the Program had helped her to clarify her values and beliefs, so that she was better able to provide direction to her children. A third woman spoke about how she had grown much closer to family members and had been able to "deal with a lot of hard issues" with them because of what she had learned in the circles.

Women also reported that the Program had helped them to work through issues with their partners, to talk more openly about their

concerns, to set clear boundaries with others, to unlock issues connected to their past and to deal with confrontations in healthier ways. Most of the women had come to understand that the violence towards them was not caused by them and had gained the confidence to leave abusive relationships so they could begin to take care of themselves and their lives.

All of the participants in the men's circle stated that they were able to give and receive support within the circle, and some noted that they were able to support participants outside the circle as well. When the participants were asked how they had learned to deal with anger differently, rather than becoming violent, they all provided examples of expressing anger in a healing way so they wouldn't hurt someone or themselves. Examples of this new behaviour included "loud screams in a pillow," "hitting a pillow or punching bag," "talking to someone I can trust," "going for a walk," "exercising," "smudging," "deep breathing" and "crying, because sometimes after the anger, there's sadness."

The men told us that they used what they learned in the circle in their lives. One participant related that he incorporated the techniques and teachings from the circle "all the time, and it works daily." Another reported that if he did not use what he had learned, "I wouldn't even be able to handle getting to the bus stop." A third related that he was "making a punching bag" similar to the one used in the circle. Another indicated that he thought issues over carefully, incorporating what he had learned from the circle, and then he talked to his partner. A fifth participant said, "I'm a very angry person, so I have to use what I learned quite frequently. To heal, you have to apply it, work on it all the time."

Most participants in the men's circle commented that attendance in the Mino-Yaa-Daa Program helped them in their relationships with partners. For some, this meant eventually accepting that the relationships with their partners were not going to continue, but that they still needed to carry on with their responsibilities as fathers. Others reported that they were beginning to work harder with their partners to recognize exactly what the problems were and to figure out how to deal with them, to talk more with their partners and to spend more time at home with their families. They generally described their relationships with their families as "improved," "better" and "healthier." Some indicated that family members had told them that they could see positive changes in them.

In the six years that the Mino-Yaa-Daa Program ran, to the best of my knowledge, only one participant reoffended by assaulting his

partner. So many have moved on to better lives. As far as I know, all of the women and their children stayed together. A few of the women are now attending university, some are working at Aboriginal agencies as helpers to other women, a few have returned to their reserve communities to work on family-violence interventions, while others are singing in women's hand-drum groups and dancing at powwows. Some women did leave their abusive partners and never returned, while others reunited with their partners who had made true change. The men of the Program went on in similar ways as the women. Two of these men are now my friends and both are in healthy relationships — one has a baby and both come to my house to play with my son.

*

According to an Aboriginal traditional teaching called the "Seven Fires Prophesies," now is the time of the Seventh Fire — a time of healing and relearning for Aboriginal peoples. This is evident from the movement towards self-government and the healing initiatives taking place in Aboriginal communities across the country. Women's activism in the area of family violence is alive and doing well, and women's leadership is growing and developing. How proud and privileged I feel to be a part of this incredible time and to witness the sprouting of such leadership.

NOTES

1. Linda MacLeod, *Preventing Wife Battering: Towards a New Understanding* (Ottawa: Canadian Advisory Council on the Status of Women, 1989), 10.

2. Canadian Advisory Council on the Status of Women, *Male Violence Against Women: The Brutal Face of Inequality* (Ottawa: CACSW, 1991), 5.

3. Health and Welfare Canada, *Working Together: 1989 National Forum on Family Violence—Proceedings* (Ottawa: Health and Welfare Canada, 1989), 21.

4. Aboriginal Family Healing Joint Steering Committee, *For Generations to Come: The Time is Now. A Strategy for Aboriginal Family Healing* (Ottawa: Aboriginal Family Healing Joint Steering Committee, 1993), 6.

5. A.C. Hamilton and C.M. Sinclair, *Report of the Aboriginal Justice Inquiry of*

Manitoba (Winnipeg: Province of Manitoba, 1991), 21.

6. Sharon McIvor, *Aboriginal Justice, Women and Violence* (Ottawa: Native Women's Association of Canada, 1992).

7. Hamilton and Sinclair, *Report of the Aboriginal Justice Inquiry of Manitoba.*

8. Ibid.

9. The quotations that follow are taken from evaluations and interviews conducted during the course of the Program and are used with permission of the participants.

THE TRUTH ABOUT US:

LIVING IN THE AFTERMATH OF

THE IPPERWASH CRISIS

Shelly E. Bressette

IT HAS BEEN SEVEN YEARS since Anthony "Dudley" George was shot and killed by the Ontario Provincial Police at Ipperwash Provincial Park on the eastern shores of Lake Huron. Seven years, and we are still waiting to learn the truth about what happened that night in September 1995. I would like to address Dudley's death and the aftermath of what is known as the "Ipperwash Crisis." I do not speak on behalf of anyone else or for any political or other organization; I speak from my perspective as an Anishinaabe kwe and lifelong member and resident of the Kettle & Stony Point First Nation, the community where Dudley was from.

The immediate story surrounding this event is that Dudley was part of a group of our people who occupied the land because it had been taken from Stony Point at an earlier time. They maintained that it should be returned because it contained ancestral Indian burial grounds. They had waited until Labour Day Weekend 1995 (and the closing of the park for the season) before they began their occupation of Ipperwash, and had even received instructions on park maintenance by

departing park personnel. On September 6, 1995, a specially trained police unit of the Ontario Provincial Police (OPP) opened fire on those community members who were peacefully occupying the park.

Kenneth Deane, the police officer who fired the weapon, has since been tried and found guilty of "criminal negligence causing death" and dismissed from the OPP. He did not serve one day in jail. As Dudley George's brother Sam George has said repeatedly, "We know who pulled the trigger — what we want to know is who gave the order." Since the killing, the family and a growing number of advocacy groups, including churches, unions and other civil and Aboriginal rights organizations, have been demanding a public enquiry. But to date, no one has had to answer for the death of Dudley George.

Many believe that the Ipperwash Crisis began after Dudley George was shot and killed. However, some of our Elders would say that the Ipperwash Crisis began in 1942, when the Department of National Defence first took the land at Stony Point. This is the story of the long history of colonial interference that has brought ongoing crisis and turmoil to our community.

Roots of the Ipperwash Crisis

Kettle Point & Stony Point are two separate tracts of land, each around 2,500 acres, located about 4 kilometres apart along the shores of Lake Huron. They are beautiful lakeside communities that have rich historical significance for the Aboriginal Nations in this territory. I was raised at Kettle Point, but Stony Point has always been my family's spiritual home. The land has a mystical quality that was spun from tales of the little people — the Goodjinishnaabeg. Its bottomless lakes and lagoons were known as "the bayous." It is a place of legends, where the Giant Turtle and Giant Serpent would rise to protect the Anishinaabeg — the true owners of the land. As kids we would climb the sand dunes and walk the cedar-lined trails, and our parents would remind us that this was still our land. My mother loved this land. My father hunted there. My sons learned to hunt there. And when it was time for me to marry, I could think of no other, more sacred place than Stony Point.

Kettle & Stony Point were known historically for their flint beds and their importance during the flint trade, which brought Indian Nations from near and far to trade for what was once our most precious commodity. By virtue of this sacred land site and its inherent

responsibility, the ancient tribes that once occupied this territory were known as the Neutrals, because they remained neutral in war and traded freely with all Nations. When the Anishinaabeg occupied the territory, they continued that tradition, and both Kettle & Stony Point were known as places of peace and sanctuary where other Anishinaabeg could find refuge and protection. The flint trade died with the coming of the white man, but Kettle & Stony Point are still recognized today as a sacred site by the Anishinaabeg.

After the War of 1812, several of the War Chiefs who fought alongside Tecumseh in battle settled at Kettle & Stony Point. The families of the War Chiefs and their descendants were entrusted with the original treaty, which "reserved" both tracts of land for their relations in 1827. In the 1840s, during the *Indian Removal Act* in the United States, Potawatomi families fleeing the "Big Knives" (the Chimokmon) sought political refuge here and were adopted into the tribe. The two communities are connected by blood, through intermarriage and adoption, as well as by treaty. Some community members have owned land on both reserves.

Ipperwash Provincial Park is located on the southern tip of Stony Point, wedged in between two beautiful beaches stretching in either direction. This portion of the reserve was surrendered in the 1920s after an unscrupulous Indian Agent declared the land of no value to the Indians. It is said that he paid $5 to every band member who voted for the surrender and then sold it to local realtors at a hefty profit.

In 1942, during the Second World War, when the Department of National Defence was looking for land for a military training base, Stony Point was selected. Under the *Indian Act*, however, they couldn't legally take the land without a land surrender, which would require a majority vote from male band members.[1] The band voted against the surrender, but the federal government invoked the *War Measures Act*, following a successful campaign by local politicians, and appropriated the land, with a promise to the community members living there that it would be returned after the war.

My grandmother was from Kettle Point and my grandfather was from Stony Point. They were married and lived at Stony Point until 1942. My mother and her family were one of the original families forcibly removed by the army. She recalls the day they showed up and put their homes on the bed of a trailer and then planted it in a big field somewhere else. A total of seventeen homes were relocated to the "sister" reserve of Kettle Point.

After the war ended, it became clear that the government had no intention of returning the land. The families who were relocated from Stony Point felt a tremendous heartbreak at the prospect of never returning home again, as well as the sting of betrayal at the government's empty promise. At Kettle Point many landowners also felt the loss, having sacrificed their own lands to accommodate the families from Stony Point. My great grandmother, for example, had owned a large farm rich with orchards, vegetable gardens and fields of wheat and oats. But during the relocation, the Indian Agent sold it off, piece by piece, at his discretion, until her farm was whittled down to a fraction of its original size.

The relocation of an entire community, the loss of traditional homelands for families from Stony Point and the loss of land on the part of Kettle Point community members who gave up land for the relocation were, and continue to be, a source of great historical trauma for this community. Entire families, once prosperous with their homes, farmlands, school and natural resources, became destitute. According to oral historical accounts, many families lost loved ones shortly after the relocation. Some were no longer able to care for their children and lost their entire families to residential schools. It was these layers of grief and trauma that would, fifty years later, seed a bitter feud between the two communities.

Several generations of former landowners fought for the return of their land at Stony Point. Among them were my grandparents, Hilda and Bruce George. My grandfather was a councilman and rallied the support of other Indian leaders. After several unsuccessful attempts, my grandmother and other women from Stony Point organized to raise money for legal costs. They held quilt raffles and bake sales and eventually made enough money to retain a lawyer to represent their claim. However, their attempts were in vain. Indians had no legal or political protection and the Department of National Defence was a powerful adversary. Nevertheless, there would be other lawyers and other fundraising campaigns throughout the 1950s and 1960s.

Throughout the 1970s, as Indian people across Canada began winning more recognition for their treaty rights, a new wave of protest began. Several demonstrations were held at the gates of the Ipperwash military base. It was women who led them. I remember attending one such demonstration, where several grandmas and their grandchildren marched with signs, back and forth in front of the military personnel,

shouting: "Stony Point! Stony Point!" Later that week I was startled when I discovered my four-year-old daughter and niece marching with little lopsided placards around my backyard shouting, "Stony Point! Stony Point!"

One of the significant gestures we made during this time was changing the official name of our first nation from Chippewas of Kettle Point to Chippewas of Kettle & Stony Point, in recognition of our sister reserve. This was important to me because it indicated that these communities were connected and that even though the land was occupied by the military, it was still ours.

My father and mother were part of the second generation to fight for the return of Stony Point. They struggled to bring the government to the table to negotiate with whatever political power they could pull together. My father was chief from 1976 to 1978 and my mother was chief from 1988 to 1990. Each made the return of Stony Point a priority during their respective term in office. In 1980, in the face of ongoing protests and civil disobedience, the federal government reluctantly entered into negotiations with the communities. The Department of National Defence offered a limited one-time-only offer to settle the claim, which their negotiators dubbed the "Shortfall Deal." The government promised that the land would be returned "when no longer needed for military purposes," along with paying the band a total of $2.2 million, as compensation for the shortfall that should have paid back in 1942, with interest. The community was once asked again to vote, this time on whether or not to accept the settlement. The majority voted yes.

A small group, mostly descendants from Stony Point, tried to block the vote for fear that the government would turn a "yes" vote into a land surrender. My family was among that group. I still remember the actual count: 212 to 41. People wept. I remember my younger sister asking, "How could they sell our Mother Earth?" My parents took an unpopular political position in the community back then because they voted against the settlement and publicly denounced it. Both were on council. Both left the community for about a year. It was a disheartening experience, but a life lesson for all of us. As a result of the settlement, each band member, with the exception of the women and children who had lost their status due to section 12(1)(b), was given $1,000. The remainder, over $1 million, was to be held in trust for future generations.

It didn't take the band long to figure out that the federal government had no intention of returning the land. Their primary uses for the base

were as a cadet training facility and as a playground for army personnel and their families who vacationed in the so-called marriage patch every summer. In truth, it had become a steady but seasonal pay-cheque for many people, including some First Nation members. The economic benefits, however, were reaped almost exclusively by the local towns and villages that surrounded the base.

The settlement resulted in endless negotiations with the Department of National Defence for the return of small portions of land, for the return of hunting, fishing and gathering rights and for jobs — all of the minor details that had been promised, but not written into the deal. For example, in 1987, a bid from the First Nation to take over the catering on the base was quickly and quietly denied, in spite of the promise made in 1981 to create more job possibilities on the base. Indeed, from 1980 until 1990, the "Shortfall Deal" lived up to its name in that it fell short of everyone's expectations — except those of the federal government and local taxpayers who still had their cash cow, the Ipperwash Military Base. In retrospect, it was this process of ongoing negotiations, which again and again proved to be futile, that was the breaking point. The government's insistence on addressing the claims of those who had been relocated separately from the claims of those who had given up their lands for the relocation was the wedge that drove the two communities apart.

In 1988, Bonnie Bressette, my mother, became the first woman chief of our First Nation. She was asked by the community Elders to run for chief because, in their words, she could get them back their land. What she did was find a way to fuel a successful lobby to embarrass the Department of National Defence on national television. CBC's *the fifth estate* ran a prime-time exposé on the DND that showed footage of military personnel frolicking on the beaches of Ipperwash while still declaring it unfit for human occupation because of the unexploded land mines. The response from taxpayers across Canada was overwhelming. The DND quickly returned to the bargaining table. In the late 1980s, the "marriage patch" was officially shut down, and the Department of National Defense began to gradually close down other parts of the base, although the military continued to occupy the barracks.

In 1993, a group of the original Stony Point landowners moved into a small unused portion of the base. By 1995, tensions had escalated again and, after the military left on Labour Day that September, several community members began an occupation of the military barracks. The

occupation of the barracks took place on the same weekend that Dudley George and other community members moved into Ipperwash Park.

THE NIGHT DUDLEY DIED

I remember the night that Dudley George was killed like it happened only yesterday. It is the fear I remember most.

I remember being awakened by the phone call in the middle of the night. It was my mother, calling from the plaza at the entrance to the reserve. "I want you to hear this from me first before you hear it from somewhere else," she said in a tone that I knew meant something was very wrong. "They shot Dudley ... and Bernard has been beaten up real bad ... they think others may be hurt, but they're not sure who." "What? Who?" I could only speak in monosyllables. My throat was tightening. "The police shot him," she said.

Her voice was fading in and out. As she was telling me what little she knew, I felt my knees buckle and I struggled to stand. I held onto the couch. I felt like someone had punched me in the stomach and I was having a hard time breathing.

By then, my eleven-year-old daughter was standing next to me. "What's wrong, Mom?" she asked. I tried to answer but I couldn't speak. My mother said she was going to try to get into Stony Point to see if she could get some of the people out of there. She told me, "Stay home with the kids. There's nothing you can do. Nobody knows anything right now. I love you. I've got to go."

I had five kids at home. My husband and oldest daughter were not there, so I woke my oldest son, who was sixteen at the time, and told him to watch the kids. By then, it was around two o'clock in the morning. I called my younger sister Barb and we arranged to meet. My daughter Chelsey and I got dressed and drove up the hill from our home along the lake, just over a kilometre to the entrance of the reserve. It was like someone had woken the entire community. Cars were coming and going on what would normally be deserted roads. Houses were lit up. It was eerie. It was like daytime, but in the middle of the night.

As we approached the plaza, I was in shock. The parking lot was filled with cars and people. But everything seemed to be happening in slow motion, dreamlike and surreal. It was a warm late-summer night, but I was trembling. Outside the plaza, people were talking, some were crying, hugging one another. The restaurant was lit up. I went inside

where they were serving up cups of hot coffee. My older sister stood nearby as our mom talked with several community members. "I'm going to try to get into the camp," she was saying. "Someone has to see what's going on. They're cut off up there."

My older sister jumped into the car beside her. I vaguely remember watching them pull away and driving out onto Highway 21 in that little '87 Mazda that our uncle had fixed up for Mom. I don't remember when my younger sister arrived, but suddenly she was there beside me. A huge fire was blazing near the intersection of Highway 21 and Lakeshore Road. Barb and I walked over to the fire where a group of fifty or more people were standing, some people were yelling, some were just silent. It was unsettling. Usually, a fire brings comfort. This was not that kind of fire. It was a barrier, a statement, a challenge to anyone around. Junk cars, tires, road signs and other refuse were thrown onto the blaze; it was a fire that would burn for days.

There is a gap in my memory. I don't know how or when, but later that night my mother and my sister arrived back safely. My mother was talking. People were standing around her listening. She was telling them how they brought out several carloads of children, women and old people. "They're in a bad way up there," she told us. "Nobody knows what's going on either. There are armed men, policemen, in the ditches all along the road."

I don't remember the exact moment when I heard that Dudley was dead. I think we knew somehow, but were just praying that it wasn't true, that this was all a terrible mistake. By the next morning it was confirmed, Dudley was dead.

I have fleeting memories of Dudley. A picture in my high-school yearbook. Seeing him standing on the street in town. He was my mother's first cousin. Dudley and I were the same age and had gone through school together, although I never understood why they lived in town. There were only one or two Indian families in the town of Forest.

Dudley George was part of the third generation to fight for the return of Stony Point. He paid the ultimate sacrifice for what he believed in. He was not the only member of his family who had fought and died for our land. Dudley's younger brother Pete and I had worked together in 1980 on "The Stony Point Defence Committee," trying to get an injunction to overturn the settlement that the majority of band members had voted to accept. The defence committee were mostly older people from Stony Point and their families who were against the

settlement. At the time, Pete was in college and I had one year of university under my belt. Pete was a poet. He was going to be a great writer someday. He had a wife and two baby girls. We had just asked him if he would be our chairperson, and he had agreed. He committed suicide that winter.

I thought about Pete after Dudley died. I don't know why Pete took his own life, but when I think about it now, I think he died from a broken spirit. It wasn't long before it became apparent that for us to stop the settlement, we would have to fight against our own people. I don't think he wanted to do that. None of us did. Both brothers had died fighting for the same cause in their own way.

A House Divided

Many of our community Elders still refer to the two reserves as "sisters." Kettle Point is "Wekwadong," or "By the Bay." Stony Point is "Aazhoodenaang," or "The Other Side of Town." However, an Elder from a neighbouring community says that "Aazhoodenaang" sounds like "twin," or in our language, "two hearts that beat as one." Both interpretations for "Aazhoodenaang" imply a connection between Kettle and Stony Point; but the nature of our connection is controversial and a source of conflict between the two communities. Some of the original families from Stony Point firmly believe that they were, and are, a separate reserve from Kettle Point. Several of these families that currently occupy the barracks at Stony Point contend that they are separate from Kettle Point. They changed the spelling of their name from "Stony" to Stoney," which was the original spelling.

After Dudley's murder, the anger in the community was palpable, and the conflict between various factions escalated. This anger came out in various forms of protest. One of the buildings at Ipperwash Park was burned to the ground. "That was for Dudley," said one young man. Another fire was set on Lakeshore Road by the south entrance to the Kettle Point Reserve. There, a group of young men with masks kept the fire burning for several days and nights, stopping cars, and exchanging words with angry motorists. Cars were painted with graffiti and parked in front of the main entrance at Stony Point. Even today, fresh graffiti is scrawled across several buildings at Stony Point, and across several abandoned trailers and old warehouses that face Highway 21. The graffiti is directed at Tom Bressette, chief of Kettle & Stony Point First Nation, at

former premier Mike Harris, at the London *Free Press*, at Canada. Abandoned, burned-out cars are still parked against every access to Stony Point. Seven years later, nothing has changed. The barracks are still occupied. The DND has not yet signed over ownership to the band, as there is still ammunition on the land that needs to be cleaned up.

At Kettle Point, the visible aftermath of the crisis is more covert, and its focus is more internal, an indication of how we have been divided. Some community members hold resentment against Stony Point occupants and families, and this resentment has crept into all facets of our community. During the day, the sign welcomes visitors to the "Kettle & Stony Point First Nation," but after dark "Stony" doesn't appear because the word has been smudged out with a paint that isn't luminescent at night. The school and cultural administration buildings have the word "Stony" either scratched out or chipped away. Perhaps most devastatingly, on the small white sign in front of the Band Office that has the names of all of Kettle & Stony Point's veterans inscribed, Dudley George's name has been scratched out.

As a people, as a community, we are now "a house divided against itself," as one Elder described it. The day before the shooting of Dudley George, the Kettle & Stony Point First Nation opened the doors of its new school. Within days the school was in crisis, as it became the focal point of the simmering layers of conflict within the community. Some community members linked the crisis to the presence of traditional spiritual practices and peoples in our communities. "Culture" was banned from the school despite protests by a small group of parents. No "Indian" dancing, no music, no prayer, no smudging — the list went on. The principal, a First Nation member, was fired because of her ties to the "traditional" community. Throughout the crisis and its aftermath, tensions at the school mounted. The school was attached to the Band Office, which was under constant threat.

Within the three years following the crisis, there were two occupations of the Band Office. Children attending the school had to endure the violence that occurred as a result. The second occupation of the Band Office led to a violent clash between an angry mob who attacked protestors, mostly women and children.

Since the Ipperwash Crisis, there has been growing concern about the effects of the crisis on our youth and our children. They have been raised in a community that struggles with internal conflict and political turmoil. Each year, there has been a significant increase in youth violence

and drug and alcohol abuse. The school now has two full-time behavioural teachers. In health care, the need for mental health services has increased dramatically. A health survey that came on the cusp of the crisis cites high rates of depression, alcohol and drug addiction, and family violence as major health concerns.

I know how the Ipperwash Crisis has affected my life and the lives of my six children, because I have lived it. I know how it has affected my mother and my father and other community elders, because I see it in their health and their quality of life. I have witnessed the destruction of a once peaceful community and continue to witness on a daily basis the anger, hurt and fear that has replaced it.

Towards Recovery

I was once told that all women have the power to heal. When I first heard this, I dismissed it. Although I have worked in the healing of my community for most of my adult life, in no way do I consider myself a "healer." A healer is, I believe, gifted by the Creator to help others in times of sickness or need, which may be mental, physical, emotional or spiritual. This teaching, however, keeps coming back to me, in various forms and from different teachers. Each time I hear it I feel doubt, and wonder, What can I do? What kind of natural healing ability do I have as a woman?

I think that my cynicism, my doubt and my fear are rooted in the fact that I am very much a part of this community, and the Ipperwash Crisis is still very much a part of our everyday lives. It lurks just below the surface. Everything appears to be back to the way it was before 1995, but if you scratch the fragile surface you will see it rise back up like a leviathan to remind us that it never left. The crisis is a powerful oppressor because it is fuelled by fear. And what we are most fearful of is the truth.

My own greatest fear is this: In what way did I contribute, either directly or indirectly, not just to the Ipperwash Crisis, but to the death of another community member? My fear has a twin — guilt: What did I not do or what could I have done to prevent the death of Dudley George?

As a journalist, I have an ethical responsibility to tell the truth. To find the truth, seek it out and expose it. But as an Anishinaabe kwe, I have an even greater responsibility to speak out on these issues that I see

affecting our children, our elders and our community. In 1995, I chose to stay silent. Whether out of fear for my personal safety or the safety of my family, it was still my choice. I saw the warning signs. I saw the build up of police and military around us. I heard the rumours and felt the tension rising with each passing moment of each day. We were "a house divided against itself." I remember hearing those words spoken at one of the open council meetings. I heard ugly, hateful remarks spoken against "Stony Point." I read equally hateful words in the newspaper every day against "Kettle Point." On the nightly newscasts we heard the coverage — racist remarks about Indians, "declining property values" and "loss of economic opportunity and business dollars." Whites against Indians. Indians against Indians. Stony Point vs. Kettle Point. Family against Family. Christian vs. Traditional. We were embroiled in conflict daily, without reprieve. And then in a flash of gunfire that lasted only minutes, conflict became crisis. And the crisis fuelled more conflict, more violence, more hate.

In my mind, I can rationalize everything that I did or did not do. But today in my heart, I still feel a tremendous burden — seven years later. More than ever, I am filled with an overwhelming sense of responsibility. I seek guidance as to how I, as an Anishinaabe kwe, can work with my people to help our families and our community heal from the violence that has resulted from the Ipperwash Crisis. This, I believe, is our historical role as Anishinaabeg. We are just now waking up to it. As Anishinaabeg, we cannot close our eyes anymore — out of fear, or sorrow, or hate. We need to wake ourselves up. We need to wake up our leaders, our elders, to what is happening to us and to our community. We are the voice of our community. We speak for our children and the generations that are not yet born. We carry the children inside us because the Creator gave us that right, and with that right comes the responsibility to protect them.

Recently, I listened as a healer instructed a young grandmother on how to help heal her granddaughter's injury by using her hands. "You have that ability. You're a grandmother," he told her. She nodded as if she'd known all along. She just needed to be validated. She had so much love in her heart for her granddaughter that there was not a doubt in her mind that she could help heal her with her loving touch, her loving prayers. Even her tears. I've just recently become a grandmother for the first time, and when I hold this tiny newborn girl in my arms, so perfect, so pure, I see creation as God intended it to be. I am filled with a

desire to help make this world a better place for her. To use whatever gifts that God has given me. I am beginning to understand more about what my teachers tell me is our natural ability as women to heal.

Healing is letting go of our pain, whether that be personal pain inflicted upon us or the kind of collective pain or trauma we experienced during the Ipperwash Crisis. Letting go means to resolve it or understand it and see it for what it is, and to move beyond it, so that it no longer takes a hold on our daily lives. Recently, at a gathering, I heard a teacher say: "We all experience great suffering in our lives, and we don't know why. But if we look at these times as teachings and ask ourselves what can we learn from these painful moments, then we can give them new meaning."

These are the teachings that I learned from the Ipperwash Crisis:

1. Never be silent. Never be afraid to speak out on matters of family and community. This is your "God-given" right and responsibility to your children, your elders and your people. Use your voice. It takes great courage to speak the truth when everyone around you is afraid. Fear is the greatest oppressor of our people.

2. Always "look twice," as one of our Elders teaches us. When you think you know what something is, look at it again. Sometimes it is not what it seems.

3. Listen with an open heart and an open mind. This is not always easy to do, because people may want to sway you to their way of thinking. But if you listen to all sides of the story and see things for yourself, you will not be easily influenced.

4. Always be honest, but be honest with kindness. Speak the truth as you see it, but with kindness in your heart to temper your words.

5. Act with a clear mind and clear intentions. To do so requires guidance from the Creator. In our darkest hours during the crisis, I knew I could always turn to the Creator to ask for guidance, for protection for my children, for understanding for those that would try to hurt us, and for help and healing to come to us in a good way.

6. Stand by your convictions, even in the face of adversity. Remember, just because the majority agree, it doesn't mean they're right. That is not true democracy. That is "majority rule" or, in some cases, "mob rule." And it takes guts to stand up against an angry mob and disagree with them.

7. Children and elders come first, always and without exception. Keep them safe, protect them because they are our past and our future. But also include them in decision-making. Talk to them. Listen to them. They will always tell the truth.

8. The most basic form of healing is "prayer." It doesn't matter where or how, Just Do It! Do it alone or with your family, in ceremony, in church, in the bush; it doesn't matter. Prayer is our connection to our Creator, to one another, to life. Prayer is the expression of love that helps us overcome these struggles.

9. Laugh. Don't be afraid to see the good side of life. Even in the most tragic circumstances, we could always find something to laugh about together.

10. Cry. Tears are healing. Don't fight them back. Let them flow.

One day we will know the truth about why Dudley George died. But whose truth will it be? Will the government's truth be enough to heal the pain and loss created by the Ipperwash Crisis and the death of a fellow human being who was our brother? We must find our own truth. As individuals, as families and as a community. We must seek this truth with courage and not be afraid to look at ourselves and one another. Then we must be able to forgive ourselves for the things that we did or did not do. We need to look to our past. Within our Anishinaabeg teachings is the knowledge of our ancestors. They were great thinkers, philosophers, prophets, poets. These teachings that they pass on to us is where our answers lie. In them we will find our own truths. It is in these truths that our healing lies.

NOTES

1. The Canadian government had for may years made it illegal for Indian women to take any part in band governance.

COMING FULL CIRCLE:

A YOUNG MAN'S PERSPECTIVE

ON BUILDING GENDER EQUITY

IN ABORIGINAL COMMUNITIES

Carl Fernández

> You can find out ... how traditional [an Indian is]. If they haven't respect for women they've lost the tradition ... they have lost something that's in their hearts or that should be inside them.
>
> — PAULA GUNN ALLEN, AS QUOTED IN LAURA COLTELLI, ED.,
> *WINGED WORDS: AMERICAN INDIAN WRITERS SPEAK*

ABORIGINAL WOMEN are community leaders who protect the future by transmitting language and culture to their children. Despite the contributions women make, they are commonly excluded from decision-making roles, with far-reaching consequences for them, their families and their communities. As targets of male domination and violence, women and children also bear the brunt of the social disruption that colonization has brought. This chapter explores how young men

can make a difference by re-establishing gender equity through the promotion of more balanced relations between men and women in our communities. My definition of gender equity hinges on the belief that the roles that men and women play in the community should be equally valued and their differences appreciated.

First, though, I will tell you a bit about myself so that you have a better understanding of who I am and why I am interested in this subject. My father is Ojibway and his mother is a member of the Wahnapitae First Nation; however, my generation is non-status. My mother is of Scottish, Welsh and Irish heritage. Thus, I identify as an Ojibway of mixed heritage. I believe that my father has set a good example on how to be a strong Native man. During the last six years, I have participated in various cultural ceremonies that were organized by the Aboriginal Student Centre at Queen's University, where I was a student. I continue to explore my Native heritage through attending Sweat Lodges, participating in traditional drumming and taking courses about Aboriginal literature, politics and women. I have an interest in gender equity because it affects so many people in contemporary Native society.

To learn more about the issue of gender equity in Native communities, I interviewed three men and five women from different Aboriginal backgrounds and ages. I talked to the women about the issues they face and to the men about how they perceive women and gender equity. I also asked several elders[1] about traditional male and female roles within our culture, and spoke with a number of younger men and women about the issues that they face today.[2] In all, I spoke with members of the Kingston urban Native community, Native students at Queen's University, individuals from the Tyendinaga Territory and Golden Lake First Nation reserves, and others from the non-status Native community of Ardoch Algonquin First Nation and Allies (AAFNA).

Gender balance strengthens our circles. Many cultural beliefs for Aboriginal people revolve around circles. The medicine wheel, the dream catcher and the round shape of the Sweat Lodge all progress in a circular manner. As Aboriginal people, we can apply this circular symbolism to ourselves, rather than the linear path that represents Western progress. We once lived by our traditions and were healthy and strong, but since contact with the Europeans, many of our beliefs have been repressed and lost. We are striving to go full circle and return to our traditions because we realize that this will strengthen our communities.

Native people understand that it is not enough, perhaps even impossible, to return to living a purely traditional life. Nonetheless, we must continue to move forward. But in order to truly progress, we must reconnect with the past and carry it with us into the future. Because of this, I begin this chapter by discussing what I learned from the elders I spoke with about the past. I then present what people shared with me about present conditions in their communities. Finally, I look at where we need to go and what young Native men can do to bring about a better future for our communities through promoting gender equity.

HOW IT WAS

Before contact, we were at the section of the circle that is rooted in land-based cultures and non-Christian societies. In these communities, the traditional balance between the roles of men and women kept our communities healthy. As many Elders and Aboriginal scholars are telling us, women historically played prominent positions in Aboriginal communities because of their working relationship with the land. This was particularly true in agricultural societies where women had control over food, lodging and other resources, which were passed on to them through clans based on the female line. In communities that relied more on hunting, it was impossible for the community to survive without the women who processed the meat and skins of animals for food, clothing and shelter. Male and female roles were therefore equally important, and respect for the contributions of both genders was necessary for survival. This symbiotic relationship between men and women both created and supported an environment of gender equity. Colonization undermined the position of women by instilling values and practices that displaced their important positions within the community. Women became less influential as European influence grew.

Two of the Elders from eastern Ontario described how colonization affected their communities. As the land was taken, and the numbers of wildlife decreased, their people lost their ability to be self-sufficient. The non-status communities, in particular, who did not sign treaties and therefore were not given reserves, were forced to live on the wastelands. The loss of wildlife shattered the interdependency between men and women, which had a devastating effect on Native communities. Men could no longer provide the raw resources for the women to refine, and so the women's position in the community diminished. As well, men

who took on paid work outside the community came to be regarded as the only ones providing for the community's survival. The few women who did work for the Europeans were almost always paid less than the men.

According to Robert Lovelace, the chief of the AAFNA in eastern Ontario, the only option available for the men in his community was to leave home to provide monetary support for the family:

> Men had to leave home for a year or two to work, which meant that the boys, girls and women would have to look after the community. The boys would be hunting because their fathers were away working in the lumber mills and mining in Northern Ontario. Women in the communities took in domestic work and went out and worked as domestics among the settlers to get a little bit of money.

The exodus of men from the community for long periods of time to earn money and the low value attached to female work led to a gradual loss of respect for the authority of women. Eventually, family authority was taken over by the young men.

In some communities, with many men leaving for extended periods of time and adapting to European culture, family dynamics changed in other ways. Native women, determined to support and provide for their families, sought non-traditional forms of work. According to Algonquin Elder Harold Perry, in his community during the Second World War, the women assumed many of the roles that were left vacant due to premature male deaths:

> The warriors got killed, so the women had to take part in other things. I don't think it was designed that way; it became that way more out of necessity.

In this regard, women held communities together by themselves, taking on many of the roles that men had occupied, and showing the kind of strength that helped their families and communities survive.

Other Elders talked to me about the devastation that residential schools brought to their communities. These schools were designed to make Native people assimilate male-dominant European values. Attending residential school forced many Native children to repress their emotions and lose their spirituality. This experience profoundly alienated young Native boys and girls from one another, from their families and from a healthy sexuality.

The long-lasting impact on gender relations that was caused by the residential schools was compounded by Aboriginal children being removed from their communities. The "sixties scoop" is well documented as a time when whole communities of children were permanently removed by child welfare authorities.[3] Robert Lovelace spoke about earlier times when children were removed from his community:

A lot of our children were scooped, starting in the early twentieth century by the Department of Lands and Forests, in co-operation with the social agencies at the time. They were not necessarily adopted. They were indentured out to farms in the south in Amherstview, on Amherst Island and on Wolfe Island. They were never reconnected with their community.

When children are taken from their homes, it causes a loss of identity for them. When children grow up in non-Native homes, they not only lose their identities as Aboriginal people, they are taught the values of a male-dominant society, which they carry with them.

Gender imbalance through the theft of children ripples through the community in other ways. With so many children absent from the communities, the elders had no one to pass the teachings and values on to. Because of this, not only was much knowledge lost, but the role of the elders was also devalued. As a result, the important roles that elders had played, especially in providing advice and balance to younger married people and helping them treat one another with respect, were disregarded.

One path that many embarked upon as a result of loss of land and livelihood was assimilation through intermarriage. According to individuals I interviewed from Ardoch, many Aboriginal people married Caucasians to make it easier for their children to assimilate. Harold Perry stated that

if children were mixed or if they could pass as white then they got along fine. So a lot of the women were encouraging their daughters to marry a white man, because their children would have a less stressful life.

Among the non-status bands, this resulted in non-Native men directly introducing male-dominant norms into Native communities, something that is seldom acknowledged even today.

A central problem that the elders identified as damaging gender relations is low self-worth among Aboriginal men and women. Low

self-worth prevents women from demanding respect from their partners and teaches men to devalue women because they do not value themselves. In this respect, the presence of low self-worth among Aboriginal youth is particularly disturbing.

In order to heal and move forward, Aboriginal people need to sort out the feelings they have towards the loss of identity and culture. From what elders have told me, the roots of gender imbalance go very deep. They are rooted in the many ways that European values have been imposed and in the low self-worth these values engender. This leads to Native women accepting their victimization and Native men waging war on women and on themselves. Because the roots are so deep, the healing process will be slow, and in order to progress, we must look to our past for strength and guidance. It is important that young men do not ignore the present-day gender imbalance that has resulted from the imposition of these values. We must talk about the need to heal so that we are better able to rebuild our communities.

How It Is

The current state of our people is one of imbalance and uncertainty. The relationship between men and women is unbalanced and men have assumed the dominant position. The poor treatment of women by men affects many areas of their lives. While women are primarily affected by maltreatment, the men are also adversely affected by poisoning their own community. The individuals I interviewed commonly identified two areas of key importance — politics and spirituality. It is these that I now turn to.

Despite their diverse perspectives, most of the men and women who analyzed the political situation in their communities agreed that women are taking a political back seat. This has especially been the case among older women — precisely the group who, in the past, would have asserted the most authority and been closely listened to. Alison Farrant, a member of AAFNA, describes how things work in her community:

> We had a women's gathering where we were talking about what we wanted to see in the community. We were throwing around ideas and we passed around the talking stick so that everyone had the chance to contribute. But when it came to the three older women, all they said was "We don't have any opinion because our husbands speak for us." And I thought that was really interesting because we

weren't talking about political things — we were talking about the community and what we wanted to see happening for our kids. And yet the three older women would not express an opinion.

Why are the older women silent? Do they lack confidence? Have their voices been actively suppressed? Do they feel that if they express their opinions it might conflict with the political agendas of their husbands? The only clear conclusion I can reach is that, in this community, there has been a history of men making the decisions and women being silent in the public arena.

There was no consensus among the men and women I interviewed as to why the women have been silent or have been less involved. Stephanie Lovelace describes a common perspective shared by the women of AAFNA:

> I see my community as a very male-dominated group of people. Not that they disrespect women, it's just that the men take more action in the group than the women. The women are taking more of a back seat, because the imprint of colonization has dictated that the men are the leaders and the women shouldn't get involved.

The men, however, tend to feel that women choose not to be involved — that the opportunity for participation exists, and that they have tried to include the women within political discussions. Harold Perry describes a common male perspective:

> We encourage the women to be involved with the band council. Not many women come to the meetings, but we encourage them to come out. Some of them attend meetings, but I think the women have a tendency to be shy.

Are the women shy, or are they actively excluded from community politics? Perhaps this sense of exclusion is not intentional, but is created by a silent set of assumptions and patterns of behaviour among the men that makes the women feel that if they voice their opinion they will be seen as stepping out of line.

As Alison Farrant points out, the men need to listen more to the women so that female opinions are valued — a process that is only beginning in her community:

> I think that men are beginning to listen to women's voices, although a lot of women feel that they are not heard and that the men are not understanding what is being said. So the women get turned off

becoming involved in politics. But I do feel that is beginning to change. At our women's gathering, we said we want the men who are going out to the negotiations to come and talk specifically to the women. We want to make them responsible to the women.

There is a sense that, because the younger women are speaking up, there is a greater awareness of gender equity among the younger people. I believe this is one area where young men can make a real difference. While older men — especially those who attended residential school — grew up cut off from female contact, most of the younger men were co-educated in public schools and have grown up learning more egalitarian values. As a result, young men are more comfortable around women. We find it easier to take women seriously and are less likely to show the kind of exclusive behaviour that older men tend to show, especially when in groups. As younger men, we can draw attention to how important it is that we work with women.

The exclusion of women from community politics has a serious effect on the community as a whole. It became obvious in talking to the men and women that they have very different priorities in making decisions about the community. According to Mitchell Shewell, a member of AAFNA:

> In some ways the men and women are separated, the men are dealing with land claims and right now the women are saying "Enough is enough. We have to develop the community and we have to start looking at the ceremonies more, we need to do more activities with the children." Meanwhile, some men are claiming that women are just not grasping how important the land claims are, that they will support the people. They say that the women don't see how the land claims will improve their community right now. While land claims and community development appear to be poles apart, they are really interconnected.

The men and women of this community have differing opinions. The men are eager to make land claims with the government, while the women are more concerned about developing healthy communities. At the present moment, it is clear that it is the men's priorities that are being acted upon. Often the opinions and concerns of the women are not taken seriously and the women could make a very important contribution to this community if they were more involved in the political process. There are crucial social problems that need to be addressed

and at present they are not because the women's concerns are not being heard. A balance of genders in the political process would enable the community to have an action plan that better suits the people. Again, this is an area where young men need to support the women's perspectives, as women struggle to have their voices heard.

Aboriginal people need their traditions to find meaning in life and guidance for the survival of our people. And yet, for many of us, particularly the younger people, loss of tradition is a reality that we are struggling to overcome. We seek to reclaim ourselves through traditional practices. There are struggles about the importance of particular traditional practices that affect women in very specific ways.

From interviewing the women, it was clear that traditional spirituality is very important to them. They spoke of relying on specifically female traditions, such as Full Moon ceremonies and the berry fast, to give them balance in their lives. However, it was in the areas where male and female traditional practices overlap that conflicts occasionally arose. The women expressed many different opinions about this issue.

Currently, women are participating in ceremonies that were traditionally held exclusively for men, such as the Sweat Lodge. The women I spoke to all felt very positive about taking part in this ceremony, although some referred to the teaching from female Elders that women do not need to attend lodges to sweat because the menstrual cycle is their form of cleansing. One woman stated that she found it affirming to attend mixed sweats because it gave her the opportunity to experience positive male energy, which was valuable for her healing. Others mentioned that ceremonies involving men and women helped to promote greater understanding and bonds between the sexes.

One interviewee talked about some of the restrictions she has experienced in practising ceremonial life in different communities. In particular, she described how contradictory the teachings are for women who are menstruating. In some ceremonies, women on their periods are told that they can't dance around the big drum, enter sacred spaces, be around medicines or approach Elders. In others, not all of these restrictions apply. At some gatherings women can't enter sacred spaces without wearing a long skirt, while at others they can. This interviewee suggested that it might help if female Elders were more often included at these gatherings. That way, they could address these issues and women would not always be told what to do by male Elders. She also pointed out that for women living in a non-Native society, timing is an important issue.

In a context where very few ceremonies may be held and where a woman may be struggling with her healing, it is difficult to constantly miss traditional events because the days of the events coincide with her menstrual cycle. Finally, the interviewee felt that the teachings about womanhood too often focus on what women *can't* do, so that women often struggle with the reasons for these restrictions, or simply become cynical about their validity in contemporary communities.

Some of the men expressed their views about women and tradition. One individual claimed that it is hard to see women as sacred in an environment where Aboriginal people struggle with many difficult issues:

> It's really hard to determine if the women are viewed as sacred within the community. It's complicated because women in our community don't demonstrate their strength. Men do not necessarily regard them as strong. I think that has to do with issues of poverty and issues of dominance by outsiders. I think that in a healthy state, both men and women recognize one another's sacredness. But in general, I don't think that men and women are healthy in our communities. I think they are working on it, they are striving towards that. But it is almost a result that you can't see until you arrive there.

When discussing how ceremonies affect women and their relationship to men, he commented:

> I can only speak as an observer. My feeling is that women who are secure in themselves and understand the value of ceremony gain a lot from attending them. I think ceremonies re-establish the balance between men and women. Men and women may have different tasks or different roles within a particular ceremony and that is why it is really important to understand the ceremony.

In talking about our histories as Aboriginal people, many of us acknowledge that Western culture has brought male dominance to our communities. And yet, in the interviews, even though the men talked about female passivity and the fact the men and women may not be healthy, they did not mention the issue of male dominance. It is possible that men don't want to admit that they are at fault? Or do they really not recognize that there are problems?

Currently, women face a number of restrictions when participating in traditional ceremonies. There are also differing opinions on the separation of genders during the ceremonies. In the co-ed Sweat Lodges that

I have attended, it is common for the women to provide teachings for the men. I was taught that women give the first teachings and, therefore, women should be the ones to provide guidance for men. Robert Lovelace points out that young men are beginning to recognize this:

> Well, I think Native men are conscious of the power of women. I think that's a good thing, that's a strong thing. Being taught in Native circles these days, and being listened to by young men ... I think that young men are beginning to recognize women's power.

The recognition that women play an important role in building a strong Nation is growing, but women are becoming impatient. Some women are challenging boundaries and participating in traditional male ceremonies, such as playing the big drum. However, these attempts to challenge a cultural norm can divide communities and the reasons for doing so reach both ends of the spectrum. At one end of the spectrum, the reason for challenging tradition stems from a desire to challenge male dominance, while at the other end, women are simply trying to use a cultural practice for healing. Stephanie Lovelace believes that it doesn't matter whether the healing originates from a male or female practice, just as long as healing is achieved. While it may be important for some traditions to be challenged so that male dominance is exposed, I believe that ultimately, gender-specific ceremonies are important for our youth when they participate in ceremonies that symbolize their different rites of passage into adulthood.

From listening to these men and women it is clear that we are still struggling within communities and within traditional practices to reassert the balance between genders. The questions we need to ask are: Where have we been, where are we going, and where do we *want* to go?

THE FUTURE

The women I interviewed all agreed that females are making a difference in their communities. Since women are givers of life, language and first teachings, they hold the people together. However, since Aboriginal communities were forced to adopt the political methods of the Europeans, the men have excluded the women from making political decisions. It's clear that the women need to be involved with band politics to ensure that their issues are being addressed. This means that the men need to stand back and allow the women to step forward so that

they can stand behind each other as equals. The women need to have a stronger voice in council meetings.

I believe the strength will come when women feel that they do not have to shout in order to be heard. At the same time, many women are being more assertive in their attempts to gain gender equity. Today, more Native women than men are likely to attend post-secondary institutions.[4] The Aboriginal students I interviewed suggested that women become educated to gain economic independence, to maximize their choices in life and to be able to bring valuable skills back to their communities.

Talking with the men raised many questions for me. For example, do they understand the issues that women face? Writing this essay has helped to answer that question and to clarify that most Aboriginal men, particularly the older generation, do not really recognize the ways in which gender inequity affects their community. By comparison, many of the younger men are undergoing a positive attitude change.

Most of the elders I spoke to also made it clear that we cannot achieve gender equity without addressing the low self-worth among Aboriginal people, and we can do this by encouraging the expression of a positive cultural identity. In the past, elders would teach our youth the skills they needed to survive. In addition, they would tell stories, and within these stories there would be an explanation of how people should behave. I feel that as the young people relearn a traditional respect for their elders, they will develop a stronger sense of how to create a community that is built on gender equity.

We need to hunt and gather resources that will get us through the harsh winter that colonization still represents, and this must be done by using the knowledge and wisdom of traditional healers. Our ceremonies can re-establish the balance between the genders and ensure that people accept and live by Native values; to restore traditional gender equity will mean that women can once again rely on male elders to adopt more positive attitudes towards them. Women need to know they have the space to address these issues without being made to feel that they are the problem. They want to reclaim the traditions in ways that feel right for them.

Ultimately, our future depends on raising healthy children. This means that we need to work together, as men and women, to care for our children and to develop healthy communities. The equitable way by which we must work together does not mean gender sameness, as Robert Lovelace suggests:

There is no such thing as gender equity, it's like bolts and nuts. The two complement each other, but they are not the same. The roles that men and women can fulfill are thus different from one another, but those roles should be complementary. I think the values and teachings show us that women occupy one side of the circle and men occupy the other. The vision is not to make one better than the other, but to show how they are complementary.

Traditionally, the roles played by men and women were valued and acknowledged as necessary for a strong community. It is the gender equity of balanced interdependency, renewed trust and true respect between men and women that Native people should strive to reclaim. In order to achieve this goal, we must live more like our ancestors. Our path must come to create a spiral, one that turns back to the past while at the same time progressing forward in order to survive in a different world.

NOTES

I would like to thank all the interviewees whose knowledge was very inspiring. I also want to thank my family for providing a strong foundation to build on. My friends deserve a lot of recognition for their encouragement.

1. The lowercase "e" in elder refers to people who are Aboriginal seniors. I use a capital "E" to refer to people who are recognized as teachers in our communities.

2. While most of the time the individuals I spoke with were willing to be identified, some of the women who spoke about problems with traditional practices expressed the desire for their opinions to be anonymous. For that reason, in the section that speaks of traditional practices, the individuals are not identified. All quotes used in this chapter are taken from these interviews.

3. See Suzanne Fournier and Ernie Crey, *Stolen From Our Embrace: The Abduction of First Nations Children and the Restoration of Aboriginal Communities* (Vancouver: Douglas and MacIntyre, 1998).

4. See Madeleine Dion Stout, *Aboriginal Women in Canada: Strategic Research Directions for Policy Development* (Ottawa: Status of Women Canada, 1998). Aboriginals clearly fare worse than the non-Aboriginal population. Aboriginal females are far more likely to have completed a post-secondary degree (or diploma) than their male counterparts (58.6 percent compared with 39.6 percent). The proportion of Inuit and Metis women holding a degree (or diploma) was 46 percent and 54.3 percent, respectively, as contrasted with rates of 22.3 percent and 29.3 percent of their male counterparts.

SELECTED BIBLIOGRAPHY

Aboriginal Family Healing Joint Steering Committee. *For Generations to Come: The Time is Now. A Strategy for Aboriginal Family Healing.* Ottawa: AFHJSC, 1993.

Acoose, Janice. *Iskwewak: Kah' Ki Yaw Ni Wahkomakanak (Neither Indian Princesses Nor Easy Squaws).* Toronto: Women's Press, 1995.

Allen, Paula Gunn. *The Sacred Hoop: Recovering the Feminine in American Indian Tradition.* Boston: Beacon Press, 1986.

Amadahy, Zainab. *The Moons of Palmares.* Toronto: Sister Vision Press, 1997.

Anderson, Kim. "Honouring the Blood of the People: Berry Fasting in the Twenty-first Century." In Ron F. Laliberte et al., eds., *Expressions in Canadian Native Studies.* Saskatoon: University of Saskatchewan Extension Press, 2000.

—. *A Recognition of Being: Reconstructing Native Womanhood.* Toronto: Second Story Press, 2000. Reprint, Toronto: Sumach Press, 2001.

Armstrong, Jeanette, ed. *Looking at the Words of Our People: First Nations Analysis of Literature.* Penticton, BC: Theytus Books, 1993.

Barthes, Roland. *Mythologies.* Paris: Seuil, 1970.

Brant, Beth. *A Gathering of Spirit.* New York: Firebrand Books, 1984.

—, ed. *Sweetgrass Grows All Around Her.* Toronto: Native Women in the Arts, 1995.

—, ed. *In a Vast Dreaming.* Toronto: Native Women in the Arts, 1995.

Brown, L. *Two Spirit People: American Indian Lesbian Women and Gay Men.* New York: Haworth Press, Inc., 1997.

Caldwell, E.K., ed. *Dreaming the Dawn: Conversations with Native Artists and Activists.* Lincoln: University of Nebraska Press, 1999.

Campbell, Maria. *Halfbreed.* Toronto: McClelland and Stewart, 1973.

Chrystos. *Not Vanishing.* Vancouver: Press Gang, 1988.

—. *Dream On.* Vancouver: Press Gang, 1991.

—. *In Her I Am.* Vancouver: Press Gang, 1993.

—. *Fire Power.* Vancouver: Press Gang, 1995.

Churchill, Ward. *A Little Matter of Genocide: Holocaust and Denial in the Americas.* Winnipeg: Arbeiter Ring Publications, 1998.

Cotelli, Laura, ed. *Winged Words: American Indian Writers Speak.* Lincoln: University of Nebraska Press, 1990.

Cooper, Nancy. "These Women Are Speaking for Themselves." In *Sweetgrass Grows All Around Her,* edited by Beth Brant. Toronto: Native Women in the Arts, 1995.

Crey, Ernie, and Suzanne Fournier. *Stolen From Our Embrace: The Abduction of First Nations Children and the Restoration of Aboriginal Communities.* Vancouver: Douglas and McIntyre, 1997.

Gould, Janice. *Earthquake Weather: Poems.* Tucson: University of Arizona Press, 1996.

Green, Rayna. "The Pocahontas Complex: The Image of Indian Women in American Culture." In *Native American Voices: A Reader,* edited by Susan Lobo and Steve Talbot. New York: Longman, 1998.

Hamilton, A.C., and C.M. Sinclair. *Report of the Aboriginal Justice Inquiry of Manitoba.* Winnipeg: Province of Manitoba, 1991.

Harjo, Joy, and Gloria Bird, eds. *Reinventing the Enemy's Language: Contemporary Native Women's Writings of North America.* New York: W.W. Norton, 1997.

Highway, Tomson. *The Rez Sisters: A Play in Two Acts.* Saskatoon: Fifth House, 1988.

—. *Dry Lips Oughta Move to Kapuskasing: A Play.* Saskatoon: Fifth House, 1989.

—. *Kiss of the Fur Queen: A Novel.* Toronto: Doubleday Canada, 1999.

Hill, Barbara Helen. *Shaking the Rattle: Healing the Trauma of Colonization.* Penticton, BC: Theytus Books, 1995.

Hill, Dawn. *As Snow Before The Summer Sun.* Brantford, ON: Woodland Cultural Centre, 1992.

hooks, bell. *Teaching to Transgress: Education as the Practice of Freedom.* New York: Routledge, 1994.

Jacobs, Sue Ellen, Wesley Thomas, and Sabine Lang. *Two Spirit People: Native American Gender Identity, Sexuality and Spirituality.* Chicago: University of Chicago Press, 1997.

Kasse, Cynthia R. "Identity Recovery and Religious Imperialism: Native American Women and the New Age." In *Women's Spirituality, Women's Lives,* edited by Judith Ochshorn and Ellen Cole. New York: The Haworth Press, 1995.

Knockwood, Isabel. *Out of the Depths: The Experience of Mi'kmaw Children at the Indian Residential School at Shubenacadie, Nova Scotia.* Lockeport, NS: Roseway Publishing, 1992.

LaRocque, Emma. "Here Are Our Voices—Who Will Hear?" Preface to *Writing the Circle: Native Women of Western Canada,* edited by Jeanne Perreault and Sylvia Vance. Edmonton: NeWest Press, 1993.

—. "The Colonization of a Native Woman Scholar." In *Women of the First Nations: Power, Wisdom and Strength,* edited by Christine Miller and Patricia Chuchryk. Winnipeg: University of Manitoba Press, 1997.

Lawrence, Bonita. *The Exclusion of Survivors' Voices in Feminist Discourse on Violence against Women.* Ottawa: CRIAW, 1996.

—. "Mixed-Race Urban Native People: Surviving a Legacy of Policies of Genocide." In *Expressions in Canadian Native Studies,* edited by Ron F. Laliberte et al. Saskatoon: University of Saskatchewan Extension Press, 2002.

—. "Rewriting Histories of the Land: Colonization and Indigenous Resistance in Eastern Canada." In *Race, Space, and the Law: Unmapping a White Settler Society,* edited by Sherene H. Razack. Toronto: Between the Lines, 2002.

—. "Gender, Race and the Regulation of Native Identity in Canada and the United States: An Overview." *Hypatia: A Journal of Feminist Philosophy,* in press.

—. *"Real Indians and Others:" Urban Mixed-Blood Native People, the Indian Act and the Rebuilding of Indigenous Nations.* Lincoln: University of Nebraska Press, forthcoming.

Lawrence, Jane E. "The Indian Health Service and the Sterilization of Native American Women." *American Indian Quarterly* 24, no. 3 (2000): 400–419.

Maracle, Lee, and Sandra Laronde, eds. *My Home As I Remember.* Toronto: Native Women in the Arts, 2000.

Marsden, Dawn. "Emerging Whole from Native-Canadian Relations: Mixed Ancestry Narratives." MA thesis, University of British Columbia, 1999.

McIvor, Sharon. *Aboriginal Justice, Women and Violence.* Ottawa: Native Women's Association of Canada, 1992.

Miller, Christine, and Patricia Chuchryk, eds. *Women of the First Nations: Power, Wisdom, and Strength.* Winnipeg: University of Manitoba Press, 1997.

Monture-Angus, Patricia. *Thunder in My Soul: A Mohawk Woman Speaks.* Halifax: Fernwood Publishing, 1995.

—. *Journeying Forward: Dreaming First Nations' Independence.* Halifax: Fernwood Publishing, 1999.

Morriseau, Calvin. *Into the Daylight: A Wholistic Approach to Healing.* Toronto: University of Toronto Press, 1998.

Ontario Federation of Indian Friendship Centres. *Urban Aboriginal Child Poverty: A Status Report.* Toronto: OFIFC, 2000.

—. *Tenuous Connections: Urban Aboriginal Youth Sexual Health and Pregnancy.* Toronto: OFIFC, 2002.

—. *Aboriginal Approaches to Fetal Alcohol Syndrome/Effects: A Special Report by the Ontario Federation of Indian Friendship Centres.* Toronto: OFIFC, 2002.

Ortiz, Simon J., ed. *Speaking for the Generations: Native Writers on Writing.* Tucson: University of Arizona Press, 1998.

Payment, Diane. "La Vie en Rose? Metis Women at Batoche, 1879-1920." In *Women of the First Nations: Power, Wisdom, and Strength,* edited by Christine Miller and Patricia Chuchryk. Winnipeg: University of Manitoba Press, 1997.

Penn, William S., ed. *As We Are Now: Mixed-Blood Essays on Race and Identity.* Berkeley: University of California Press, 1997.

Roscoe, W., ed. *Living the Spirit: A Gay American Indian Anthology.* New York: St. Martin's Press, 1988.

Smith, Jaune Quick-to-See. "Give Back." In *Give Back: First Nations Perspectives on Cultural Practice,* edited by Caffyn Kelley. Vancouver: Galerie Publications, 1992.

Stout, Madeleine Dion. *Aboriginal Women in Canada: Strategic Research Directions for Policy Development.* Ottawa: Status of Women Canada, 1998.

Torpy, Sally J. "Native American Women and the Coerced Sterilization: On the Trail of Tears in the 1970s." *American Indian Culture and Research Journal* 24, no. 2 (2000): 1–22.

Tuchman, Gaye. "Introduction: The Symbolic Annihilation of Women by the Mass Media." In *Hearth and Home: Images of Women in the Mass Media,* edited by Gaye Tuchman, Arelene Kaplan Daniels and James Benét. New York: Oxford University Press, 1978.

Tuhiwai Smith, Linda. *Decolonizing Methodologies: Research and Indigenous Peoples.* London: Zed Press, 1999.

Welsh, Christine. "Women in the Shadows: Reclaiming a Metis Heritage." In *New Contexts of Canadian Criticism,* edited by Ajay Heble and Donna Penee. Peterborough: Broadview Press, 1997.

Williams, Walter L. *The Spirit and the Flesh: Sexual Diversity in American Indian Cultures.* Boston: Beacon Press, 1991.

Winnipeg Art Gallery, Catherine Mattes and Lita Fontaine. *Lita Fontaine: Without Reservation — Catalogue of an Exhibition Held at The Winnipeg Art Gallery* Jan. 17 to Mar. 15, 2002. Winnipeg: The Winnipeg Art Gallery, 2002.

CONTRIBUTORS

ZAINAB AMADAHY (Cherokee) is a Toronto-based writer, singer/songwriter, consultant and community activist. Zainab is the author of the science fiction novel *The Moons of Palmares*. She co-wrote and performed on Spirit Wind's debut CD *Breathing the Wind* (distributed by WRPM), and wrote and performed for the indie film *Where Angels Don't Fly*. Along with Spirit Wind, Zainab was the subject of the documentary *Breathing the Wind,* which aired on TVO and Vision TV.

KIM ANDERSON (Cree/Métis) is a writer, editor and educator. She makes a living doing research and writing on social and health policy issues for Aboriginal organizations in Ontario. Kim is the author of *A Recognition of Being: Reconstructing Native Womanhood.* She lives in Guelph, Ontario, with her partner and their two children.

CYNDY BASKIN (Mi'kmaq) has worked within Toronto's Aboriginal community in the areas of community development, culture-based programming and healing. Her work focuses on family violence interventions, restorative justice and Aboriginal ways of helping. Cyndy is an Assistant Professor in the School of Social Work at Ryerson Polytechnic University in Toronto and a PhD candidate in Sociology and Equity Studies at OISE/UT.

FAY BLANEY (Homalco/Coast Salish) is an instructor in Aboriginal Studies, Women's Studies and Canadian Studies at Langara College, and a sessional instructor in Women's Studies at the University of British Columbia. She is one of the founding members of the Aboriginal Women's Action Network and an executive member of the National Action Committee on the Status of Women. Fay is still working on her thesis and hopes to go on to do doctoral work in the field of Aboriginal education.

SHELLY E. BRESSETTE (Anishinaabe kwe) is from Kettle & Stony Point First Nation in Ontario. Her Anishinaabeg name is Zoongaabiitoon Odenaakwe or Weaving the Village. Shelly is forty-five winters old, mother of six, with one beautiful granddaughter. Her life partner is Miles Morrisseau. Shelly's work includes journalism and counselling. Currently, she works for Kettle & Stony Point Health Services in its residential school healing initiatives. She enjoys being with family, walking along the lake and learning her Anishinaabe language.

NANCY COOPER (Ojibway/Irish) is from the Chippewas of Mnjikaning First Nation. She is a writer and a photographer. Her poetry has been published in *The Colour of Resistance, The Sweet Grass Road* and in *Sweet Grass Grows All Around Her.* Nancy is an adult educator and has worked in the Native literacy community in Ontario for twelve years.

ROSANNA DEERCHILD (Cree) has had her poetry published in literary magazines like *Prairie Fire, CV2* and *dark leisure.* She is a member of the Aboriginal Writers Collective of Manitoba Inc., which authored *urban kool,* a contemporary Aboriginal anthology. Rosanna is also a journalist, most recently with Aboriginal Peoples Television Network. She lives in Winnipeg.

CARL FERNÁNDEZ (Anishinaabe) is an Aboriginal Recruitment Officer/ Academic Advisor at Queen's University in Kingston, Ontario. He has had several experiences as an educator, including child education at a preschool in Jamaica and facilitating safe-sex workshops in Guyana, South America. In the past he has spent many summers working as a wilderness trip leader with adolescents. He thoroughly enjoys spending time with family and friends.

LITA FONTAINE (Dakota/Ojibway) is a Winnipeg artist and a member of the Long Plain Band, Manitoba. She holds a Masters in Fine Arts (2001) from the University of Regina and a Diploma in Fine Arts from the University of Manitoba (1997). Lita currently works with the Seven Oaks School Division as the Artist in Residence/Community Resource Worker. She has participated in group and solo exhibitions on local and national levels.

ELIZE HARTLEY (Métis) was born and raised in what is now the historic Métis village of Vassar, Manitoba. The search for work brought her to Ontario where she raised five daughters and graduated from McMaster University. She looks after her home and her husband, volunteers on many

Aboriginal boards and committees, visits schools and introduces children to Aboriginal stories and traditions. She is the founder of the Métis Women's Circle. She goes where the Creator sends her.

JEAN CATHERINE KNOCKWOOD (Mi'kmaq) is a storyteller, educator and researcher. She has done research on self-government, health, special needs and tobacco. Jean was the founder and principal/manager of the Indian Brook School for students in the primary to twelfth grades. Jean views school as a means for self-sustainability and community economic development since tuition dollars can be recycled though jobs and services. Jean lives on the Shubenacadie Reserve in Nova Scotia with her husband Bernie and their daughter Catherine.

BONITA LAWRENCE (Mi'kmaq) is an Assistant Professor at Queen's University, where she teaches courses in Women's Studies and Native Studies. Her research focuses on mixed-race, urban and non-status Native identity. Her book *Mixed-Blood Urban Native People, the Indian Act, and the Rebuilding of Indigenous Nations* will be published by University of Nebraska Press in the Fall 2003.

CAROLE LECLAIR (Red River Métis) is an active member of the Métis Women's Circle in Hamilton, Ontario. She holds an MA in English from Guelph University and a PhD in Environmental Studies from York University. She is a member of the faculty at Laurier University, Brantford, teaching in Contemporary Studies and Indigenous Studies.

SYLVIA MARACLE (Mohawk, Wolf Clan) is a member from Tyendinaga Mohawk Territories. She is the Executive Director of the Ontario Federation of Indian Friendship Centres, as well as a board member for the Legal Aid Ontario, Ontario Aboriginal Housing Services and the Aboriginal Healing and Wellness Strategy Joint Management Committee. Sylvia has been involved in many other local, provincial and national Aboriginal organizations.

DR. DAWN MARTIN-HILL (Mohawk, Wolf Clan) holds a PhD in cultural anthropology. She is one of the original founders and current Academic Director of the Indigenous Studies Program at McMaster University. Her book *Indigenous Knowledge and Power: The Lubicon Lake Cree* is currently pending revision with University of Toronto Press. Dawn's research includes Indigenous knowledge and Aboriginal women, spirituality and traditional medicine, and the contemporary practice of Indigenous traditionalism.

GERTIE MAI MUISE (Mi'Kmaq) grew up in St. George's, Newfoundland. After receiving a BA from Memorial University she came to Ontario and has been active within the Aboriginal community for ten years. Gertie Mai is a singer, traditional hand drummer, folk guitarist and lyricist. Currently, she is employed as the Aboriginal Health Advocacy Co-ordinator at the Ontario Federation of Indian Friendship Centres and is enrolled as a part-time student in Holistic Health.

REBECCA MARTELL (Cree) is a member of Waterhen Lake First Nation. She is currently an Aboriginal Associate with the University of Alberta's Department of Occupational Therapy, Occupational Performance Analysis Unit (OPAU); a member of the National Advisory Committee on Fetal Alcohol Syndrome; and a member of the Alberta Aboriginal Committee on Fetal Alcohol Syndrome. She is working towards a degree in psychology, and continues her involvement with First Nations across Canada and the United States in addressing community wellness.

LYNN NICHOLSON (mixed-blood Métis) is a member of the Métis Women's Circle and works as a community development co-ordinator in Toronto. Lynn returned to college and university as a mature student to study phytopharmacy, women's traditional knowledge and the Mohawk language. Her garden project, funded by the Ontario Trillium Foundation, is dedicated to the memory of her grandmother Lyons, an herbalist, whose ancestors emigrated to Upper Canada from Pennsylvania as United Empire Loyalists.

LAURA SCHWAGER (Mohawk) is a recent graduate of Fine Arts at Queen's University where she was also a teacher's assistant for Introduction to Aboriginal Studies. She is a member of the Queen's Native Women's Traditional Hand-Drumming group and co-ordinator of the Native Women's Cultural Programming for Queen's and the Kingston community. She is looking forward to teacher's college where she will be taking part in the Aboriginal Teachers Education Program.

SHANDRA SPEARS (Ojibway) is from the Wolf Clan and is a member of Rainy River First Nations/Manitou Rapids. She was raised in Chatham, Ontario, and has performed as an actor and singer throughout North America. Shandra was a founding member and co-facilitator of the Rejoining the Circle post-adoption/foster care support group in Toronto. She graduated from Honours Drama and Communication Studies at the University of Windsor in 2003.